What Do You See?

Phenomenology of Therapeutic Art Expression

of related interest

A Multi-Modal Approach to Creative Art Therapy
Arthur Robbins
ISBN 1 85302 262 4

Art Therapy in Practice
Edited by Marian Liebmann
ISBN 1 85302 057 7 hb
ISBN 1 85302 058 3 pb

Art Therapy with Offenders
Edited by Marian Liebmann
ISBN 1 85302 171 7

Arts Therapies and Eating Disorders
Edited by Ditty Dokter
ISBN 1 85302 256 X

What Do You See?
Phenomenology of Therapeutic Art Expression

Mala Gitlin Betensky

Foreword by Judith A. Rubin

Jessica Kingsley Publishers
London and Bristol, Pennsylvania

First published in the United Kingdom in 1995 by
Jessica Kingsley Publishers Ltd
116 Pentonville Road
London N1 9JB, England
and
1900 Frost Road, Suite 101
Bristol, PA 19007, U S A

Library of Congress Cataloging in Publication Data

A CIP catalogue record for this book is available from the Library of Congress

British Library Cataloguing in Publication Data

A CIP catalogue record for this book is available from the British Library

ISBN 1-85302-261-6

Printed and Bound in Great Britain by
Biddles Ltd., Guildford and King's Lynn

Contents

Part IV: Art Expression for Art Therapy Diagnostics

Part V:

Foreword

As I read Dr Betensky's most interesting book – what did *I* see? I saw a rich feast, from philosophical reflections about phenomenology to psychological notions about the meaning of 'gestalt'. I saw a varied menu of ideas and experiences in many areas – in research, in diagnosis, and in psychotherapy, each using art media with patients of all ages. And I felt the painful poignancy of the last chapter in which we hear and see how doomed children in a concentration camp were able to cope with the terror of their fate through their own creativity. As I read and looked, I often thought to myself, 'What a marvellous job of synthesis, this integration of art and phenomenology and gestalt psychology'. I learned the specific techniques and findings described by the author and I was reminded of the endless creative potential within each of us, exemplified by Dr Betensky's achievement in this thought-provoking volume.

It takes courage to confront and to convey the complexity of competent clinical work. In contrast to Dr Betensky's thoughtful and scholarly effort, we often find in the field of art therapy (and in other disciplines as well) a persistent search for simple answers to complicated questions. I used to think that this phenomenon was a reflection of lack of experience; but I have had to reluctantly admit over time that, while experience may reduce the intensity of the pressure for easy answers, it is no guarantee that the person will give up the quest. What seems to happen instead is that such questions tend to be put into a more sophisticated form, but are in essence the same. In case you are wondering what I have in mind, I refer to queries such as: 'What do you do when ?' or 'What does it mean if ?'

I have wondered what could be done about this insistent desire for certainty on the part of fellow art therapists. One could, of course, throw up one's hands and decry the presence in the field of so many dependent individuals. Or one could try to provide them with as many specific answers

as possible. Some authors, while well-intentioned, have done just that and, to my mind, have inadvertently interfered with the ultimate professional development of their insecure readers. Others, like Dr Betensky, have described their own work in its actual complexity in order to provide models of thoughtful clinical decisionmaking.

Lest the reader think I am being unsympathetic to the needs of art therapists for guidance, let me assure you that I have the utmost respect for: the universal wish for an omnipotent/omniscient other, the innate drive to reduce tension through certainty, the natural desire for predictability and consistency, the normal fear of helplessness and concomitant desire to be in control, and the need in many areas of life for what psychoanalyst Heinz Hartmann called 'secondary autonomy' of ego functions, wherein decisions become largely automatic and preconscious; that is, easy and effortless.

In providing viable answers that are not simple recipes but rather models of how to think about one's work, Dr Betensky has made a significant contribution to the literature of art therapy. She describes through vivid case examples how she approaches the mystery of each new human being and the challenge of helping that individual. She tells about how she has utilized the frustration and ambiguity of not knowing answers as a challenge to design a research study or a diagnostic protocol.

Although most art therapists are practising artists, it is intriguing that so many seem so often to be inhibited, unable to use their creativity in the service of their clinical work. Perhaps, in spite of their facility with visual media, some may be lacking in 'ego strength', inner security, or other relevant personal attributes. If so, I would hope that those individuals would obtain some kind of therapy for themselves so that they can be free to enjoy divergent thinking as clinicians and not need so often to have premature (convergent) closure.

I have often thought, however, that what many art therapists need even more than psychotherapy is permission to use the creative part of themselves in their work with others. Perhaps, having been artists, they are under-standably cautious about tapping what they know to be powerful, but not easily controlled, inner resources in the service of psychotherapy. Nevertheless, one can safely harness one's creativity in both realms through respecting the boundaries inherent in the art process as well as those intrinsic to the therapeutic contract.

With due respect, therefore, for the potency of the passions within, I submit that the answer to the many questions so persistently asked by anxious

clinicians lies in the selective development of creative thinking capacities in the service of the therapeutic task at hand, whether the questions be about the 'what' of symbolic meaning, the 'why' of behaviour, or the 'how' of intervention. Dr Betensky seems to have done that without falling into the potential trap of using creativity in the service of personal needs.

In order to be able to do so, however, it was necessary for the author to have more than a strong ego and a taste for ambiguity, more than self-awareness and ongoing self-scrutiny. She also had to have in her mental storehouse some basic understandings about both art and psychotherapy, the informational wherewithal underlying her creative clinical competence. In a sense, these basic learnings are analogous to the kind of extensive experience with his medium upon which any creative artist must draw when going to work. Without such a well-internalized familiarity with the tools and raw materials of his art, no one can achieve his highest aesthetic potential. Similarly, even the most naturally gifted, creative, and caring clinician cannot reach his full potential as a therapist without having integrated essential knowledge about art and therapy upon which to draw freely and spontaneously.

What Dr Betensky has done is to provide us, not only with the kinds of creative syntheses exemplified in her diagnostic, therapeutic, and research work; she has also introduced us, clearly and vividly, to the basic elements of symbolic expression in art – line, shape, colour, and so forth – and how they can be viewed from a phenomenological perspective. She also teaches us about phenomenology, about how she applies that theory to art therapy in both diagnosis and treatment.

Throughout, she is not only creative in her thinking, but also scholarly in her approach; citing relevant findings, and integrating them with her own original investigations. Dr Betensky describes both assessment possibilities and work over time, as well as a naturalistic example of the therapeutic usefulness of art (the children of Terezin). She continually explores different avenues, suggesting, for example, alternative combinations of tasks in her diagnostic test batteries. She is open-minded, not dogmatic; a position consistent not only with the phenomenological orientation, but also with being a secure, mature clinician.

Dr Betensky has integrated theories of personality and psychotherapy which underly her work. It is necessary to do so in order to be able to do genuine creative problem-solving about how to use materials and one's self to help the patient. She has given us a fascinating glimpse at her work as well as a clear understanding of why she does what she does and how she

thinks about it. We would do well to adopt those of her techniques which seem relevant and to adapt them as needed in the flexible manner of the author herself. And we would do very well to emulate the kind of scholarship, clarity, and creative synthesis evident in this book, whatever form our own work eventually takes.

Judith A. Rubin
Pittsburgh, PA

Preface

This book presents a phenomenological perspective of symbolic art expression in art therapy and in psychotherapy.

Guided by a therapist who has no predetermined meanings in mind, clients untrained in art learn to look at their visual productions, and see in them the inner experience that guided their hands in the shaping of the art work. Seen serially, the art works become foci of therapy, part of which is change detected in the art works.

The phenomenological perspective is presented in the first chapter of Part I. This is, essentially, an anthropo-philosophical view of present- and future-oriented human beings-in-the-world. These human beings are persons, not objects. Each of them is a phenomenon with generally shared but individually coloured innate qualities and propensities that make their relationships in their worlds highly individual.

Some of these phenomenal qualities are intentionality, experiencing that involves all mental forces, conscious self-reflection, a need to create, and the striving for mental and spiritual growth throughout life. I believe that this kind of philosophy promotes a therapeutic thrust towards health and that it is needed by both therapist and client.

The second chapter of Part I comprises the phenomenological method of art therapy. Clear in its basic ideas and steps, it is flexible enough for therapists to suit clients' pace. The basic tenets of the chapter are: (1) the art production is a phenomenon with its own structure; (2) the client learns to see all that can be seen in it; (3) the client's precise verbal description of the art work's structure is essential; (4) the client connects the art work with the inner experience. Even as the therapist helps clients to see the structure of components in their mutual relationships, the method underscores the primacy of clients' eyes and minds as they arrive at self-discovery in their self-expressions.

The highlight of this process is in the clients' very specific linkage of the inner experience with the structural dynamics of the art work. The gestalt-based principle of similarity of the two structures offers one aspect of the mechanism behind this process of expression. The other aspect is the Arnheim theory of visual thinking and visualization that grew out of his study of the relationship between the senses, particularly sight, and the psychology of thinking, particularly imagery. This theory has become part of the conception of phenomenological art therapy and psychotherapy presented in the book.

The four chapters of Part II address the chief formal components as used in art therapy – line, shape, and colour in their interrelated dynamics. Other aspects and modes of symbolic expression found in clients' work are also discussed. Occasionally, references are made to artists' art.

Part III devotes two chapters to symbolic expression through the scribble, a popular technique in art therapy. The first chapter offers a classification of scribbles accompanied by samples. In addition, that chapter discusses diagnostic possibilities of the scribble from the perspective of the formation of autonomic self within one's world. In the second chapter, the scribble is presented as the sole means of self-expression in a case of pre-anorexia and one of anorexia.

Part IV consists of two chapters on art expression for art therapy diagnostics. The special features in these chapters are (1) a method for qualitative diagnostics which benefited from Amadeo Giorgi's concepts of phenomenological research, and (2) a first full diagnostic battery for adolescents.

Part V, the chapter about Holocaust children's art expressions, deviates somewhat from the rest of the book in that there is no therapeutic aspect in the discussion. This special chapter highlights the power of art expression in children under ultimate stress, the intensity of their inner experience, and its visualization in the structure of the pictures. The phenomenological study of the children's art presented in this chapter helped me learn how to look in order to see. I hope that this will help others to see.

This is a book for art therapists and advanced students. It can be used as a textbook on phenomenological art therapy; for therapeutically-oriented art teachers, educators and social workers; and for practising psychotherapists, to see that art is a source of expression demonstrating how a person *is*. I believe that the book fills a need in art therapy and helps alleviate the neglect of art in the praxis of psychology.

Part I

Philosophical Orientation and Method

About Phenomenology for Art Therapy

The term phenomenology has been known in philosophy since the middle of the 18th century and was subsequently elaborated on by a number of philosophers into a variety of divergent themes. At the beginning of the 20th century, Edmund Husserl[1] (1859–1938), founder of modern phenomenology, gave it a new meaning which gained significance as his Science of Consciousness, a study of phenomena (things, objects) and their structures as they present themselves in consciousness as immediate experiences. A phenomenon (a verbal noun from the Greek verb 'to appear') can be perceived and observed with our senses and with our minds.

Phenomena include visible, touchable, and audible things in the world around us, as well as thoughts and feelings, dreams, memories, fantasies, and all that stems from the human mind or spirit and belongs in the realm of mental experience. By means of the study of consciousness, Husserl tried to reduce the perception of phenomena to their essence.

It often occurs in the history of ideas that a new idea captures intellectual and social attention in reaction to a crisis which occurs when the previously prevalent idea is then the answer to the crisis. In reaction to positivism, phenomenology called for a turn 'to the things themselves' and to investigation of the fullness of subjective experiencing of 'things', away from preconceived or inferred theories about them. Such was the purpose held in common by a number of phenomenologists at the beginning of this century who applied the phenomenological theory and method to their study of a

1 Edmund Husserl, *Ideas*, 1913; reprinted in 1976 by Humanities Press, NJ. Also, *Husserliana*, microfilm, New School for Social Research, NY.

variety of themes. Thus, Edmund Husserl[2]developed transcendental phenomenology, the science of intuitive investigation of the structure of 'pure consciousness'; Max Scheler[3] (1874–1928) and Alexander Pfänder[4] (1870–1941) explored structures and interconnections within phenomena and intraconnections among them; Martin Heidegger[5] (1889–1976) developed hermeneutic phenomenology, whose task was to arrive at meanings of phenomena pertaining to human existence; Moritz Geiger[6] (1880–1937) was first to study aesthetics on phenomenological grounds.

Others studied ways in which phenomena appear in our consciousness and still others investigated modes in which phenomena are given. Contemporary phenomenologists investigate the place of man in phenomenological contexts of psychology, religion, social existence, science, essentiality of the human body, and expression.

Phenomenology grew into a movement in Western Europe, reached the United States in the middle of the 20th century, and was introduced to university courses in philosophy and phenomenological psychology. Phenomenology influenced psychotherapies, particularly those of humanistic origins.

I became acquainted with philosophical phenomenology in my student years. Its chief interest in qualitative exploration of the human experience spoke to me. Its opposition to restrictions in psychology to behaviour and behaviour control, to mechanistic associationist views as well as to reductionist tendencies in the study of man and woman, was what I was looking for. When I arrived at a synthesis in my background and interests among psychology, Gestalt psychology and particularly the Arnheim psychology of art, psychotherapy, the history of ideas, and art, and was searching for an appropriate method that I could use experientially, some aspects of Husserlian and more recent phenomenology seemed quite naturally to answer my quest. By then, art therapy had taken a central place in my psychotherapeutic work; and phenomenological theory, in addition to some aspects of phenomenological method, appeared appropriate for art therapy. This book is the

2 Edmund Husserl, *Ideen*, (Ideas) Niemeier, 1913.

3 Max Scheler, *The Nature of Sympathy*, translated by Peter Heath, Yale Univ. Press, 1954.

4 Alexander Pfänder, *Phenomenology of Willing and Motivation*, translated by Herbert Spiegelberg, Northwestern Univ. Press, 1976.

5 Martin Heidegger, *Sein Und Zeit*, Niemeier, 1927. English translation *Being and Time*, London, SCM Press, 1962.

6 Moritz Geiger, *Zugänge zur Ästhetic*, Leipzig, 1928. Also, 'Das Unbewuste und die Psychische Realität,' *Jahrbuch für Philosophie und Phänomenologische Forsehünige*, IV, 1921.

result of practising the synthesis[7] and studying other approaches in art therapy and in psychotherapy.

Since theoretical considerations are essential to art therapy, which is empirically-oriented but is also in need of philosophical underpinnings, this chapter will be devoted to some ideas in philosophical phenomenology relevant to art therapy. I will start with a basic concept of Husserlian phenomenology.

1. Intentionality[8]

The subject of intentionality is man. Phenomenologically, however, man and his being are both so connected with the world and so intimately related to each other that in reality man is man-in-the-world. Man is deeply affected by the world, at times even burdened with it. In art therapy and in psychotherapy, we often meet overburdened man, woman, and child, each preoccupied with the stresses of their personal being-in-the-world and dominated by overwhelming human vulnerability.[9] In my work I often see them retreat with their burden into psychopathology. Their art-therapeutic work may become a source not only of immediate release, but mainly a pre-intentional record of the immediate experience of stress and flight. Guidance by the art therapist into an intentional perception and study to see their own painting, sculpture, or collage may open new possibilities for them.

2. The Art of Looking and Seeing

The experience of *seeing* is of vital importance, and perhaps this is one of art therapy's most important contributions to general therapy and even to phenomenology itself, because art therapy pays attention to the authentic experience in a twofold way. First, clients in art therapy produce an art expression that is direct experience; then they experience its appearance in their eyes and in their immediate consciousness, and this is a second direct experience. In the second experience, however, they need some help, for they

7 Mala Betensky, 'Phenomenology of Self-Expression in Theory and Practice', *Confinia Psychiatrica*, Int'l. Colloquium for Psychopathology of Expression, Jerusalem, 1976. Also, 'The Phenomenological Approach to Art Expression and Art Therapy,' *Art Psychotherapy*, 4:173–179, 1977. And, M. Betensky and A.O. Nucho, 'The Phenomenological Approach to Art Therapy,' *Proceedings*, 10th Annual Conf. of AATA, 1979. Also, *Proceedings*, Conf., 1981.

8 Husserl, *Op. cit.*

9 William F. Fisher, 'Existential Vulnerability and Psychopathology,' Paper given at APA Conference, 1982.

must learn how to look in order to see all that can be seen in their art expression. When I succeeded in suspending all my *a priori* judgments and all acquired notions about what I was supposed to see; when I trained my eyes to look with openness and with intention at the object of my sight, I began to see things in that object that I had not seen before. Slowly I began to understand the truth in Merleau-Ponty's statement that ... 'to look at an object is to inhabit it and from this habitation to grasp all things'.[10] This is a phenomenologist's way of looking in order to see, seeing with intentionality. In the Husserlian science of consciousness, seeing with intentionality also suggests a suspension or 'bracketing', at least temporarily, of previously acquired notions. For those might obscure the sight of things as they are.

For the needs of art therapy, the philosophical concept of intentional looking and seeing must be translated into art-therapeutic and psychological terms, and related to the specific client's inner experience and its symbolic art expression. The Arnheim gestalt psychology of art answers that need most effectively, thereby bringing the synthesis of approaches in this book to closure. Thus, for example, the concept of seeing with intentionality has been concretized in this book as the act of intuiting; that is, of mentally focusing on the inner experience and its essential concept, then visualizing it with art materials in shapes and colour.

3. Intentionality and Meaning

Intentionality means that I am intent upon the thing that I am looking at. By means of my intent look, I make that thing appear to my consciousness more clearly than before I was intent on looking at it. The object of my attention begins to exist for me more than it had before. It is becoming important to me. Now it *means* something to me. At times, a meaning becomes vital to my existence, to my being. Indeed, man is an intentional being with an intentional consciousness that makes the world actual to him. Intentionality may even help invent new worlds and make the invisible visible and the inaudible audible as in the arts and sciences.

4. Intentionality as Relatedness

Intentionality[11] also means that our consciousness always relates to some thing or to some body. This, in turn, means that it is always directed to reality,

10 Maurice Merleau-Ponty, *Phenomenology of Perception*, Routledge & Kegan Paul, NJ, 1962, p. 68.
11 In this book, 'intentionality' is used in two ways: one is as the concept of relatedness, the

to the world. Thus, intentionality has direction built into it. A client of mine, overburdened and withdrawn, persisted for some time in drawing tables, stools, aeroplanes on the ground, and other still objects. Cautious in making new contact with the world, he was trying to direct his intentionality – sensory, rational, and emotional – to inanimate objects first. He was not just hiding his feelings. On the contrary, he was turning toward everyday objects and was trying to get to know them in the *Lebenswelt*, the everyday life.[12] Hence, his production of a variety of stools and tables in various positions. His was a beginning of the return from the escape from being-in-the-world.

5. Intentionality and Body

Intentionality of consciousness resides in the body, and that explains man's orientation to the world. That the body is intentional is almost an obvious fact. We are born into a world which is already there; thus, our body meets the world. With our senses developing in and along with the body and with our growing consciousness, we discern things in the world. Nor do we go about it in a piecemeal manner, appropriating each activity to its own sense and organ alone. When our eyes see and our ears hear, it is not a function of the eyes or ears alone; it is the whole body that is conscious of what the eye discerns in the visible world and what the ear hears in the sonorous world. Artist and art teacher Nicholaides expressed it well when he taught his students how to look at a model: '...what the eye sees; i.e., the various parts of the body, actions and directions, is but the result of the inner impulse, and to understand that one must use something more than the eyes.'[13] And when we run or rush, our whole body is in motion along with our legs, quite consciously intent upon the purpose and destination of our running. Thus, our body is permeated with intentionality within a wider unity of the body.

6. Unity of Body

The wider unity of body includes sexuality in a phenomenological way. Merleau-Ponty (1962)[14] studied extensively the phenomenological nature and role of sexuality in contrast to the psycho-sexual view of orthodox

other as the concept of intentness (as an 'intentional looking'); the first intensifies the second.

12 Husserl relates the immediate experience of phenomena to the world of everyday life (*Lebenswelt*).

13 Kimon Nicholaides, *The Natural Way to Draw*, Houghton Mifflin Co., Boston, 1941.

14 Merleau-Ponty, *op. cit.*, pp. 154–173.

psychoanalysis,[15] about the artistic symbols based on the emotional and bodily priority of sex. He perceives sexuality as a generality that finds its expression in all behavioural ways – rational, emotional, bodily – that are not explicitly sexual. Phenomenologically seen, sexuality is not a force of itself and by itself. It transcends itself along with other forces in human existence and merges with those other forces so that we cannot pinpoint exactly which forces make us do what we do. Together they characterize our body in a most subjectively unique unity.

7. Unity of Emotion and Unity of Expression

The same intentionality permeates emotion, again in contrast to the dualistic view of emotions as separate forces capable of influencing body. At this point, Plato[16] and William James[17] come to mind. Though many ages apart, both investigated the problem of emotion and thought, Plato by means of philosophy, James through introspection. While the ancient philosopher endeavoured to separate 'passions' from 'reasons' and 'spirit', James asserted that both, thought and emotion, act together as integral parts of the 'stream of consciousness'. That was an ingenious formulation of an experiential process, not subject to mechanistic determinism, but a constant flux of a variety of sensations to the brain. From that 'stream' man selects certain messages to notice and to act upon. I find these Jamesian insights akin to phenomenological concepts of intentionality and interacting within the unities of body, consciousness, and emotion. It was within that context of thinking and feeling that James chose the phenomenon of religious experience as a theme for investigation, clearly not as a subject for the study of pathology, but worthy of scientific investigation as a human experience of genuine expression in feeling and thought.

Coming closer to contemporary phenomenologists, in Strasser's philosophy of feeling, man's emotion is a 'determinate mode of man's gradually accustoming himself to the world', this gradual accommodation being characterized by *motus*, movement.[18] This explains the general animation or state of excitement of the whole person in anticipation of an emotional

15 Rudolph Arnheim, 'Artistic Symbols – Freudian and Otherwise,' in *Toward a Psychology of Art*, Univ. of Calif. Press, 1972.

16 Timaeus, Plato With an English Translation, Loeb Classical Library, VII: 178–184.

17 William James, *Principles of Psychology*, Hold & Co., NY, 1890. Also, *The Varieties of Religious Experiences*, Longmans & Green, NY, 1902. And, Jacques Barzun, *A Stroll With William James*, Harper & Row, NY, 1983.

18 Stephan Strasser, *Phenomenology of Feeling*, Duquesne Univ. Press, Pittsburgh, 1977.

experience. *Motus* is also evident in many manifestations of expressivity characterized by the unity of body-consciousness-feeling. The experience of *motus* is known to artists and inventors in all arts and sciences. Art therapists, too, notice the rising *motus* in the thin but observable transition in their clients' art processes from pleasurable play with art materials to more serious art expression.

Established by Klages as the principle of the Unity of Expression (1936),[19] this important but now little known principle seemed to have been submerged in American psychology by the extraordinary impact of Freudian psychology and the popular wave of behaviourism. It has reappeared, however, in more elaborate form, in Strasser's work and in the recent phenomenological writings of Remy C. Kwant, who studies expression as a creative disclosure of being.[20] Strasser clearly places emotion within intentionality and discerns three phases of emotion accompanying expression: the pre-intentional, the intentional, and the meta-intentional. This, too, is a helpful classification for the art therapist's observation and guidance of a client's visual perception of the completed art expression. The pre-intentional phase of emotion is a vague state experienced by some pressure generated from an impression, ever so slight, of an unidentified object in the field of vision. The vagueness becomes intentional in the second phase, where it connects with the identified object, and turns meta-intentional in the third phase, when object is fully perceived and felt as part of the person's consciousness and existence.

8. Meaning

The important thing about this crescendo of intentionality of emotion in relation to object, particularly in the case of the clients' art expression, is that in the process an additional factor emerges: meaning.[21] Meaning appears rather early in life when the baby, as soon as it is physically ready, busies its eyes with a visual area in an effort to structure a bit of the surrounding reality. This is the baby's movement toward the world. It is also a first expressive activity on a pre-conscious and pre-intentional level. In the process of growth, it becomes conscious, emotion-laden, and meaningful when the

19 L. Klages, *Grundlege der Wissenschaft vom Ausdruck* (Foundation for the Science of Expression), Leipzig, 1936.
20 Remy C. Kwant, *Phenomenology of Expression*, Humanities Press, NJ, 1978.
21 For man's need of meaning read Victor E. Frankl, *Man's Search for Meaning*, Beacon Press, Boston, 1969.

child is physically ready to interact with the world. In that interaction, we organize our visual field so that a certain object in that field becomes visible to our eye and thereby begins to exist for us more than other things in that field of vision. It then takes on some importance for us and thus becomes meaningful. I often observe similar emergence and structuring of meaning in my clients' discoveries as they intentionally look at their art expressions. I also find that the emergence of meanings, even small subjective ones, noticed when a line or colour suddenly becomes visible, enables the client to see unrealized possibilities or untapped potencies. This may have some bearing upon the question of the unconscious in phenomenological thinking and art therapy.

9. Phenomenology and the Unconscious

The vagueness of the stirrings toward an object yet to be identified in a visual field, classified in phenomenology as pre-conscious and pre-intentional, is probably the closest point of meeting between unconscious-minded psycho-analysis and consciousness-minded phenomenology. Historically, the study of consciousness was not yet well known when Freud formulated his conceptions, nor were the founders of phenomenology interested in psycho-analysis then. Much of the same could be said about Gestalt psychology at the time of its beginnings, even though Gestalt psychology and phenomenology were both reactions to positivism and associationism. The lack of mutual interest and contact among all these orientations can be understood in terms of each one's total focusing on the challenge of its own endeavours.

Somewhat later, however, phenomenologists did write about the unconscious. Husserl stated that the unconscious 'is anything but a phenomenological nothing, but itself is a marginal mode (*Grenzmodus*) of consciousness'.[22] And Martin Heidegger, one of the founders of phenomenology,[23] comes somewhat closer, albeit only to a certain point, to the unconscious through his concept of *Dasein* (being-in-the world). He presents the concept of two dimensions of Being: the dimension that does not show itself (ontological) is intimately interwoven with the one that does show itself (ontic). He thinks that phenomenology can reveal the concealed dimension of Being.[24] Thus, the unconscious processes are hidden in the ontological

22 Quoted within a quote from Binswanger in Herbert Spiegelberg, *Phenomenology in Psychology and Psychiatry*, p. 236, Northwestern Univ. Press, 1972.
23 Martin Heidegger, *Sein und Zeit*, Niemeyer, Tubingen, 1960.
24 Heidegger. *Ibid.*

dimension of *Dasein* which phenomenology can reveal. And yet, Heidegger is also convinced that beyond the phenomena of phenomenology there is 'nothing else'.

Husserl does not negate the unconscious, but thinks that the phenomena of consciousness must be studied first. Generally, to German phenomenologists the theme of consciousness was of primary importance, and perhaps, therefore, their early interest in psychoanalysis and its focus on the unconscious, was only slight. There were, however, some exceptions, notably Moritz Geiger, the first phenomenologist to publish an essay on the subject of the unconscious,[25] albeit not treated on psychoanalytical grounds. In this essay, Geiger called for a scientific investigation of the unconscious, its function, and its place in the psychology of man. He suggested an interesting concept of active and non-active experiencing, which somewhat resembles the pre-conscious and conscious aspects of experiencing. Some scholars tried to synthesize phenomenology and psychoanalysis. One of these was Paul Schilder,[26] who made an effort to assimilate the unconscious, but reached as far as the pre-conscious. A further attempt at bringing both approaches closer together was that of phenomenological psychiatrist Ludwig Binswanger.[27]

10. A Conceptual Experience

As I write about these ideas of the unconscious and pre-conscious and their impact on the experience of experiencing, and remember Geiger's examples of viewing paintings, I recall my own experience in an art gallery: I look at a painting that draws my interest and, almost immediately, walk away, to another. While facing that other, my eyes turn back again to the first one. Why? What about it, or about me, makes me move back to it, this time to look with full intentionality? I sit down and gaze at it much longer, noticing things that were not there before. Something in me feels satisfied now, solved, as it were, completed. It seems that I have experienced two kinds of experiencing. First, a non-active, then an active one, to borrow Geiger's concepts, quite appropriately now. The non-active experience left me with a sense of something unfinished coupled with some unrest. Perhaps I felt a need to complete the experience by relating to the first picture with full

25 Moritz Geiger, 'Das Unbewuste und die Psychische Realitat' (The Unconscious and Psychological Reality), *Jahrbuck für Philosophie und Phänomenologische Forschung*, IV, 1921.

26 Paul Schilder, *Seele und Leben* (Soul and Life), Springer, Berlin, 1953.

27 Ludwig Binswanger, 'Freud's conception of man in the light of anthropology' and 'Dream and Existence' in Jacob Needleman, *Being-in-the-World*, Basic Books, NY, 1963.

intentionality. Or, perhaps, the 'things' in the picture presented a challenge. However, seen, there it was, a true Gestalt principle at work, the principle of human strife for completion or wholeness merged, in my experience, with the live principle of intentionality. For a little while I pondered the whereabouts of this whole experience: has it emerged from Heidegger's 'Concealed Dimensions of Being' that phenomenology was able to reveal?

It seems to me that phenomenologically-oriented art therapy comes closest to the fulfilment of the task that Heidegger assigned to phenomenology: revealing the hidden aspects of man's Being as phenomena accessible to consciousness and to conscious treatment. Art therapy can help achieve this aim in two ways. One is a free expressive process of self-projections with art materials, which the client views as many-sided, unbiased, structured fields of vision composed of expressive and interactive components. The other way of revealing hidden aspects of one's inner experience by extending consciousness is the act of intuiting, previously mentioned, to be followed by a spontaneous drawing of shapes in colour. The art expression is then perceived as a structural field of vision, in the gestalt-art manner.[28]

Through the art of looking at their own art work, new facets of self become apparent to the art makers and new communication takes place between the art work and the subjective experience of the client-turned-beholder. Clients learn to perceive more clearly and more articulately the components as phenomena and their interaction in the art work as a whole. They connect those with their own inner psychological forces and apply the newly acquired art of looking to phenomena outside and around themselves in their own world, and in that of others. As they discover facets of self in their interactions with others, yet another interesting occurrence takes place: they transcend their self-centredness and become a member of the world, literally, in their everyday life. They assume responsibility for their art work from the start and actively participate in the intellectual, art-oriented process of working through the difficulties that have arisen in the interaction between themselves and others. This is the particular contribution of the phenomenological approach to art expression in therapy, arrived at through art work and the treatment of the artistic organization of the art expression from pre-intentional functioning to fully intentional living.

28 For details, see Part II, *Symbolic Expression of Shapes* and *Symbolic Expression of Colour.*

11. The Need for a Phenomenological Approach to Art Therapy

Since phenomenology is an open-ended orientation with focus on a variety of phenomena-based themes, therapeutic art expression and art therapy qualify as legitimate themes for a phenomenological theory and method. The emphasis on visually expressive self-projections with art materials of people in need to find themselves in the world, makes art therapy uniquely suited to both the aspects of the philosophy and the method. In addition, phenomenology offers an answer to a long needed unbiased approach to art therapy in all its spheres: theory, training, and professional practice.

At large, art therapy has been formed by psychoanalytical, mainly Freudian, and also Jungian, psychology and psychiatry, and by behaviourism. These approaches formulated the practice of art therapy from its beginnings and subsequently, also, most art therapists' comprehension and interpretation of clients' art work. Both approaches are founded on naturalism and positivism, and on a philosophical anthropology that pre-supposes 'homo Natura' as underlying all human existence, including psychopathology. This means that many, if not most, art therapy training programs rest on the assumption that man is entirely definable in terms of the physical and biological sciences. Since the philosophical anthropologies are not taught in art therapy programs, art therapy education remains biased towards one philosophy of man and remains uninformed or only slightly informed of others. The phenomenological approach is quite distinct from the naturalistic approaches and should be taught. Founded on the philosophical anthropology of man as being-in-the-world, phenomenology asserts the centrality of man's subjective experience, its intentional character, and its accessibility to consciousness.

All of these propensities endow man and woman with an ability consciously and actively to experience oneself and others, and with a possibility to change something in ourselves, not just passively to bear the burden; or even to change something in the world, and not merely adjust to it. Art therapy offers a micro-world of experiences, safe risks, and problems that can be solved, at first on the painting surface or with clay, then in the everyday life. Manipulating art materials and getting to know their nature and uses, making changes of colour occur, arriving at decisions in art situations, facing the necessity to make choices, and bringing into being new things with one's own hands, then acquiring new ways to view them – all these lead the client in art therapy to a renewed ability to look at and feel self-among-others in one's own world and in the larger world.

CHAPTER 2

The Phenomenological Method
of Art Therapy

The approach discussed in Chapter 1 is accompanied by its own method of
art therapy presented in this chapter. It is an empirical version of the theory
generally, but not strictly shaped along the lines of some concepts of
philosophical phenomenology, merged with concepts of Gestalt psychology
of art. An art therapy method has to be flexible enough to suite the special
nature of the art therapy field, itself a merger of two disciplines – art and
therapy – that grew into one field directed toward restorative aims. The
method has been tested over a span of fifteen years in practice with clients
of all ages, individual and in groups, with supervisees, in numerous work-
shops, and in teaching. An outline of the method follows:

Sequence One: Pre-Art Play with Art Materials – direct experiencing

Sequence Two: The Process of Art Work – creating a phenomenon

Sequence Three: Phenomenological Intuiting[1]
1. Visual Display
2. Distancing
3. Intentional Looking to See

Sequence Four: What-Do-You-See? Procedure
1. Phenomenological Description

1 'Intuiting' as a technique is also applied in Part II, Chapter 4 *Symbolic Expression of Shape*,
to facilitate visualization of an inner experience, in shapes.

> 2. Study of Structure, Interrelated Components and
> the Whole-Quality
> 3. Phenomenological Connecting and Integration

The first sequence introduces clients to the process of direct experiencing through sensory and playful pre-art experimentation with art materials. From there they go on to the second sequence, the art work, commonly known in art therapy as the creative process. The third sequence centres on the phenomenon of the completed art work and the process of studying it by concentrated looking at it to see all that can be visually perceived. Looking to see is a silent process.

The fourth sequence consists of the client's verbal accurate description of what she/he sees on the art work surface. This is followed by a hinted-at or guided study of the structure of the art work, the dynamics of the components and other aspects of the art work. This part also marks the beginning of connections that the client makes to personal meanings, leading to the client's integrative understanding of the whole process.

The first two sequences are practised by most approaches, although not as parts of a formal method. The central contribution of the phenomenological method lies in the third and fourth sequences. I will now consider some aspects characteristic of each of the above-mentioned sequences.

Sequence One: Pre-Art Play

For new clients in art therapy, this is an important time for sensory, emotional, and conscious experiences as they freely experiment with art materials. Trying out paints and mixing them in playful ways may lead to little discoveries about the materials, and also about the new clients themselves. These direct experiences arouse sensory feelings of art materials as well as a variety of emotions and thoughts. And naming colours, describing the experiments and becoming aware of what those experiments make one feel, are a helpful introduction for new clients to the process of self-expression with art materials. That process is specified in Part IV, devoted to art therapy diagnostics. Additional benefits of the playful time with art materials are that clients make new things, that they make something whole out of isolated parts, and that they begin to set up problems with art materials and try to arrive at solutions. The pre-art span of time varies with clients, their difficulties and needs, in addition to age. One client may 'play' one-third of the first hour and then move on to the second sequence. Another may extend the playful experimentation to a few sessions; yet others may need only a few minutes' play in the beginning of each session; while yet others,

particularly children, like to 'mess', as they say, with one art material for a while, then switch to another, and mix them. Eventually, all abandon the playful experimentation in favour of the more serious job of choosing materials for the second sequence, the art work process.

Sequence Two: The Process of Art Work

At times, as a carryover from the playful experience, other times in a clearly consciously planned manner, clients silently retreat into quiet communication with their art expression, even while the art therapist is with them. This change from the first sequence can be observed in clients of all ages, even young children. Also, regardless of age, in this sequence most clients show behaviour considered by students of creativity to be characteristic of artists at work: concentration on the art work, purposefulness, involvement, excitement, inventiveness, problem creating, and at times, problem solving. When the artmaker in therapy runs into a problem difficult to solve, the art therapist is there to help. I tend first to engage the client in taking a long look at the art project, to locate the area of the difficulty, and to describe it as precisely as possible. Then I help to specify the problem, and encourage attempts at solutions. In the case of a painting or collage, one might try to locate the problem in composition or in colour and suggest working with the problem area of the composition, or with the colours in question, on a separate sheet of paper beside the art work. Artmakers' pleasure or displeasure with their art work process or with the product is often discussed with clients on the levels of their ability, skills, and possibly in relation to evident feelings.

Sequence Three: Phenomenological Intuiting

This is a time of treating the completed art work as a phenomenon that has its own structure, expressive values, and meanings. The evidence of such treatment lies in the placement of the art work where it can be conveniently viewed. Clients are encouraged to take an active part in such placement of their art work. Symbolically, by taking responsibility for the placement of their work, they take responsibility for their problems. Thus, from the beginning of their therapy, every step carries some psychological and therapeutic value.

It is important that there is enough room for client and therapist to step back and gain comfortable distance from the art work. The concept and act of distancing helps not only the eye to see, it also creates a necessary measure of detachment for the client from his own production to view it with some objectivity, along with awareness of ownership. Thus, *distancing*, the first

concept that gave rise to the present method in the early 1970s, is an essential element in art therapy as a facilitation of the next process, intuiting.

Intuiting is the process of intentional looking at the art expression to see all that can be seen in it. The art therapist may say to the client-turned-beholder, 'Take a good look at your picture, concentrate on it. When the picture is right in front of your eyes, you don't see it as accurately as you do when you gain some distance from it. So take a long look in silence and discover things that you have not noticed before'. In this process of silent intuiting, certain details or relationships 'eyed' at a glance may come forward, may become more important than other things in the field of vision. Soon the detail begins to matter and the viewer begins to make connections to some meaning.

The client's awareness is now deepened and enriched by new observations that 'ring a bell' in their mind. The important and new things that they might notice are relationships among the components of their art work, such as two colours meeting in contrast or harmony, or an odd location of a component, or a line striking because of its thickness, jaggedness, mildness, and so forth.

Sequence Four: The What-Do-You-See? Procedure

Now the art therapist invites clients to describe what they saw on the picture, in answer to the question What Do You See? The question is superficially simple and naive. It contains, however, three of the fundamental aspects of the phenomenological approach. One is the importance of the individual perception – what do *you* see; you, the artmaker – so that the therapist can work from there, for the client's initial description leads to the client's inner reality. Another aspect is the client's feeling of being heard; a beginning of trust. And the third aspect is what do you *see*? This is all that *is seen* by the client in the art expression itself, not surmised or thought out from a pre-established theory when evidence is blurred by principles. When needed, therapists help the client to see things in the art expression that remained unnoticed, for the client's eye has yet to learn to see. These things are often components of structure: how the components relate to each other and how they relate to the overall structure; that is, what role they play in the whole of the picture. Thus, description proceeds to dynamics of structure and from there to structure of the artmaker's inner experience. Clients locate expressive qualities on the picture and learn to identify their feelings or attitudes in the located qualities. Description – the answer to What Do You See? – spreads into a conscious effort to connect the art work with the inner experience which was the prime mover in the art work process that brought forth the

visual art expression. Thus, a circle comes to closure and that is the integrative aspect of the Fourth Sequence. In fact, every occurrence of connections of elements in the art work with elements of the inner experience of self is an act of integration. Arrival at personal meanings is such an occurrence on a clearly conscious level. An occurrence of that kind is a self-discovery.

Not every art work in art therapy leads to self-discoveries or even to slight connections to self. As the observer's eye learns to see and notice all that can be seen in a picture, the ability of connections to self gradually grows. It is the therapist's 'What about...' or 'What Do You See?' and 'What else do you see?' questions that act as catalysts to draw out from the clients the essence of their personal dilemmas as simply as they can state them with an art material, then with words.

A withdrawn and unaware adolescent boy who produced a picture of a fish in a net responded to the What-Do-You-See? question with a reality-oriented descriptive, 'I see a fish...caught in a net'.[2] He went on to say, with growing tension in his voice, that the fish 'feels sad, and mad'. In a subsequent session the *description* continued when the boy was able to point to the lines on the picture that conveyed the 'stiffness' of the fish, its immobility and, in contrast to that, the brilliant colours 'decorating' the fish. In reply to the therapist's wonderment about this contrast, the boy referred to the 'madness' of the fish 'because *he* couldn't show his colours to all the other fishes in the water'. The pronoun *he* served as a transition to the boy's subsequent ability to refer almost directly to himself. This is an example of a slow process of self-discovery in *becoming*: the pre-intentional level of self-recognition with the feeling of the fish was *becoming* intentional, indicating a possibility of more pronounced ability to come. The example also shows that 'sequences' overlap in the treatment process of an art expression.

A thoughtful but inhibited adolescent girl responded to the What Do You See? in her picture: 'Well, I see a group of people (*pause*) they are sort of standing around (*pause*) and (*pause*) they look sort of distressed and everything...'. These first words of a description are discussed and specified, and the girl's often used 'and everything', for which she had no clear concept, although it meant something to her, is gradually being clarified and understood by both client and art therapist as the description of the visual product proceeds. The therapist must be a good listener, too, to pick up vague clues from clients' slow and often laborious verbal reflections about feelings

2 Mala Betensky, *Luis and the Fish*, videotape in colourful pastels produced by Aina O. Nucho, The Media Center, School of Social Work and Community Planning, Univ. of Maryland, Baltimore.

invested in the art and evoked by looking at it. This curious interaction bears the essence of an integration of mind or self, with the art expression.

The unfolding of ideas and feelings contained in the visual product usually proceeds along two lines. One line of treatment will start with the client and deal with the content of the picture or sculpture. The other will treat the structural properties of the visual product and the relationships between these properties, which sophisticated clients take up on their own. Generally, the therapist will go along with the client's description of content and then will turn to structure if the client has not taken the initiative to do so. With the adolescent girl, the therapist tried to find out who the people might be; why they are all huddled together; what is happening to them right now, what might happen in a moment?

Much as this line of treatment yields in the client's interesting observations about content, it is not all. From the phenomenological perspective, discussions of the content are somewhat less fruitful than are the possibilities offered by the dynamics around structural components of the art work. With their property of conveying expressive qualities, structural components in interaction represent the client's inner reality more accurately and often more acutely than does the content, which is on a more remote level of symbolization. Here is an excerpt from a videotape showing the transition from content to structure, in this case, grouping.[3]

> Th: Now let's take a look at the placement of the figures. Which figures are placed where on the sheet of paper?
>
> Cl: Well, the people are all sorta huddled together, and, um (*pause*) they seem like they are all sorta huddled together in little groups.
>
> Th: Which groups are huddled together? Can you make some groupings there?
>
> Cl: This group right here and these three figures (*pause*) and these three right here and those two (*pause*) and that one up there.

In a later session, 'that one up there' became the centre of self-discovery: the girl recognized herself. A bit of integration occurred. But such moments of recognition of self do not have to be the crowning achievements of single art therapy sessions. They come gradually, on their own.

Clients' reflections back to the development of an art work may lead to moments of integration as they look at the completed picture. They may

3 Mala Betensky, *Naomi, Ibid.*

comment on an original intention and actual outcome. While some parts or components of the completed picture may have been consciously decided upon, others might have arisen as if on their own, without a decision or awareness on the part of the artmaker. Here is an example taken from the same videotape:

> Cl: It looks like this person right here (*pause*) ummm (*pause*) is not as worried as all the others...
>
> Th: Which one?
>
> Cl: This one right here.
>
> Th: The one in yellow?
>
> Cl: Uh huh.
>
> Th: Is not worried as the others? Uh huh, uh huh (*long pause*). Were you aware of that while you were drawing it?
>
> Cl: No, I see it now.

Another possibility of phenomenological integration may arise in the search for similarities and differences in the same client's art work over time. By looking at a current art expression as one of a series when shown with previous ones, clients discover certain recurrent details or a certain use of materials, or a recurrent absence of essential features. The client's recognition of the recurring element causes his wonderment. 'What comes to mind?' asked by the therapist, will lead to the client's connection to some feeling or attitude expressed in the recognized element.

Another example, small but illuminating, took place during a girl's art work in a therapy session. She was stretching the upper part of her body quite strenuously over a large sheet of drawing paper to reach an area on its opposite side in an effort to colour it with blue chalk. In her overwhelming passivity in most life situations, it did not occur to her that a turn of the paper would help her reach the area more comfortably and colour it more effectively and pleasurably. She did respond to a hint of suggestion. Apparently, the occurrence touched something inside, probably a connection to self. For, in a later session, she recalled the change she had made 'on the paper' by turning the far edge toward herself and proceeded to report on how she found herself more able to make 'bigger changes' on her own, such as making friends, scheduling her classes, and 'doing things at home', the major difficulties in the life situation of this adolescent.

Termination of Art Therapy

Termination should extend over two or more art therapy sessions. These sessions are to be devoted to a display of all or most of the client's art expressions. At this time, clients are quite active and independent about taping their art expressions on the wall or placing them on the floor according to an order upon which they decide. The art therapist will also find that, this time, it is the client who takes the lead in discussing the art expressions.

Essential Factors in the Phenomenological Method

The centrality of the artmaker is one of the most essential factors in the method. The clients in art therapy, whose first-hand experience goes into the artmaking, are the chief beholders of their own art expressions. They are the ones who then experience the process of looking at the self-made phenomenon as it appears to their senses and consciousness. Thus, the artmakers themselves arrive at subjective meanings, not the art therapist.

This aspect of freedom from predetermined judgments is most needed for the treatment of art expression in art therapy.

Art phenomenologist Moritz Geiger succinctly described the three features that marked the phenomenological method in its origin:

> 'The first mark of the phenomenological method was exclusive attention to the perceived phenomenon, since investigating phenomena was the method's aim. The second mark was to aim at capturing the essence of phenomena, not just their circumstantial features. And the third mark was that the essence of a phenomenon be captured neither by induction, nor by deduction, but solely by way of intuiting.'[4]

Briefly, the task of descriptive phenomenology is intuiting by recognizing the essence of phenomena and systematic descriptions of direct experiences guided by the concept of intentionality, all leading to integration. These tasks of the method do appropriately fit the nature and aim of art therapy. For

4 Moritz Geiger, *Phänomenologische Ästhetik*, pp. 136–158 (author's translation). Also, M. Geiger, *Zugänge zur Ästhetik*, Leipzig, 1928. And, M. Geiger, 'Beiträge für Phänomenologie des Ästhetischen Genusses,' *Jahrbuch für Philosophie und Phänomenologische Forschung*, IV, 1913.

application of the phenomenological method to the practice of art therapy, a few additional features have to be considered.

Art Materials[5]

Art materials, preferably derived from natural resources, are active participants in the client's art work. They challenge his sight and touch. They bring forth emotional arousal and consciousness all at once. Being themselves bits of the world, these materials contribute to the client's getting back in touch with the world. Thus, there is an ongoing dynamic process between material and artmaker. It is of special interest for the art therapist to notice which of the materials evokes the most expressivity from the client. Free choice of materials is therefore a most important factor in the process of art work.

Words and Silence

Yes, the phenomenological approach does use speech because words are expression just as art is; because consciousness, thought, and speech are often one; and because in phenomenology we intend to articulate, and that is the job of words. In this method, however, words have a special role at appropriate times. Such times occur in the pre-art playfulness with art materials when, in addition to gestures, clients express interest, care, fear and excitement in words rather often, and sometimes they also utter feeling-toned sounds. Words are used even more often in the fourth sequence of the present method of art therapy. That is the time when artmakers relate to their art work in words, when speech is centred on the articulate description of the art expression and is interwoven with the personal experience of it. That is also the time when all the intensive silent intuiting activity finds its way into the verbal description.

It is equally important, however, for the therapist to remember that a great deal of the activities, especially in the second sequence – the art work process – may occur in silence. It is, therefore, essential that the client be given sufficient time to do, and to examine, the art work silently. Thus, art therapists must learn the importance of silence, free themselves from the inner pressure to interrupt silence, and learn to be comfortable with silence. When clients are absorbed in their work or when they are silently gazing at it, it is

5 For more viewpoints, see 'Media Potential: Its Use and Misuse in Art
 Therapy,' pp. 111–113, *Proceedings*, 13th Annual AATA Conf., 1982.

wise for the art therapist to listen to that silence, just as it is important to listen to words.

At this point, it is useful to see how art therapists relate to their role and task within the phenomenological approach and method.

The Art Therapist's Role

From all the foregoing, it is clear that well-trained and experienced art therapists elevate the client-artmaker's ability to sensitive looking and to accurate seeing. They aim at helping the client-artmakers to see the essence of their dilemma by making connections to self discovered in their art expressions.

Art therapists see realistically their personal role in relation to their clients. Just as the art therapist is a member of his or her world, so is the client a member of his/her world. Clients may be alienated from their worlds and the world at large. The effort of their therapists is to help them back by understanding and compassion, with the help of visual self-expression, and other basic philosophical and methodological tenets of the phenomenological approach. But the art therapist is not to rush a client into his or her own world, as that may obscure the client's way to return to his world as a participant, or to shape a new world for himself. Nor should therapists allow themselves to use a client's mother, wife, father or husband or lover, and neither are they a better version of a parent, spouse, sister or brother. Nor should art therapists feel that they are a client's sole or most important therapist when that client is also treated by other mental health professionals. Any of these 'should not's' will not stand in the way of respect and compassion for the client and for his plight.

In the case of a client's exaggerated feelings for the art therapist, a suggestion of drawing the relationship in shapes and treating the picture phenomenologically might clarify the problem and even solve it. If art therapists find themselves overly involved and assuming that they are quicker to realize it than their clients, they can discuss their feelings with a professional and make appropriate decisions.

Concentration on the art expression, the centrality of the artmaker, and the unprejudiced Description – all of these lend a mode of objectivity, trust, and a safe and warm relationship. Thus, the phenomenological approach and method shield both art therapist and client from the vicissitudes of transference–countertransference.

A Sense of Personhood

The thrust of phenomenological art therapy or art psychotherapy relates to the human experience and its art expression by the subjects of the experience. The art therapist relates to the bearer of the experience, and its expression, as to a person. The phenomenological treatment of each art expression as a phenomenon speaks of the therapist's perception of the client as a human phenomenon. Indeed, an essential feature of the approach is the aim at confirmation and restoration of clients' sense of personhood.[6]

Many, if not most of the clients in therapy, young as well as mature, bring to therapy a wounded sense of personhood. They felt the insult of that essential-to-growth ingredient that is a child's early sense of being a person in the eye and mind of his parents. It is a sense that a child develops by the very presence of the parents' attitude and by being listened to with patient intentionality when his speech is still slow and inarticulate. Failure to develop an early sense of personhood will create angers hard to extinguish at a later time if they turn into depression.

Professionals engaged in mental health and therapeutic work rightly embraced the Eriksonian concept of basic trust[7] as an essential factor in a child's personality growth. But in order to become the essential factor, trust must start in the parents' initial grasp and feeling that their child is a person. That does not always happen, even in the presence of parental love and devotion. And so it often occurs in therapy that planting a sense of personhood in a client's state of being becomes the therapist's difficult but worthy task.

In the phenomenological method of art psychotherapy, the very mode of treatment of a client's art production as a process of an inner experience and therefore a part of self, arouses trust in the artmaker-turned-beholder and eventually initiates a beginning of a sense of personhood in the course of therapy. This sense grows with the systematic art expression and disclosure of the inner experience as clients are sensitively listened to and guided in the reading of their own art expressions. Such guidance places clients in the active position of taking responsibility from the start, first by grasping the nature of their inner experience and of the role it played in their lives and relationships, then by discovering abilities and ways of reshaping their perceptions, attitudes and relationships. The first of these relationships

6 Gordon Allport, *Pattern and Growth in Personality*, Holt, Reinhart & Winston, New York, 1961. Also, G. Allport, *The Person in Psychology*, Beacon, Boston, 1968.

7 E.H. Erikson, *Childhood and Society*, W.W. Norton, New York, 1950.

constantly being reshaped is that between client and therapist, indeed it is on-going in the space between them: the client struggling out of resistances, dependencies and disturbed perceptions, to self-discoveries, while the therapist, knowing his or her own place, warmly and selflessly guides the client to a sense of personhood.

Participant Observers

Art therapists are also participant observers. In that capacity, they are far from being passive, for their eyes and minds work silently and sympathetically to get to know their clients through the art work. Art therapists are busy unobtrusively observing their clients' work, gestures and verbal expressions as they select art materials during the process of art work. Sensing to what extent a client needs the art therapist's physical distance or closeness or other kinds of support, is another aspect of the task. And noticing one's own visceral and emotional reactions to what the client does and who the client is, is yet another.[8] This is how the art therapist gets to know each client as a person. Clients sense the attitude and, somehow, gain strength from it. Perhaps this is another kind of transference: an attitude to people and to life is being transferred from therapist to client.

8 Sondra Geller, 'The Unique Dynamics of an Art Therapist and Her Client,' unpublished paper, 1980.

Part II

Symbolic Expression in Art Therapy

Expression, the Whole-Quality of Art Therapy

Expression permeates the client's art work. It is expression that carries and conveys meaning. And it is in expression that we find a potential source of therapy and change, for the art therapy actually occurs in art expression.

The tendency in art therapy to discuss each of its two components, art and therapy, independently, to define the role of each in the field, and then to study the interface seems contrary to the genuine character of art therapy.[1] Art therapy is a synthesis of the two components. By virtue of the synthesis, art therapy becomes one, something new of its own, a gestalt as it were, with properties of the synthesis, in addition to the properties individually contributed by art and by therapy. It is not by the sum of its properties that a figure or an entity becomes a gestalt. Nor is it enough to say that the entity is 'more than the sum of...' without specifying the nature of 'more'. the additional quality, a whole-quality which bestows upon art therapy its wholeness, is expression.

What Visual Expression Does

Symbolizing with art materials and art components, visual expression portrays and represents aspects of the human expression in forms of human or animal body, elements of nature, objects real or invented, and abstractions. All or any of these forms of expression appear in artists' art. In art, however, artists' work is subject to aesthetic standards such as organization, balance and rhythm, a variety of related components rich with their properties, and expression. In art therapy, we do consider organization and surface properties, but not primarily as aesthetic criteria. Even the poorest organization is noticed and accepted as part of self, or as a moment in the state of being of the artmaker; that is, as expression of his inner universe.

While expression in art portrays something of the universal human experience, which may or may not include the artist's emotions, expression in art therapy most of the time represents the personal feelings and emotions of the client artmaker. As in art, so in art therapy, aspects of universal or subjective human experience find their expression in lines expressive of

1 Judith A. Rubin, *The Art of Art Therapy*, Brunner/Mazel, New York, 1984.

moods; in colours expressive of emotions; in shapes expressive of weight, which also symbolize the world; and in motion, stance or gesture expressive of vitality and feeling about self, and aliveness.

The Nature of Expression

Expression is a given propensity which answers a human need to portray in individual ways feelings and thoughts about what one is or, in certain cases, what one aspires to be, these feelings and thoughts being human experiences. This given propensity is being manifested in the early cry of a baby, in the growing baby's structuring of a field of vision, and in the general style of interaction with its world. The given need of expression is manifest in another given propensity, that of using some visible or audible means to make the expression tangible. In visual expression, it is the handling of materials to produce things, to invent, to make art.

All of these activities display highly individual expressions of producers, inventors, and artists. This can be seen with clarity even in the simple, unsophisticated art productions of people untrained in art who, nevertheless, show signs of individual styles of expression.

Flowing directly from self and its human experience, expression is an authentic, original, and direct human experience itself. As such, its rise and existence do not need to be explained by the complex mechanism of sublimation which presents art as the releaser and gratifier of forbidden sexual wishes.[2] Visual expression of the human experience transcends the sublimation theory just as it transcends beliefs in sources of creative inspiration outside of self, or in irrational forces invading the human interior to command creativity.

We know from art therapy that persons untrained in art do express their own inner experience in art components that carry feeling values, all of which combine into certain wholes. These components are line, shape, and colour. The following three chapters will discuss clients' symbolic expressions made possible by the structural relationships of these components. A fourth chapter will consider additional modes of expression known in art and also found in art therapeutic productions.

2 Sigmund Freud, 1905, Three Essays on the Theory of Sexuality, in *The Standard Edition of the Complete Psychological Works of Sigmund Freud*, Vol.7, J. Strachey, ed. Hogarth Press, London 1953.

Symbolic Expression of Line

This chapter is designed to engage therapists' interest in the expressive values of line. The four sections of the chapter will (1) present the experience of an art therapy group with expressivity of line; (2) relate affective lines to rhythms of nature; (3) report past research on line and its expressive qualities; and (4) discuss the author's two-art study, with adults and with children, of structural patterns of affect spontaneously expressed in line.[1]

Section One: Clients Experience Expressivity of Lines

This section reports on a group experience during a series of 15 two-hour art therapy sessions with a group of five young mothers who had difficulties rearing their children. They had just completed their pastel drawings of 'Something About Myself in My Childhood Home' and were now silently looking at the pictures.

In answer to the What-Do-You-See? question, they showed worried faces. One of the women whispered, 'My picture is so different...it is so stiff...I can't understand it myself...' Two women went up to look at her picture more closely because 'the lines are so faint, now I see that you did make a picture'. A fourth woman thought her own pictures 'too loud, with all the shrieking colour and thick lines'. And the fifth woman, who had initial doubts about 'picturemaking as a remedy' to her urgent need for 'real advice what to do and what not to do with my kids', gazed at the pictures and said, 'Ten minutes ago there was nothing here, all of us said that we couldn't draw

1 This chapter concentrates on line in colour, but is not a study of colour *per se.*

a line. Now here are five large pictures and, oh, I can see a lot of things in them, but my pictures is the stiffest of them all... How do you make it not stiff? How do you put some life in it?' The rest of the group vigorously nodded in support.

At that moment, it seemed appropriate to postpone my methodical plan to have the group intentionally look at their art, precisely describe what they saw, and proceed to the unfolding of personal meanings. Instead, I felt the group needed a few exercises with some pure lines and with a variety of properties of the lines. I expected that the exercises would ease my clients' eye–hand communication, awaken awareness of the many possibilities with line, enable them to make changes in lines and, generally, touch off sensory–affective stirrings in response to the stimuli emanating from the lines and colours that they would make. The ultimate expectation was, of course, that all this activity with art materials in their hands would evoke and facilitate expression in their art.

And so each person took eight sheets of white 18" x 12" drawing paper to work with pastels.

In *Exercise One*, the group was asked to look at their pictures mounted on the wall, extract from any of them lines or parts of lines, and draw those with a chosen colour in a column on the first sheet of paper.

Exercise Two had the clients look at the line they had just drawn and draw beside it basically the same line, but with some visible alteration.

Exercise Three asked them to choose a colour and to draw, on a fresh sheet of paper, a very thin line with the weakest of pressure, then proceed gradually to increase the pressure of the pastel in a series of lines from weakest to strongest pressure.

Exercise Four called on them to 'draw lines that go somewhere'. That was designed to develop awareness that lines may have direction.

Exercise Five asked for 'lines that have to do with each other': meet, cross, clash, embrace, and so forth.

Exercise Six called for a continuous pleasant line and a continuous unpleasant line.

Exercise Seven suggested 'a colourful dance of lines'.

Exercise Eight instructed the clients to 'put together a few lines in colour to indicate a little landscape or something occurring in nature'.

The eight exercise papers, spread in parallel columns on the floor, became the centre of a vivid discussion about qualities of line and colour, how the lines made one feel and what can be done with them for expression. When I shared the experience with a few fellow art therapists, some thought that I had been too didactic and that the stream of material from the unconscious

had been stopped in favour of the teaching intervention. It seems to me, however, that as in art, so in art therapy, colour, line and form are important means for expressing inner experience and creating new experience, and that clients in therapy, particularly in art therapy, must be experientially and cognitively introduced to such means of expression. The last two exercises were intended to link the clients' experience with rhythms as old as the world: the rhythms of nature.

Section Two: Lines as Rhythms of Nature

These are the lines that artists skilfully endow with properties and expression, that children naturally draw at their age level, that clients, untrained in art, spontaneously produce for personal expression. From infancy through to old age we assimilate roundness, horizontality, verticality and all other modes of direction and motion manifested in nature, that evoke in us feelings expressive of those manifestations. A mountain stretching its peak toward the sky arouses in us feelings of grandeur. On a mild summer day, a slowly rolling ocean evokes rhythms of calm and repose, as in Winslow Homer's 'Rowing Home'. The same ocean's angular leaping storm waves arouse anguish and agitation, as in Marin's 'Boat in Choppy Water'. The sight of a toppling tree gives us a 'sinking' feeling, while upward and outward reaching swirls suggest awe and aspiration, as in Van Gogh's 'Cypresses'.

These and myriads of other rhythms in nature as well as in architecture and art have in them a basic invisible line which defines their direction and movement. Indeed, art teachers often 'draw' in the air an imaginary line essential to form, to indicate its direction or motion, thus symbolically abstracting the form. When I recently revisited two portraits by Edgar Degas in the National Gallery of Art, I was struck by the invisible yet essential lines that defined not only direction, movement and mood, but, indeed, the whole of each portrait.

Madame Camu's figure in profile leans forward along a diagonal line —/— expressive of tension, perhaps also of some insecurity. She might be listening to what a guest is saying at the far side of her 'salon', not seen in the picture, which the artist, however, enables us to visualize. The dark background reds in dim evening light and the even darker red of the figure strengthen the tension. In contrast, Madame de Gas' portrait exudes a calm of acceptance with a touch of melancholy, but not depression. Her essential line seems to be this ⌒\, a mild, rounded line sloping downward. Against the pleasant blue/gray background, the soothing pale grays of the seated

figure facing the observer seem to complement the accepting, melancholy
mood of the essential line.[2]

Figure 1. Madame Camu; *Edgar Degas;* *Figure 2.* Madame Rene de Gas; *Edgar Degas;*
National Gallery of Art, Washington; *National Gallery of Art, Washington;*
Chester Dale Collection. *Chester Dale Collection.*[3]

These two symbolic lines, expressive of moods, may serve as an introduction
to repertories or vocabularies of 'moody' lines known to artists and art
teachers as well as to choreographers and actors. These are the essential lines
that are most often invisible, but can be visualized through direction,
movement, and hue (see examples).

Many of these lines also appear visibly or invisibly in the spontaneous
projections of clients in art therapy. While they model, paint or draw, they
do not, most probably, think in terms of components, properties, or essential
lines. They just model, paint and draw. Their feelings and thoughts, sponta-
neously evoked as they work with art materials, flow onto the surface of the
production in process and are experienced in the raw, as it were. Only later,
when the finished art work presents itself through the eye to their visual and
cognitive perception, do they discover relationships among lines and prop-
erties, affective values and personal meanings. A variety of lines expressive
of affective values is shown in Figure 3.

2 A relevant detail is that Madame de Gas was blind.
3 Transparencies reproduced by permission of the National Gallery of Art, Washington, D.C.

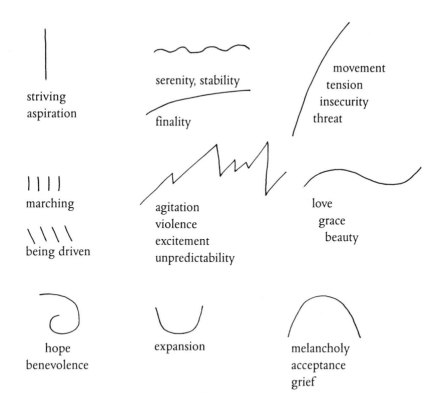

Figure 3. Examples of lines and their affective values

Kandinsky speaks of the vertical and horizontal lines in terms of temperature: vertical lines are warm-to-hot, horizontal ones are cool-to-cold. This suggests also a perception of these lines in terms of temperament.

Section Three: Early Research on Affective Values of Line

Research on affective values of line and form goes back to the 1919–1920 study of *Affective Tone of Lines: Experimental Researches* by Helge Lundholm,[4] much quoted by subsequent students of line. Lundholm's scientific curiosity was aroused by art writers' statements about 'melancholy lines' or 'quiet lines' of certain classical school masterpieces (such as Perugino's 'Madonna') and

4 Poffenberger and Barrows, Psychological Laboratory, Columbia University, 1924.

'violent lines' in baroque art. These statements suggested to her some challenging problems for research. One of the problems was whether the feeling character of line is a quality of the line itself, or whether it is suggested by the 'literary subject' of the art work. Another was whether the phenomenon of affective quality is perceived equally by various observers.

To answer these questions, Lundholm had a small group of subjects draw 'pure lines' which represented their feelings. She found that lines could be grouped into simple classes and that lines had direction. This experiment was followed by another student of line who studied feelings aroused in *looking at* lines of various kinds instead of drawing them.[5] Between the 1920s and the 1970s, other researchers worked on basically the same problems. Although modest, this research was effective, for it discovered a rather rich var

Concentrating on clusters of adjectives signifying various emotions and moods, some of these studies found that people express agitated emotions in irregular, jagged and sharp-angled lines, while they express the more quiescent states of mind in gently curved or relatively steady lines. In other experiments, abstract conceptions and grammatical relations were found to be expressed in a manner that communicated the meaning to others rather reliably (Krauss, 1930;[6] Peters and Merrifield, 1958;[7] Hippius, 1959;[8] Werner and Kaplan, 1963;[9] Kreitler and Kreitler, 1972[10]).

Still other studies concentrated on investigating the consensus in grasping the meaning of various lines and forms. For example, sadness was coupled with slightly curved downsloping lines, serenity and tranquillity with horizontal lines, cheerfulness with horizontal or ascending lines, and vivacity, agitation, and anger with angular and curved lines (Poffenberger and Barrows, 1924;[11] Krauss, 1930;[12] Hall and Oldfield, 1950;[13] H.R.L. Hall, 1951;[14] Sheerer and Lyons, 1957;[15] McMurray, 1958[16]).

5 Poffenberger & Barrows, Psychological Laboratory, Columbia University, 1924.

6 R. Krauss, 'Über graphischen Ansdruck' (Concerning graphic expression), *Zeitschrift für angewandte Psychologie, 1930, 48*, 1–141.

7 G.A. Peters and P.R. Merrifield, 'Graphic representation of emotional feelings', *Journal of Clinical Psychology, 1958, 14*, 375–78.

8 M.T. Hippius, Experiment described in H. Rohracher, *Kleine Charakterkunde*, Wien and Innsbruck, Urban and Schwarzenberg, 1959.

9 H. Werner and B. Kaplan, *Symbol Formation: An Organismic-Developmental Approach to Language and the Expression of Thought.* New York: Wiley, 1963.

10 H. Kreitler and S. Kreitler, *Psychology of the Arts*, Durham: Duke University Press, 1972.

The general conclusions that can be drawn from past studies appear to be that (1) lines are expressive through a variety of properties, (2) both art maker and observer have associations of meanings to line or form which they make or see, (3) the meanings are personal and/or culturally shared, and (4) drawers and observers agree on the meanings of the same lines, but differ in degree of agreement.

Research in the 1970s and early 1980s changed from concentration on pure lines to emphasis on interrelated art components including line and its qualities, and on specific psychological problems by studying patters of affect expressed in line and other related components in both categories. Here are some examples of such research: form perception in abstract art;[17] patterns of line drawings depicting the complexity of an adolescent personality;[18] differences between reactions of older children and adults, and younger children to qualities of paintings;[19] and *The Munch Paintings as a Study of Composition and Lines Provoking Tension.*[20]

Drawing upon the research reported above, I tried to do some further research on the subject of line and its qualities in a two-part experiment, one with adults and one with children, during 1978–9 and 1982–3, presented in this chapter.

11 Poffenberger and Barrows, 1924, *op. cit.*

12 Krauss, 1930 *op cit.*

13 K.R.L. Hall and R.G. Oldfield, 'An experimental study on the fitness of signs to words', *Quarterly Journal of Experimental Psychology, 1950, 2*, 60–70.

14 K.R.L. Hall, The fitness of signs to words', *British Journal of Psychology, 1951, 42*, 21–33.

15 M. Scheerer and J. Lyons, 'Line drawings and matching responses to words', *Journal of Personality, 1957, 25*, 251–73.

16 G.A.A. McMurray, 'A study of "fittingness" of signs to words by means of the semantic differential', *Journal of Experimental Psychology, 1958, 56*, 310–12.

17 Martin S. Lindauer, 'Psychological Aspects of Form perception in Abstract Art,' *Sciences de l'Art*, 1970, Vol. 7,1–2, pp. 19–24.

18 Mala Betensky, 'Structural Patterns of Visual Expression', *Art Psychotherapy*, 1973, vol. 1–2, pp. 121–129.

19 Jane L. Kenney and Calvin F. Nodine, 'Developmental Changes in Sensitivity to Content, Formal, and Affective Dimensions of Paintings,' *Bulletin of Psychonomic Society*, 1979, vol. 14, 6.

20 Uriel Halbreich and Dorothy Friendly, *Confinia Psychiatrica*, 1980, Vol. 23, 3, pp. 187–192.

Section Four-A: Structural Patterns in Spontaneously Expressed Affect – Experiment with Adults

The rationale for the experiments with adults and with children was that line does not remain pure, that it always relates to other lines or forms, that it goes to and comes from somewhere, and that lines and their properties are interrelated when they express a concept. Briefly, the procedure for the studies was designed to find out whether spontaneous visual expressions of affect fall into patterns of components and properties.

Method

In a number of small groups, 450 adults were asked to draw with crayons on paper spontaneous responses in colour and line to each of three words: love, fear, anger. Four hundred response pictures for each affect were randomly selected for the purpose of studying properties inherent in each group of affect responses and for setting up lists of criteria for each. The number of pictures was further reduced by methodical random selection to ten final responses for each affect. These thirty final pictures were designated for slides in preparation for the validation process by judgments.

Judgments for validation

The thirty slides, ten for each affect, were presented to a class of ten social psychology students.[20] With lists of criteria for consultation, the judges were to distinguish and name the three affects by the patterns perceived from the projected slides on the screen. Their task was to determine whether the projected drawing represented Love, Fear, or Anger.

Results

		Judgments			
		Love	*Fear*	*Anger*	
	Love	86	7	6	99
Intentions	*Fear*	23	56	22	101
	Anger	1	25	74	100
		110	88	102	

20 Personal Communication, Robert E. Kraut, Ph.D., Cornell University.

As shown on the table above, there were about 100 judgments made on each affect category (ten slides/category times ten subjects). When the slide was supposed to represent love, 86 per cent of the judgments were love, 7 per cent were fear, and 6 per cent anger. That is, in the love intention, subjects agreed that it represented love 86 times out of 100.

In the fear category, 56 per cent of the time the subjects thought the slide represented fear, 23 per cent of the time they thought it represented love, and 22 per cent of the time that it represented anger. While subjects were not judging randomly, they do not strongly agree with the artists' intention.

A. (Slide: Love) (Slide: Fear) (Slide: Anger)
- Love: round lines, pinks
- Fear: centre dot black and red, emanating lines in grey to black
- Anger: fierce red lines and a black centre

B. (Slide: Love) (Slide: Fear) (Slide: Anger)
- Love: wavy lines in warm colours out of round centre in warm pinks and lilac
- Fear: grey rising from 'hole'
- Anger: multiple lines in red and orange controlled by blue line

Figure 4. Two samples of adult love–fear–anger

Finally, in the anger category, 74 per cent of the time subjects considered the slide to represent anger, 25 per cent of the time to represent fear, and 1 per cent of the time to represent love.

To phrase this another way, love pictures were generally not confused with anything, anger pictures were confused with fear but not love, and fear was confused with both anger and love. These results could come from three overlapping sources:

1. Fear as either an emotion or a picture is similar to both anger and love, while love is dissimilar to anger. That is, a continuum of emotions would have fear between love and anger with fear coming closer to anger, depending upon the degree of saturation of anger inside the observer's self. This may be related to one of the unresolved problems of this study: we do not know about the inner state of self when saturated, overwhelmed or flooded with a certain emotion, and what this does to perception at the observer's viewing of a very dynamic state.

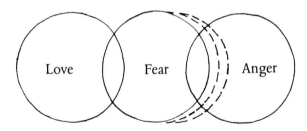

Figure 5. Continuum of emotions with fear between love and anger

2. It is possible that while the emotions and pictures are clear and distinct, the sets of criteria are not quite distinct; namely, the criteria for love are, perhaps, clearer than those for fear and anger.

3. At the bottom of each rating sheet, the subjects listed criteria they used most. Colour, line and form, and movement were the most used. Were fear and anger similar with regard to these criteria? Upon examination, similarities were indeed noticeable and so were differences. The general dynamism of line and form, and movement characteristic of anger was lacking in fear, and the frequency of hot colours coupled with black, outstanding in anger, appeared on only two out of ten responses in fear.

Section Four-B: Structural Patterns in Spontaneously Expressed Affect – Experiment with Children

Forty-six boys and girls in grades four to six of a small school were each given three 12" x 9" sheets of drawing paper and a box of eight crayons. They were asked to make pictures with colour and line in spontaneous reaction to a word denoting a feeling (Appendix I). There were three words: Love, Fear, Anger; and there were 276 responses. When a list of criteria for patterns of lines, colours and their properties in the response pictures was established, the general number of pictures was randomly reduced to six representing each affect, to be presented in three displays to five boys and five girls in grade four to six of another school, for judgment and validation. The judges were not offered lists of criteria, but were asked to vote their judgments according to their direct visual experience of each display of the original pictures of the three emotions (Appendix II).

Results

Judgments

Intentions		Love	Fear	Anger	
	Love	271	2	3	276
	Fear	0	258	18	276
	Anger	0	12	264	276
		271	270	282	

As shown in the table above, there were 276 judgments on each affect category (6 pictures/category times 46 subjects). When the slide was supposed to represent love, 271 judgments were love, two fear and three anger. That is, in the love intention, most subjects agreed that it represented love.

In the fear category, 258 subjects thought it represented fear and 18 judged it to be anger (about 7% of the 176 judgments).

In the anger category, 264 considered it anger and only 12 judged it fear (about 5%).

Love pictures were not confused with anything, anger pictures were somewhat confused with fear, and fear pictures were somewhat confused with anger.

No marked differences were found between the judgments of boys and girls. The outstanding difference between the judgments of adults and children was the children's clear differentiation between fear and anger. Children seem to distinguish fear from anger more clearly than adults. The reasons for this are not very clear, however. Perhaps one reason is that children ascribe their fears to concrete things: darkness, thunder, monsters in dreams or stories, punishment, an aggressive child or adult, and they experience specific fears; while in the experience of adults and adolescents, anxiety or fear often interact with anger in their unawareness. In relation to love and anger, however, the love pictures of the children resembled those of their elders in the soft, rounded, pastel-coloured, gracefully moving patterns for love, in contrast to the strong-coloured, high-pressured lines of anger bursting explosively in dynamic sharp-angled patters all over the pages. The children's pictures appeared to be more open, more spread over the surface of their given space and, generally, more naive.

A. (Slide: Love) (Slide: Fear) (Slide: Anger)
 Love: blue centre circled by pink and orange round lines, feathery
 lines in warm colours in motion
 Fear: black zigzaggy line moving up on rusty background
 Anger: a burst, uncontrolled, of black and red lines, in all directions
 towards the outside

B. (Slide: Love) (Slide: Fear) (Slide: Anger)
 Love: intertwined round pink and red lines
 Fear: a grey oblong 'bug' creeping up
 Anger: a controlled triangular centre in red surrounded by red lines,
 multiple small lines directed toward the outside

Figure 6. Two samples of children's love–fear–anger

Summary

Theoretical, experiential and therapeutic implications of the experiment with
affect visually expressed by adults and by children will now be considered
from the perspectives of psychology of affect, Gestalt theory of perception,
and therapeutic art expression.

A few assumptions about the nature and role of emotion preceded and
accompanied the two studies of structural line patterns in visually expressed
affect. These are (1) that emotions are tensions and degrees of excitement
natural to human existence; (2) that emotion exists in all human experience,
physical and mental, in varying degrees of intensity; (3) that emotion is an
activating and energizing as well as a withholding agent in all human
activity; (4) that emotion operates along with cognitive, goal-conscious, and
creative aspects of human life; and (5) that new emotions can be generated
and experienced in new situations.

From the point of view of Gestalt theory of perception, the judges looked
at the affect pictures and perceived them visually, cognitively, and emotion-
ally all at once. As they perceived the reappearing components and their
properties in mutual relationships within each affect category, those patterns
evoked similar structural constellations in the perceivers' operative brain
apparatus, transmitted by the sensory mechanism of the eye. Correspond-
ingly, confused or overlapping visual patters of fear and anger in the adult
pictures appeared to the adult observers, too, as confused or overlapping.
but, as noted in the experiment with children, there was hardly any confusion
between fear and anger in the child responses and judgments. The inter-
changeability of intense fear and anger in the adult emotional experience,
often observed in psychotherapy, was visually confirmed in the graphic

patterns of the adult responses to the experiment and was so perceived by the adult observers, the judges.

From the art therapeutic perspective, the experience proved to be positive at the stage when artmakers assumed the role of observers and confronted some self-discoveries. The possibility that the same person can be both actor and observer of his own action has been presented in the psycho-social theory of attribution.[21]

In their role of observers, the artmakers saw their art products as visual percepts. The interaction between percept and personality helped the art-makers-turned-observers grasp meaningful connections between their art products and aspects of self, and that is how moments of self-discovery occurred.

21 Kelly G. Shaver, *An Introduction to Attribution Processes*, Winthrop Publ., Cambridge, Mass., 1975, p. 27.

Symbolic Expression of Shape

The previous chapter dealt with symbolic expression of line. When lines form closure, a shape is created. Line drawings may also contain shapes or suggest formation of shapes, as in the case of the spontaneously drawn scribble, popularly used in art therapy and discussed in a later chapter of this book. This chapter treats shapes on their own as bearers and conveyors of symbolic expression. We will discuss some of the basic qualities and features of shapes intended for symbolic expression. This will be followed by drawings of concepts of an inner experience visualized in shapes by five clients, including an example of a serial treatment of successive shape drawings made by one of the clients. Finally, an examination of three-dimensional shapes in clay by several children and by adults in a group art therapy session will conclude the chapter.

Shapes are replete with possibilities of symbolic expression. The locations of such expression are in the whole of the shape, in the basic components of the shape, and in their mutual relationships. Some of the chief components are lines, angles, and colour. Others are weight and size. Another source of expression is in the location of the shape itself on the surface. When a drawing consists of two or more shapes, we have an interrelationship that calls for special attention to the individual role of each shape in spatial relation to others and to their points or areas of contact.

Observation and description of all structural aspects of shapes are of special importance because the components and their relationships are powerful sources of symbolic expression touching on aspects of the art-maker's first-hand inner experience and on the discovery of meanings.

Two major qualities characteristic of shapes and evocative of expression are particularly helpful to clients in art therapy.

The first quality is simplicity, a well-known positive Gestalt quality. Most clients' drawings of shapes are usually simple and easy-to-draw geometric figures – the circle, the triangle, the square or rectangle, and their variations. These basic shapes lend themselves to modification, elaboration, symbolic thinking, and visual embodiment of concepts and feelings. They pose no threat to persons whose emotional experience is complex, at times obsessive, burdensome, and in urgent need of some relief. Indeed, the process of visualization in simple shapes offers the relief of simplicity and clarity, evidenced in the artmaker's rather clear descriptions of their shape drawings. The intentional drawing of aspects of an inner experience in shapes is of itself a new, direct and intensive experience in structuring one's inner feelings and thoughts. The drawing, then, becomes a first-hand source material for therapy.

The second major quality characteristic of shapes is abstraction, in some ways akin to simplicity. In art, abstraction is an aesthetic expression of a universal human experience, reduced to its essence in form. It is a visually captured moment of intensity embedded in the simplicity of the artistic form.

There is abstraction also in the shapes of art-therapeutic drawings. It is rather far removed from abstract art, although some clients quite naturally draw on artistic levels. But it seems that training or skill and even talent do not make the main difference between abstract art and abstract therapeutic art, although abstract shape formations appear in both. The difference lies, perhaps, in the universality of the artist's art expression, and the privacy of the art therapy client's art expression. The former's urgent need is art expression of and for the world; the latter's urgent need is therapeutic self-expression of a most inner world.

Much thinking goes into the process of a therapeutic art expression, along with intense feeling. It is, actually, a complex mental activity on a high experiential level. All mental forces join in the activity: thinking, memory, emotions, sensory experiences (hearing someone represented as an abstraction), imagination, selectivity, also humour. In this sense, the whole wide and complex mental operation of an art expression can be described as a cognitive–emotive act. Since abstract art calls for skilful elaboration and aesthetic refinement, it is all the more puzzling to find abstract art expressions in art therapy.

Expressive of most inner states of mind, abstractions in art therapy are quite original in concept visualization. Time and again the art therapist is surprised to see shapes emerging on blank sheets of paper moments after clients are asked *to gaze at colours, close their eyes, feel themselves into the concept*

they wish to express, see with their mind's eye the essential things about it, and draw shapes.

The mental exercise just described is a practical application of the phenomenological concept called *intuiting*, mentioned before. It is a concentrated effort of the client to carry out the double task of experiencing things intensely, and seeing those things in shapes. This can be likened to being immersed in a certain state of mind, and seeing oneself immersed in it. All clients, children and adults, actively respond to the exercise with a very special aliveness. The sophisticated and the less sophisticated are given the same instruction. For many, this may be a first try at taking a look at their difficulty and seeing it as an independent phenomenon. That is when visualization occurs, and shapes emerge on paper, at times also in clay.

As will be seen throughout the chapter, intuiting is used routinely before the actual drawing or modelling when the client is seated in front of the art materials gazing at them. The following pages display and discuss a number of shape drawings made by five clients.

Shape of Family Division

A 23-year-old woman drew the human shapes of her family with the wide side of pink, yellow and blue pastels and found herself confronted with some family realities. She gazed with amazement at her art production, remarking how divided her family was, how far apart her parents were even though 'they did everything together', and how she turned away from one sub-group toward the other despite her real wishes. Lacking artistry, the picture nonetheless has organization, balance, and expression, and is a condensed presentation of basic realities invisible to her in everyday life, but made visible now with stark clarity.

Shape of Family Pressure

This presents another example of an even more abstract art expression, void of human forms or features and closer to oblong geometric shapes squeezed together in primary reds, blues, yellows and violet. This, too, is a family portrait – a depiction of inner family impacts and pressures, a complete symbolic expression in shapes. According to the client, a bright student suffering from depressive moods, he was lagging behind in his work and earning low grades even though 'he studied long hours into the night'. He was unable to describe his family verbally. Assuring me about the abundance of love and care, he also said that his family was 'so different' from other families he knew, and that 'words evade description'. He said that he was

unable to draw people. When I suggested that a picture in shapes might be helpful, he immediately responded.

Although his picture gives no indication of human forms, it exudes a sense of tremendous push and pull in the very compact and probably anxious and angry family of two parents with three sons, my client the middle one. When he looked at the mounted picture, he said, 'I didn't know that it's still so hard on me. This is my third year away from home but, oh, boy, I'm still all there!' Then he proceeded with the description of the five glaringly coloured compressed shapes that left him no air to breathe.

This was not material flowing from the unconscious. On the contrary, it was conscious material clarified by the client's act of visualizing a hard-to-bear and hard-to-grasp mental and socio-cultural situation. The new experience of seeing his own picture of shapes in all their structural simplicity helped him grasp and verbally describe the concept of family pressure, in equally simple words. The drawing played a most helpful role in the young man's therapy.

Figure 7. Shapes of transition

The female client stared a while at the 18" x 12" paper, then resolutely drew her picture. In answer to the What-Do-You-See? question, she gave the following description, here somewhat condensed:

> 'The triangular, zig-zaggy shape outlined in violet up there in the upper left-hand corner is moving out. Its longest edge is not rigid; it is, rather, somewhat rounded. That is the good part of the relationship which it represents, but as it goes down, it deteriorates, getting sharper, into this quite jagged bottom edge. Horizontally, across the upper part of the paper, this large orange-outlined shape is moving in from right to left, towards the violet shape partially overlapping it, though the violet one is seen through; the upper line of the orange shape is thick; it continues more thinly, turning into this rhythmic inner line to close up the shape as it meets the upper angle; on the bottom right corner is me – the pink drink in a glass on a placemat striped in cool colours; the glass with the drink is the only realistic part of the picture; I am watching what goes on with these shapes and having good, loving feelings, but also experiencing *this* (pointing at the "pool" of black marks "dripping" from the violet shape), the bitter remnants of that relationship.'

She went on to describe the colours and their symbolic meanings: the violet for anger; the orange for a beginning of warm feelings; the cool, pleasant colours of the glass outline and of the mat contours – being pleased with her present life; and the warm vibrant pink of the drink – the only truly chromatic item in the drawing (all others being outlines only) – an expression of being alive inside and able to experience exciting feelings, yet watch them as they are changing.

Of special interest is the difference in the client's mood and feeling before and after she had produced the drawing. Beforehand, the tension of conflicting feelings and the confusion of anger with other emotions could not subside despite this client's excellent verbal facility, because words could not help her grasp the structure of her inner ongoing experience.

It was the pre-drawing process of intuiting her inner experience as she stared at the blank sheet of paper and the open box of pastels that helped her 'watch' the transition of her feelings from one emotional involvement to another. This called for an intensive emotional and cognitive effort. She grasped the essential features of her crisis as she visualized them in lines, shapes and colour, all related to each other. She could now see and understand her inner reality with clarity and relief, and emerged stronger from this confrontation.

Some weeks later, she looked at the picture again. This time she saw the orange-outlined shape from left to right. Occupying the rest of the upper space, it was moving away from the jagged violet shape. She noticed an imaginary line leading from the glass straight up to the upper right angle of the orange shape. Even the slanted lines on the placemat pointed now towards the orange shape. There was something of a self-discovery in these new observations. My client came closer to a resolution of her now specified crisis. She was ready to move on to other aspects of her inner conflicts.

The following sequence of two shape drawings began with Miss Z's visible excitement at the sight of the bright colours in a new box of Alphacolor pastels in front of her. Briefly instructed about intuiting and asked to draw some shapes about how she felt, the client gazed at the colours, declaring that she didn't know what she was drawing even as she began carefully to draw three dark red triangles on the upper part of an 18"x12" sheet of drawing paper, outlined them with heavy black lines, and drew on top of the red insides black sharp-angled criss-cross lines (Figure 8). She then added a fourth shape on the extreme left, leaning at some distance toward the group of triangles, but ultimately turning upwards and away from them. That shape differed conspicuously from the others. It was oblong and curved, lightly outlined with thin black lines, filled in with a 'soft, warm red', and had no

Figure 8. Shapes of recognition

bottom outline for closure, thus allowing the colour itself to terminate its spread instead of a line for closure. The client noticed that and called it 'an opening, perhaps to get out'.

Thinking out loud that 'there must be something underneath all this', she drew the black poles to support the shapes, fortified the structure with the middle bar and drew the baseline, topping it with the playful wavy line in soft red. She began the drawing on the upper part of the surface and continued downwards.

Silently looking at her drawing and describing it in detail led her into reflective observations and symbolic meanings. She noticed that the fourth shape on the upper left was quite 'different from the other shapes'; that its red colour was 'soft and warm', as was the red of the wavy bottom line; and that both soft reds 'belonged together', perhaps representing her 'own self'. She also suggested that the soft hues of red might indicate that she had been of a happy mood in her infancy, but that she soon became 'sad' and 'stayed that way' despite present professional and financial success.

A few weeks later, following more art – and verbal psychotherapy – we looked at the picture again. At first sight, the client found it 'childish – only a child could draw such a simple picture'. Upon silent concentration, however, she noticed differences among the triangles in the upper group: the strongest and darkest middle triangle, on 'his' right, a similar but weaker one on 'his' left, a somewhat distanced triangle with a rounded tip, and at the far left 'the fourth shape, very different'. At the sight of that shape, my client's face saddened. Repeatedly uttering 'I don't know', she sat down and quietly cried for a little while. When she looked up again, I asked, 'How many shapes are there?' 'Four', she said. 'How many in your family?' 'Four,' she answered in astonishment, immediately making the symbolic connection between the four shapes and the four members in her childhood family. She then stepped up to the picture to identify Father, Mother, older sister and herself in the group of shapes.

Even though she had verbally related her life at home in detail during the past few therapy hours, her first-hand inner experience of an oppressive life is portrayed in the drawing of the shapes. She recognized herself in 'the different shape', passively leaning yet ultimately striving upwards; in its weak outlines, along with the surprising strength of leaving 'an opening for a way out'; and in all the many feelings – warm and bitter kept so long inside without being understood, now manifested in the colour of that 'different' shape.

To become more aware of some of those feelings, she was asked to draw some more shapes. First intuiting the emotional experience, she visualized it

in Figure 9. As in the earlier drawing, she started with the upper shape, adding the lower part of the picture later.

Figure 9. Shapes of recognition

From left to right appeared the fierce and fiery zig-zaggy shape, tearing horizontally through the width of the surface. Its many sections were sharp-angled, coloured hot pink and outlined with thick red. The centres were electric blue. The last section on the far right resembled the open mouth of a fish.

She coloured the lower part of the paper in three sections divided by wavy lines: a blue sea, a brown shore, and green fields. A delicately textured light blue sky formed the background for the upper part of the picture.

Z thought that 'the shape' with its ferocity of line, movement, and colour 'must be' her anger, of which she had not been aware at all. On the contrary, she thought of herself – and so did others think of her – as 'good natured', for she never felt angry, not even with persons who had failed her.

She was upset with her picture and described it as 'a monster snake flying across the sky with open jaw to devour everything, even these light blue

clouds'. She also noticed the contrast between the light-textured blueness of the sky and the 'shocking' colours of the shape flying above sea and fields.

Having always known herself as a sad and passive person, especially in relation to men, she suddenly identified herself as a very angry person, as angry as 'that shape' itself.

This client's formless emotionality was in urgent need of visual expression in shape and colour. Her anger and sadness were, indeed, like fluid colour – itself without form, but in need of form to be symbolically expressive and therapeutic.

The enormous confusion of heavy sharp-angled lines in red, black and violet, as though they denied, indeed, their own and others' existence, reflected Miss N's state of mind when she first came for therapy. Soon, however, shapes-to-come appeared in her subsequent line drawings. Sometimes these were just pairs of lines forming angles, other times they were round or oval lines striving to be completed into shapes. Such open shapes created tension-laden planes attesting to the inner tensions of the client. Thus the young woman began her art-psychotherapeutic treatment for acute depression, accompanied by fears and almost total withdrawal. Some of her drawings of shapes became milestones in her treatment, for in them she confronted the reality of her most inner feelings and her defensive thoughts about herself-alienated-from-the-world. Such confrontations became sources of self-discovery. When slowly worked through and assimilated, they evoked change.

Five of a series of seven shape drawings are shown and discussed below in their inter-shape serial relationships. This discussion is based on the client's own observations, descriptions and thoughts about symbolic personal meanings as she looked at her pictures and described them.

Figure 10, drawn on the left side of an 18" x 12" paper, is an open oval shape outlined in pale cream, coloured blue, and accentuated with a heavy red line. Inside the cavity-like plane is a black egg shape. Somewhat paler on the right side, the shape sends out into the world some misty, undefined marks in pale blue. 'The big oval is protective and warm,' said the client-turned-observer, 'But also angry; and I, the black egglike shape, am in that space hiding with my fears and depression and sending out to the world this blue weak, hesitant, timid self, always saying, "maybe", "perhaps", well…' She thought that the protective oval was also her male friend who imposed his dominance upon her. She also thought that the two shapes might represent the strong love–anger bond between herself and her mother.

When I noticed the vacant space between the two shapes inside the plane and also the intensity of the black, pushing, as it were, toward the oval shape,

Figure 10. Shapes of change: A serial treatment

Figure 11. Shapes of change: A serial treatment

I wondered about the two observations. Miss N took a long while studying that area and observed that, while she was sending signals of timidity and fear out to the world, inside the shape she was charging at the oval, but at the same time keeping 'him' at a distance. Thus, she realized that there was great power in her depression, and that she used that power in relation to the male friend; and that she was also in a conflict about needing his protective power and being angry about it.

The drawing called her attention to the nature of her depression. And so she produced Figure 11, also on the left side of the 18" x 12" paper, where she appears alone, as a female figure in blue, seated inside a cone-shaped black 'shroud'. 'This black is not as black as the egg shape (in Figure 10),' she said. 'There is more light in this one; I put myself in a stronger blue and into the shape of a human and I went over the contour and the features with pencil. It felt good to do that, to make sure that this is a defined shape even though it looks sad. It also made me feel that it's me, myself, a human, not a doll (referring to an earlier drawing in the series), and not a black egg.'

'What else do you see?' I asked. 'I see that the "shroud" shape is all open at the bottom – for a way out, I guess,' she replied. The drawing also suggested to her an embryo in the egg. 'But (*she stepped back to see it in perspective*) this blue human figure is a mature person, not an embryo,' she observed.

Figure 12. Shapes of change: A serial treatment

Of Figure 12, drawn this time on the right side of the paper, the client said that she 'finally made a complete shape', taking care to make the inner black of the banner-shaped triangle blacker than the black in the two previous drawings. She outlined the 'banner' in red and added a few rigid red lines emanating upwards into its surroundings, most dramatically.

Right under the banner a small child is running away. The child is outlined with three wavy lines in a soft red corresponding to the infant's soft, rounded body shape. Symbolically, the black banner was the client's expression of her father who, with his angry rigidity and strange educational philosophy 'wanted me to be how *he* wanted me to be, always crushing me. Yes, this little kid under the banner, she *is* running.'

A curious thing occurred to the 'little kid' as the artmaker was drawing her. As she started to draw 'a crushed child', the thought came to her that she 'was not going to be crushed, that (she) could get away instead'. That was how the child, running for her life, emerged. Indeed, as I was watching the process of drawing the child, I noticed a different beginning – a halt, a decisive change of line and shape, and relief in my client's facial expression. That was as close as an observer could get to actually seeing the occurrence of an important change in a direct inner experience being visualized as a shape.

For my client, this series of shapes led to a gradually emerging realization of her need to separate from the impact of her father's unpredictable angers and rigidities, from her suffering as a result of that, and from her own erroneous identification with her very passive mother. Both of these involvements had become crippling dependencies seriously undermining her self-worthiness and even the shaping of her present life.

Figure 13, the last drawing of the series, is larger and brighter than the rest. The rather Picassoesque drawing occupies most of the vertically used 18" x 12" space and is located in the centre, the blues and reds are bright, and black is used minimally, not for depressive expression. The largest portion of the drawing represents the artmaker herself, no longer hidden in other shapes but squarely placed in the centre.

That shape representing herself rests on a strong foot, substantial enough to support a large head, as well as a disproportionately strong arm protecting itself from a large scary eye looking down from above and symbolizing Father. The eye in the head of the central shape representing herself – an intensely black vivid point – meets the eye looking down from above. It is an eye-to-eye confrontation. This was a first confrontation between Father and daughter and, although still scared, she dares to look at him straight in the eye. Could it be that she no longer needed to fear Father? Could it be

Figure 13. Shapes of change: A serial treatment

that the drawing was a new statement of what had been and she, perhaps deriving some gratification from having been hurt so badly and so long, still defends herself from a father who has no such impact any more?

These and many other aspects of this client's inner conflicts emerged from her shape drawings and verbal descriptions, reflected upon, that reappeared in verbal psychotherapy and, in turn, generated more drawings.

When a number of drawings or other art expressions by one client share recurring features that make a pattern, it is therapeutically profitable to mount them as a series and to apply serial treatment, as shown above. Serial treatment is then a fruitful combination of art and words as well as of art and therapy.

Three-Dimensional Shapes

Some clients in art therapy find full self-expression in two-dimensional shapes drawn or painted on flat surfaces. Others seem to need to invest their experience in three-dimensional shapes. This part of the chapter will deal with clay shapes made by children and by an adult art therapy group.

Sculptural shapes are multi-dimensional entities within their surrounding space. In addition to height or length and width, they also have dimensions of depth and weight. A sculptural shape may have a number of small surfaces or planes. A sense of balance, higher and lower levels, and a variety of angles are also characteristic of some sculptural shapes. In addition, a flow of all the characteristics and related features, along with gesture and symbolic expression is of paramount importance in sculpture. These are, of course, the elements of artistry. A person not initiated into three-dimensional art may find the task overwhelming. Yet, we see in art therapy expressive, if naive, productions in clay with distinguishable mass relationships, some directionality, acceptable balance, and significant personal symbolic expression. We also see that the artmakers know what they shape.

Clay Shapes Made by Children

Figure 14. Four-year-old boy: that my mom, that me. I won't let her go 'cause she won't come
 back. (2" high)

Figure 15. Nine-year-old girl: Oh, my Dad just went for another cup of coffee. See, he holds the empty cup. (The Father had left the family. Her sculpture broke a long time of pretending that he was still at home.)

Figure 16. Six-year-old boy: This a man with his dog. When I was little, I was jealous of our dog. See, my dad loved the dog and sometimes I jumped and barked like the dog and my dad was mad. He was so mad. (3" high)

Figure 17. Eleven-year-old boy: this is just a dummy, doesn't know what's going on ... doesn't care to know.

Figure 18. Ten-year-old boy: The title of this shape is The Hunchback of Notre Dame. (3.5" x 2.5")

Asked to make a shape in clay of something important they sometimes feel inside, say to themselves or remember, a few children produced individually the following shapes, with comments.

About the Hunchback

Figure 18, originally a six-inch-high blob of clay, roughly shaped like a rock with some planes and angles protruding into space, was a result of play experimentation. It held the boy's attention over a number of weekly visits. Each time, he asked me to keep it moist for the next visit. Each time the boy roughed it up some more and when he noticed an elevation on its back, he christened the blob The Hunchback of Notre Dame.

Eventually, he decided to make the Hunchback 'real'. Most seriously, the young client worked rather aggressively at the shape over a number of therapy hours. Some parts were chiselled out, other parts were built on with fresh clay as the boy visualized which of the protruding parts of the old shape indicated the Hunchback's limbs. When the desired figure was finally shaped and balanced, he carefully painted it with successive layers of green and blue poster paint.

There was expressionistic and therapeutic significance in the succession of changes from the blob. Following a long series of drawings and sculptures of baseball heroes, computer robots and prizefighters paralleled by his growing belligerence, the two Hunchbacks were a first indication of some inner change: this bright, precocious boy began to intuit his inner feelings and thoughts.

Looking intensely at the finished 'real' Hunchback, slowly circling on a turning board, the boy described the head bent down yet striving forward, the formation of the shoulders as seen from all sides, the oversized hands and feet, and the profile of the figure with the emphasized hunchback. 'People think that he is ugly, but he isn't, not really. Inside he is good, but people don't understand him. He is funny, I mean strange; but he doesn't mean to be'. Mingled with descriptive phrases were also emotional utterings. The boy's steady and intense process of devoted work to bring the Hunchback out of the blob indicated, or started, his own changing inner experience.

'So what can I do? You don't tell me what I should do!' he yelled during one of his subsequent therapy hours; thus directly seeking ways to get out of his impasse as the conflict between him and his world grew unbearable. He was, indeed, ready to free himself, just as he freed the Hunchback of Notre Dame from the blob.

Clay Shapes in a Group of Adults

In some art therapy group sessions devoted to visual expression in clay, adult participants were asked to express in shapes 'a concept, thought, or feeling personally important to you'. Upon completion, all productions were displayed for the group to observe and discuss. Some were briefly titled, others were also described. Each shape slowly turned on a turning-board as the group observed and listened to the artmaker. Here are five out of seven shapes, with their titles and somewhat condensed descriptions.

Figure 19. My Marriage: Something is happening to the bond we had

These productions, too, were preceded by the intuiting method; that is, a process of individual silent concentration on the essential features of one's inner experience, then visualizing it in shapes with the art material at hand, to share with the group.

The process generally evokes a variety of lingering feelings that surface in the handling of the clay and in the productions. In this group, some of the feelings shared by the participants were grief, anger, hope, regret, relief, and tension. There were also changes of feelings as the mutual comparing, inquiring, and helping went on. The group's visualized concepts invested in the clay shapes led to valuable self-discoveries, understood and shared by seven people who helped each other.

Figure 20. The Forgotten Feeling: I didn't know what exactly to shape so I decided to just play with the white clay. Then my hands began to shape this and it felt so good. It's a long time since I felt good

Figure 21. It's Time to Pick Up the Pieces and Be of One Piece Again: That's all I can say now

Figure 22. That's Me, the Real One: At work, my supervisees come to me for help. I am their big man to go to. But they don't know how small I feel inside. So that's my concept of me, I guess

Figure 20 evoked dormant feelings in most of the group about 'forgotten good feelings'. A usually doubting and silent group member asked of the artist 'just how (she) felt "good" from just handling a piece of clay', and listened attentively to her answer. Others suggested that the element of play gave rise to the 'good feeling'. Still others spoke of the importance of awareness of good feelings that 'one overlooks or doesn't notice', or 'takes them for granted', and 'no space for good feelings'.

Figures 19 and 23 challenged a few members to discuss deterioration and neglect of it in marriage. The sculptor of Figure 21 talked of detecting 'early cracks in the relationship' that he refused to recognize. That helped

Figure 23. A Family Dream: I wish this were true, but you know that I don't let it come through, and it is too late now

the artmaker of Figure 19, who had not grasped the change in her 'bond', to specify the change and trace it back to earlier developments that neither she nor her husband noticed 'because (they) just didn't see'. Figure 22 evoked a rich verbal exchange about coping with contrasting feelings that often block a person's functioning at work and at home, and how one might balance those contrasts. One member said to the artmaker that when the group began, she was a little afraid of him. She asked, 'Do you scare your supervisees because you are scared yourself?' And a few members exclaimed in unison, 'What are you scared of?'

Summary

This chapter discussed symbolic expression of shapes. In its two main sections, two-dimensional and three-dimensional shapes were shown and analyzed in the context of individual treatment of children and adults and also adults in an art therapy group. Quotations and condensations of the artmakers' comments accompanied the art productions. Theoretical discussions of concept visualization, symbolic expression, and structural qualities

of shapes prefaced the chapter and accompanied parts of particular case studies.

Through the shapes they drew and modelled, the people of this chapter – young and mature, individuals and members of a group – tried to grasp some simple truths about themselves in their worlds. In many cases, they partly succeeded; in some, they succeeded rather well. As I observed the visualization of concepts in shapes I sometimes considered it a psychological and therapeutic wonder.

Five interacting ingredients bring forth wonders of this kind:

1. One is the authentic human need for expression, focused in art therapy on expression of what the clients think ails them. Quite often they resist the act of expression or are truly unable verbally to express what they feel and think. Art therapy offers them nonverbal yet effable ways of expression with art materials that also open verbal channels of expression.

2. Another essential ingredient is appeal. Abstract lines and shapes have a very special appeal to clients in therapy. Being non-material, abstract shapes possess the fascinating and soothing double quality of both concealing and revealing.

 As basic geometric entities, or kin to geometric figures related to the natural world, abstract shapes speak to basic forces in the individual existence of the client artmaker: the forces of feeling, thinking, sensing, remembering and imagining, all of which work together in the symbolic expression of shapes, even as they work in the inner experience, inside. Also as entities composed of vital relationships among their components, indeed depending on such relationships for their very existence and value, abstract shapes strike deep chords in the individual's interior life. Pictured in shapes, the tangled inner experience assumes some order.

3. A third ingredient has to do with the human body and its faculties. For it is by the force of the clients' human faculty of isomorphism that the structure of the shapes reflects the structure of the inner experience in simpler order.

4. And there are, of course, the art materials, an important ingredient from the world with a strong appeal to the client.

 Superficially, art materials may be perceived as means only for the actualization of expression. In a more functional way, however,

their appeal is structural, for they address themselves through the senses and through the mind directly to the essential psychological forces, often even arousing those forces from passive or dormant states.

The preference of material for expression is therapeutically important. While some children in this chapter could not respond to a request to draw shapes, they immediately responded to clay, and that material helped them express strong emotions and memories. The ten-year-old boy needed to chisel and build with clay to shape his own selfhood. And, in a case presented elsewhere, a 12-year-old boy chose to struggle with hard wood and nails in the making of a self-portrait. The structure of the material probably appeals to the structure of the mental experience and, thus, influences specific choices of art medium for expression at corresponding times in therapy.

5. The fifth ingredient is the method of art therapy. Essentially, the present method is a synthesis of concepts in phenomenology and gestalt principles of expression and perception. The components of the synthesis are, specifically:

 (i) Phenomenological intuiting of the inner experience to facilitate visualization, particularly helpful to clients in therapy;

 (ii) Perceiving the art production as a phenomenon with its own life and structure;

 (iii) A phenomenological description of all that can be seen in the art-therapeutic production;

 (iv) Studying the network of inter- and intra-relationships in the whole of the production. The rest – the symbolism of personal meanings as seen in the structural features of the art work – follows by itself. That happens when clients grasp what they see and verbally relate it to their own selves, even as they point to the specific relationships among the components representing those meanings.

 (v) An additional important feature of the method is periodic reviewing of certain shape productions, and the serial treatment of shapes. Finally,

(vi) The unique role of expression. In fine art, abstract line and shape drawings appeal to observers mainly through the integration of innovative, artistically executed components in a given space. As to meaning, observers often create it by and for themselves, or they just enjoy the aesthetics of what they see. In the shape productions in art therapy, however, expression takes the lead. There, components, relationships, and other features and qualities of the whole, are all in the service of expression.

Symbolic Expression of Colour

Like shape and line, colour is a phenomenon that has its own structure, properties and expressive qualities, all related to symbolic expression of the human experience. From everyday life we know that colour can arouse, disturb, fascinate, mystify and soothe; that colour conveys and symbolizes emotions and feeling-toned thoughts; that colour has the power to bring back to mind experiences long forgotten and to reconstruct vanished scenarios in the way aromas and sounds sometimes do. Indeed, colour is known to be associated with sound, as is sound with colour, in the experience of some people, especially those who combine music and painting in their lives.[1] Colour became a focus of the work of some healing therapists[2] and of those engaged in therapeutic treatment specifically by drawing patterns in colour within the perimeter of the mandala[3] Sanskrit: circle, wheel). Colour made its way into culturally shared concepts and symbols.[4] Anthropology, mythology, and science are all concerned with colour. Yet, colour is also highly individual.

Aiming at understanding symbolic expression of colour in art therapy, this chapter will discuss (1) the structure of colour, and its relationship to emotion and form, and (2) the therapeutic function of colour; that is, what

1 Notably W. Kandinsky in his life and writings and Paul Klee, among others.
2 Faber Birren, *Color Psychology and Color Therapy*, Citadel Press, Secaucus, NJ, 1961. Also, Edwin Babbit, *The Principles of Light and Color, the Healing Power of Colour*, Citadel Press, Secaucus, NJ, 1980.
3 Joan Kellog, M.A., ATR, *Mandala: Path of Beauty*, 1984; and Mandala Card Test, 1980.
4 Carl G. Jung, *Man and His Symbols*, Doubleday, NY, 1969; also *Symbols of Transformation*, Routledge & Kegan Paul, London, 1956.

some of the clients talked about earlier and what they have done with colour for symbolic expression of their inner experiences in search of self.

The Structure of Colour

Structure of colour refers to its innate order and qualities. Although colourist painters work with colour according to their inner need, that need is refined with the artist's knowledge of the structure of colour as a component in art. Theoreticians among colourists, notably Kandinsky,[5] created a body of theoretical information along with a psycho-philosophical orientation about colour, much of which I find applicable and effective in art therapy.

A certain order based on the innate qualities of colour regulates the relationships among colours and affects the creation of new colours.

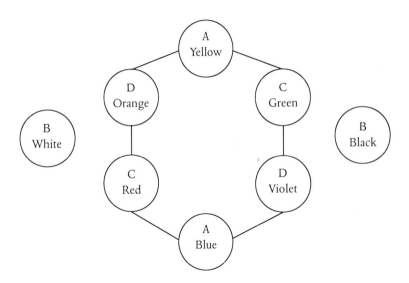

Figure 24 Kandinsky: Circle of Colours

According to Kandinsky's Circle of Colours reproduced here in Figure 24,[6] the parent group of colours is a small trio of primary or primitive yellow, blue, and red. Close in rank is another small group of mixed colours that

5 Wassily Kandinsky, *Point and Line to Plane*, 1979, and *Concerning the Spiritual in Art*, 1977, Dover Publications, Inc., NY.

6 *Concerning the Spiritual in Art*, op. cit. p. 42.

stand, however, on their own: the colours orange, green, and violet. Placed on the opposite sides of the Circle are black and white, one a darkening agent for other colours, the other a lightening one.

Kandinsky points at other ways to group colours: by light and dark or warm and cool. These two groupings open four possibilities of colour combinations: warm–light, warm–dark, cool–light, and cool–dark. From these combinations new colours can be brought into existence. Indeed, untrained clients in art therapy choose and create colours according to this natural classification based on innate qualities of colour. It is therefore important for art therapists, particularly those who come to art therapy not from art but from psychology, education or social work, to know about innate qualities of colours. I stress 'innate' because in their expressive efforts, our clients' innate senses and emotions turn quite naturally to the innate qualities of colour.

In his writings, Kandinsky offered a qualitative description of individual colours. Even though much of it has become common knowledge in our time, I still lean on it for the clarity and the simplicity about his way to see and to feel colour. The following paragraph combines Kandinsky's ideas, here abbreviated, with a few of my own observations of clients' work with colour.

Innate qualities of colour

The warm colour yellow, on one pole of the Kandinsky Circle, tends to burst out of itself, to spread and to reach out. These qualities sometimes seem also aggressive or insistent. On the opposite pole is blue, tending to withdraw into itself and keep distant. Thus, yellow is ex-centric, while blue is con-centric, in Kandinsky's wording. Blue is considered spiritual, profound, and heavenly, but also hesitant, vague and hiding, depending upon the kind of blue.

The intensely warm red is powerful, though the power is contained within itself. Red does not spread as does yellow, but it generates a rich array of shades when cooled with admixtures of blue or white.

White and black are the most outstanding pair of contrasting colours, although they are considered by some as not chromatic. Both are symbolic of silence, white the silence before beginnings, black the ultimate silence. White symbolizes purity, holiness, religious joy and, in some cultures, mourning. Black is symbolic of grief and mourning, night, depressive moods, and a sense of the profound. Interestingly, young children like black paint because 'it's shiny'. They have not yet learned of black for mourning and grief.

A mixture of black and white results in the inactive colour grey. Depending upon the admixtures in the blend, grey may express acceptance, containment, comfort, indifference, repose, reservation, reticence, also modesty and formality.

Green is a blend of yellow with blue. Green is refreshing, restful, lively, although somewhat tiresome.

Orange is a blend of red with yellow. Orange can be warm and outgoing, almost approaching the viewer; but with a preponderance of yellow, orange becomes shrill and unpleasant.

Violet is red cooled with blue. With more red than blue in the mixture, violet becomes the colour of anger or hostility. With little red, more blue, and a touch of white, the pleasing shade of lavender can be obtained, for some a colour of joy and other positive feelings.

Brown is an interesting but difficult colour for clients to mix. The possibilities of symbolic expression with brown are many. Depending upon the yellow admixture with red, black and blue, brown may arouse and express repulsive feelings or regressive states of mind. It may also become a rich earthy colour or soft and protective, drawing the viewer into its warmth.

Blending colours

The guiding principle for the creation of new colours is blending opposite but complementary colours. In art, artists' inner need to harmonize expression with aesthetic organization determines their choice of admixtures for blending. In art therapy, the artmaker's raw need to express his first-hand inner experience determines those choices. We often see in art therapy clients' thoughtful search for the 'right' colour, right for them, to express what they feel.

Blending colours as an art-therapeutic activity can be effective with a variety of clients who withhold expression: the unresponsive or withdrawn, the passive who believe that nothing can change, those who are not self-reflective, those afraid to approach the deeper dimensions of feeling and thought, the depressive, or those whose emotional responses and other reactions are 'flat'.

Simple descriptions of what they see in the process of mixing and blending as well as in producing a new colour will provide these clients with stimuli for emotional and cognitive arousal.

Colour and emotion

The above paragraphs have often alluded to the existence of a relationship between colour and emotion. This paragraph briefly examines researchers' attempts to establish a scientific basis for this relationship.

Rorschach[7] assumed an empirically-based relationship between colour and emotion (1942, 1951) when he asserted that colour responses on the Rorschach Examination represented subjects' total affective responsiveness. The question of a systematic theory for the empirically-based assumption remained a challenge to researchers, however. Schachtel (1943)[8] suggested the existence of one mechanism that activates or influences both colour and emotion; Wexner (1954)[9] asserted a correspondence of specific colours to specific emotions; Crane[10] and Levy[11] reported in their findings that colour was related to clusters or patterns of emotions and that contrasting emotions were found in the clusters.

The colour–emotion relationship finds its theoretical underpinnings within the framework of Arnheim's gestalt-based structural visualization theory of symbolic expression (of the human experience). In the previous chapters, I applied that theory to symbolic expression of lines and shapes. The principles that govern expression of lines and shapes apply also to expression of colours. Briefly, the structures of these art components are similar to the structures of inner experiences visually expressed. In the orientation of this book, the inner experiences are condensed to their essential features by the phenomenological device of intuiting before visualization. Inner experiences are intensive because all mental forces take part in the process of experiencing. Yet, each of these active mental forces or components corresponds to a particular visual component more closely than to other components. This is true especially of cognitive forces and shapes as well as of emotional forces and colours.

7 Herman Rorschach, *Psychodiagnostics: A Diagnostic Test Based on Perception*, Bern, Switzerland, H. Huber, 5th Ed. Also E. Supola, 'The Influence of Color on Reaction to Ink Blots,' *Journal of Personality*, 1950, 18:358–82.

8 E.G. Schachtel, 'On Color and Affect,' *Psychiatry*, 1943, 6:393–409.

9 L. Wexner, 'The Degree to Which Colors (Hues) Are Associated With Mood-Tones,' *Journal of Applied Psychology*, 38:432–35.

10 R.R. Crane, 'An Experiment Dealing with Color and Emotion.' In *Art Therapy Viewpoints*, E. Ulman and C. Levy, Eds., Schocken Books, NY, pp. 358–61.

11 Bernard I. Levy, 'Research into the Psychological Meaning of Color,' *Am. J. of Art Therapy*, 1984, 23/2:58–61.

Colour and tension

As spectators, we experience tension in art,[12] particularly in the artists' use of colour. This tension is part of an aesthetic experience. The tensions abundantly seen in art therapy productions are a personal language in art components of people under the stress of their plight who need to give expression to that very stress and plight.

Artists counter the tensions in their art with planned relief. Thus, the tension-and-relief scheme becomes in art an elegant solution and an exciting device within the artistic organization of an art work. This is not so in art therapy, except for rare cases when a client is endowed with the spark of artistic skill or talent.

In art therapy, tensions last through numerous art productions, and relief arrives only gradually in the process of therapeutic art work when it can be seen in content and structure. Within the structure, colour is particularly rich with expressive qualities of relief as well as of tension, and with an ability to give off some of its own symbolic expressivity to other components.

Tension can be seen in saturated colour, in clash of colours, in shrill colours of two areas that meet along a contrasting shrill-coloured borderline, in overlay of colours dark on light or light on dark, and in a variety of achromatic use of colour.

Relief through colour when it arrives as a client's own need can be achieved in the blending of colours. Watching clients' facial expressions in the course of blending colours can be a telling experience for the art therapist who observes the clients' facial muscles relax, and the smiles that appear on their faces at the surprise and pleasure of what they feel and see. Soon verbal descriptions follow. Choosing colour for admixtures and obtaining the desired shades, are probably the clients' answers to new emotional needs. And the pleasure derived from the new interest in colour blending is itself a relief from oppressive tensions.

To be sure, clients bring their tensions into any kind of therapy, often growing even more tense at the beginning of a therapy engagement. Art therapy offers an opportunity to relieve those and other tensions by the mere work with art materials that appeal to the client, in addition to the activity of blending opposite–complementary colours. The synthesis of two colours weakens the individual power of the opposite components while, at the same time, merging them creates a new whole endowed with symbolic meaning.

12 H. Kreitler and S. Kreitler, *Psychology of the Arts*, Duke Univ. Press, NC, 1972, Part I, Ch. 2.

The new colour obtained gives the artmaker an invigorating sense of stepping forward.

Colour and form

Psychologically and therapeutically, colour and form are bound together within an opposite but complementary relationship. We owe the recognition and the formalization of this relationship into concepts and into diagnostic criteria to the genius of Rorschach.

When we think of form, we visualize something with boundaries. When we think of colour, we have a sense of something undefined, fluid and spreading, eventually stopped by a line, a shape, or a neighbouring colour. Then, however, the spreading colour becomes form.

In art, colour is the most prominent expressive component, itself becoming form within the artistic organization of an art work, the artist being quite aware of this special colour–form function. For an art therapy client, the main function of colour and form is the expression of his or her inner experience which is activated by all mental forces. Intensified by the act of intuiting and by the appeal of the art materials, the experience or some concept of it is prompted into the process of visualization and the act of a visual presentation.

In art therapy, clients are not asked to respond to colour or form. Their affective responsiveness to these components is in their choices, for they freely work with colour and form. Yet the Rorschach concepts of colour–form, form–colour, colour (alone), and form (alone) are very important and effective for the art therapists in getting to know their clients and trying to help them. When we apply these concepts to our observation of what clients do and how they go about it, we learn something about their affective adaptability. Examples of affective adaptability are degrees of impulsiveness and self-control. Signs of these affective tendencies can be seen in clients' use of colour abundantly or minimally, within form or with no form, or in their abstention from colour in favour of work with pencil or, at best, crayon. At times, the art therapist is the first one to notice such signs of affective adaptability, and to report the observation to those competent to administer the Rorschach Examination for reliable diagnostic evaluation.

The Therapeutic Function of Colour

Some clients feel colour intuitively and deeply. They have a conscious need for specific colours to suit or to soothe specific emotional moods. When they are elated or burdened with complex emotional experiences, colour will be

their chief vehicle of expression, sometimes with no form at all. They are the 'colourists' in art therapy. Their colour expression eventually does assume form, but the inner experience and its changes determine that. Once colour assumes form, the role of form becomes clear: it then defines colour, contains it within boundaries, and bestows upon it an articulate, vital meaning. Some clients will journey a long while, with pastel and brush, from the boundless and diffuse colour expressions understandable to them in terms of emoting to better-balanced visualizations of a mature conceptualized experience. Those are journeys in search of self.

In this part of the chapter, we turn to the people in the book to see how they used colour for symbolic expression of special aspects of their inner experience.

Colour of rebirth and growth

These are pictures of the first art production and the last one in a client's two-year span of art psychotherapy.

The figure (not shown) must actually be seen in the original to be recognized as what the artmaker needed and intended it to be: 'I wanted to paint the ugly in me'. The self-assigned task took her through many darkly painted papers, slashed, torn and daubed with undefined muddy-coloured blobs of no form at all, except for accidental bubble shapes of thick brown-black-grey paint. The slashes and tears created some texture, a semblance of unintended form when bits of torn paper curled up offering the concerned therapist hope for eventual control through form.

Numerous paintings later, colour still the dominant vehicle for this client's visual expression, she abandoned her preoccupation with 'the ugly in me'. The new themes lacked the diffusion of the early paintings. These themes were expressions of specific states of mind: fears, depression, and anger in smeared and dripping reds and blacks.

Eventually, these colours began to assume forms of houses, blue and black, or red and black on extra-large papers expressive of the child's forlornness. This development opened new possibilities for visual and verbal expressions abundant with memories of emotional abuse by grown-ups in her childhood home, and of her tangled bond with Mother. There were also many colour sketches of Mother expressive of the good mother, but more so of the restrictive mother who 'owned' her, a child forever, not allowed to grow up.

Then there followed numerous paintings of babies and infants in warmly glowing flesh colour. Soon after, there appeared young female figures in more mature flesh colour, with more cream in the colour mixtures. These

paintings developed into a series of pregnant 'Madonnas'. My client was symbolically re-living her life in full colour-form.

To achieve the appropriate shades of the then essential mature flesh colour, she worked hard to blend proper quantities of colours to achieve a certain shade of pink with cream, yellow, orange and white. She mixed and blended patiently and seriously, experimenting with the admixtures, sometimes with pastels, other times with paint. As she worked, her facial muscles relaxed from the usual tension. Her Madonnas, too, looked relaxed, full with promise of re-birth. These paintings were followed by a mother-and-child series. As I observed the client's silent expressive work, I realized that there was an inner, affective and also rational succession of colours in her series of developmental art productions from dark foreboding colours to warm ones, and from uncontrolled colour to full colour-form.

The change in the client's use of colour in relation to form prompted another change. It was her choice of another art material, needed for another phase in her symbolic expression. She returned to clay, the material she had begun to handle many months before but abandoned for the more pressing need to paint the dark, formless pictures. This time she was ready to work with form and shape. She was also ready and intent upon struggling with clay, a material demanding three-dimensional treatment, an eye for interrelated multi-levelled dimensions and control. Her final therapeutically significant sculpture was a full-figure female nude preceded by a large, full-figure self-portrait.

Throughout her therapy, this colour-inspired and colour-stimulated client guided her own use of colour by listening to her inner needs. Having given full expression in formless colour to the unhappy existence of an emotionally undernourished self, she progressed to expressing anger turned into depression, first in muddy colours, then in glaring reds and blacks. From there she started on a journey of re-birth in one special colour of the female skin. That colour became symbolic of growth and maturation. It had to be worked at, mixed and laboriously blended, as did her inner experience, intensive and engaging all her mental forces, so that she might become a self-sustaining person.

In the following three sections, we will treat the colour component in shapes discussed in the previous chapter. They are 'Shapes of Transition', 'Shapes of Recognition', and 'Shapes of Change', a serial treatment. Some of them appear in colour.

Colours of transition[13]

According to the client's own account in her description, the two upper shapes were a visualized expression of an experience of transition from one relationship to another. The organization of the shapes satisfied and, indeed, expressed her need to grasp the very mobile situation of that transition. But there was more to it: the many not-quite-clear emotions still in flux. These were delicate, hard-to-define feelings about the outgoing shape that bore both resentment and good memories and some rising warm feelings about the in-coming shape, kept under control. She needed to grasp these in-between feelings. Her solution was to use colours, particularly transitional ones, for the outlines only, to indicate but not yet to define these new delicate feelings and to *see* the conflicting feelings before she could commit herself to clear emotional involvement.

This use of colour for outlines only is expressive of emotional conflict and of control of affect. This is confirmed in the distancing of the glass with the pink drink, the only chromatic segment in the picture. The fully coloured 'drink', contained in glass, a transparent material that separates her from the upper shapes, symbolized the artmaker's need to harness her emotion and to act as observer of the shape dynamics, in order to win some delay for the new involvement.

As to the symbolic expression of the outline colours themselves – dark violet for the outgoing shape, orange for the incoming – both colours are in antithesis: orange oriented to light, violet to dark. The concentric violet and the eccentric orange were symbolic in some ways, she realized, of the two relationships, of the subjects of those relationships, and also of her own feelings about each: anger for one, guarded receptivity for the other. The unity of colour and shape in the picture as a whole attests to the unity of feeling and thinking, along with other mental forces in the artmaker's experience and in its visualization.

Colours of recognition[14]

The second of Miss Z's shape pictures in the previous chapter is an example of self-recognition through colour by a client who, unlike other clients discussed in this chapter, was conceptually unaware of the symbolic possibilities of colour. But she liked colour and used it intuitively with ease.

13 See Figure 7, 'Shape of Transition', Part II, Chapter Four, p.47.
14 See Figures 8 and 9, 'Shape of Recognition', Part II, Chapter Four, pp.49–51.

Indeed, colour became the primary determinant of this client's symbolic expression.

She was annoyed with the shrill colours of the 'flying snake', as she described it. The colours were magenta and primary red, meeting at a borderline that was electric blue. These colours symbolically merged with the zig-zaggy shape composed of sharp-angled sections and expressive of violent anger or perhaps of despair, and certainly of acute tension. In answer to my question, 'What else do you see?' she noticed with pleasure the contrast between the shrill colours of the shape, and its background of a sky coloured in peaceful light-textured blues. The pale blue sky reached down to a peaceful ocean landscape in vivid blue, brown and green.

The tension of colour on the upper part of the picture was so unsettling to the artmaker that she found immediate relief in the invented peace of the mildly coloured landscape below. But then, the need to express her angry unhappiness was so pressing that the shrill-coloured shape was the first thing she drew with pastels on the upper part of the surface.

This was one of the rare clients in art therapy who expressed tension and relief in the same picture. For the client, however, it was an overwhelming confrontation with both violent and peaceful forces in herself.

Colour, conveyor of change. A serial treatment[15]

The colours in most of the pictures in this series are blacks and blues. The blacks are saturated and therefore prominent and tension-arousing. The blues are tenuous, subdued, and 'timid', according to the artmaker's description. The blacks were a symbolic expression of her protective withdrawal, while the blues represented her own idea of 'how I appear to people outside', the 'outside' being 'hostile people' who saw only 'negative things' about her.

Black is most saturated in the shape before last – the sharp triangle 'banner' in which the client deposited all her depressive anger, a symbolic expression of Father exuding his angers into the outside in red lines 'moving up'. The child, also black to symbolize Father's impact on her depression and fear, is disengaging herself from the triangle. Surrounded with wavy lines in soft red she runs for her life, a life in her own way, not 'his'; that is, Father's. Black is the colour of total passivity and ultimate silence and that has been the dominant mood of the artmaker.

In the same triangle shape, colour indicated an early change in the way client began to perceive her situation. She placed her own angry depression

15 See Figures 10–13, 'A Serial Treatment', Part II, Chapter Four, pp.53–56.

where it belonged, and made the affected child disconnect herself from a life-long angry dependency upon the impact of Father's fear-arousing angers and his contempt for her. The primary red of the rigid lines and the soft red of the wavy lines symbolized the difference between Father and daughter, who was trying to make it on her own.

A further change through colour occurred in the last picture of the series. Black disappeared, except for a small horizontal line under the eye looking down from above, and a sharp point in the eye of the central shape representing the client herself. Reds and blues, both in strong lines as well as in soft and textured shadings, were prominent. The blues changed from 'timid' to 'vivid'.

Following this series were some paintings with greens, rich warm pinks and yellows, a variety of blended colours and shades, all entirely new on the palette of this client. These were symbolic expressions of the inner resources and capacities of this client, yet to materialize in her life. The use of these pleasurable colours was a surprise in view of her usual preference for dark colours and pencil drawings. When I wondered about that, she said, 'Perhaps because colour would stir up too much emotion'.

'Skipping' colour

This is a picture by a ten-year-old girl who enjoyed working with colour and often painted in her free time. She made the picture with poster paints and with crayons during a therapy hour and titled it 'The Walk', changed from 'A Walk with Father'. We will focus attention on her achromatic use of colour in the otherwise colourful picture, and on the way she noticed it herself.

When the child indicated that her picture was done, she helped me tape it to the wall at her eye level. Familiar with the What-Do-You-See? procedure, she placed two chairs at some distance and both of us proceeded to look at the picture for a while, I reminding her to notice things that she might not have noticed during the process of art work.

Th: What do you see, J?

Cl: I see a girl playing with her ball in the park. That's me…can I say something else?

Th: Of course, just say it.

Cl: Well, I see that she doesn't really care to play and oh, oh, over there is her dad, in the back, kind of behind…(*laughs*) and he doesn't care to walk (*pause*) do you see that?

Th: umhm...and what else do you see?

Cl: See that house up there? That's our house. We live close to the park. Not really that close, but I wish we were closer, and see, my mom, she goes back into the house? See, she told my dad to take me for a walk in the park and...(*abruptly*) that's all I see.

Th: How about the rest of the picture?

Cl: Oh, oh, there's all the trees and the flowers and some of the sun. It's setting, it's so pretty, and all the tiny flowers...

Th: I see, and you certainly gave them a lot of colour.

Cl: mmhm, I love to colour trees and flowers.

Th: Now, let's go back to the people in the picture. What on the picture shows us that she doesn't really care to play with the ball or that dad doesn't really care to walk. Can you take a look and tell me?

Cl: Well, see, the ball is rolling away and she doesn't run after it. She just walks and her face is kind of worried,...the mouth (*pause*) oh, I don't know (*distressed*)...

Th: What about the mouth, J?

Cl: It's just a straight line, like made, or something.

Cl: Oh, he looks like he wasn't there. See, he didn't want to go. He was made with me (*pause*) and oh, I forgot to fill in [with colour] his blazer and, oh, his shoes, and oh, what's the matter with me? I didn't hardly make his face. Do you want me to do it now?

Th: You can do it later if you wish. You did give a lot of paint to the park, though.

Cl: Oh, yeah, trees and flowers I love to colour (reaching for green crayon to add some more grass).

As we continued, the child noticed with dismay that she 'skipped' colour on mother and house, also.

This conspicuous use of colour by omission, particularly in view of the chromatic nature of the picture as a whole, is expressive of some disturbed feelings of the artmaker about the subjects of omission of chroma. To be sure, at the time the omissions had a positive function in that they offered the child some relief of tension by avoidance of involvement with the parents. The fact of the child's noticing her achromatic treatment of the people in

her picture initiated a process of art therapeutic work related to the family problems as well as a series of therapy hours with the parents.

Omission of colour in details of a colourful picture is an uncalculated way for the artmaker to express uneasy feelings about the subject or theme of the omission. This child's achromatic use of colour suggests a few theoretical and practical aspects in art therapy of interest to art therapists:

1. The child demonstrated and confirmed the empirically-based assertion that affect and colour are related.

2. She communicated her individual affect-chroma expression to the therapist by omitting colour on significant persons and details in her life.

3. Such omission of colour is a signal of some affective disturbance, important for a therapist to notice.

4. The child's own discovery of her chroma omission indicates strength and readiness to deal with the indicated difficulty.

5. It is important that clients, younger or older, be guided to notice such omissions on their own, rather than be confronted by the therapist.

The phenomenological orientation and method of art therapy facilitated the child's self-discovery, later profitably used in her therapy.

Other Symbolic Expressions of Colour

Now we turn to other chapters in Part II to show how some other clients used colour for symbolic expression in art productions mentioned or discussed in contexts other than colour.

In Chapter Four, Figure 8 (p.49) is the student's compact configuration of five shapes in five glaring colours expressive of his depression.

And in the next chapter we will see:

1. The withdrawn boy's rampage of a fire in red, dark blue and black, symbolic of his consuming rage; also, his soothing picture, in greens and pale blues, of rain softly falling on bending grasses.

2. Young George's repeated 'Sunset Signatures' in bright crimson with a tinge of violet in it, just enough to convey his sadness, masked with loud belligerence. And,

3. Figures were viewed by spectators who were struck by the expressive colours. In one figure the young girl's sweeping with

smears in dark reds and violets, oversized colourful flowers as sad as the child herself, and a slashed dark red sun, are all expressive of the child's foreboding feeling of disaster, and were so perceived by the spectators.

4. The schizoid young man was drawing and reached out for a yellow pastel, began to apply the warm yellow and a spot of warmer orange to the picture of his family outlined in black, and suddenly threw the pastels away in ferocious anger and fear. Such was the power of the warm outgoing colours on the inner experience of this profoundly disturbed young man.

Summary

This chapter about symbolic expression of colour centred on two themes: the structure and the therapeutic function of colour. Structure of colour included groupings of colours, innate qualities of colour, discussions of colour and emotion, and colour and form. In the part dealing with the therapeutic function of colour we saw how some clients in the book used colour for the expression of their immediate inner experience and in search of an authentic self.

Additional Aspects and Modes of Symbolic Expression

The additional modes of expression discussed in this chapter are subtle but they occur in art therapy rather often. It is their visual expressions that inform the therapist of mental forces present but inactive in the clients' inner life. Such was the case of an adolescent boy described by his parents as 'listless, like sleepwalking, not answering; we wonder if he hears us…' They remembered that he used to 'play around' with paints and crayons, and thought that perhaps this would bring him into therapy. Indeed, it was art therapy that helped him agree to come 'for one visit if she won't ask me questions'.

A silent relationship grew. He was drawing and painting as I was observing with amazement the flying objects emerging from under the crayons, the leaping bicycles, breaking clouds, people running from fires. At first he tore up every picture as soon as it appeared on the surface. Gradually, however, he allowed me a little time to look at them before he proceeded to destroy them. Once, he crumpled a painting into a ball and threw it into the waste basket. It is 'Fire', in black, red, orange, and blue which I rescued. In time, the violence subsided in favour of calmer, more rhythmic motions, such as people riding bikes on the ground and even stopping at red lights, or rain steadily falling on bending grasses against a blue background. 'I like this picture', he said, 'Can I take it home?'

In time, it was possible to tape some of these pictures on the wall in order that both of us might look at them together, in silence. A few weeks later, he noticed inside his folder the old fire picture which I had rescued from the waste basket. He was quite curious about it and began to talk of 'all those

pictures' of the past. He helped me tape it on the wall beside his calmer art works. He looked, saw, described, and discovered. That picture was the only extant representation of the hardest time of his life, a time of violence kept under the hard control of detachment.

Expression in Gesture

I find in clients' art work that gesture can be more expressive of deep emotion than posture or a clear-cut body movement. When the subject of the picture or sculpture, person, animal, plant, or object appears to our eyes tired, puzzled, pensive or eager, it is the gesture of the total form which bears that expression. It is a live impulse from within the artmaker which our eye perceives when looking at the production. A telling gesture seems to speak of the whole of the painted or modelled subject. At times, gestural changes in clients' art subjects help me recognize parallel changes in those clients' feelings about themselves.

Figure 25

In the course of L's art therapy, she painted many colourful and delightful abstractions of landscapes, all expressive of intensive, often euphoric feelings dominated by extremes of love and anger. But the most telling of her art works about her intimate feelings of self were the sculptures of 'woman', here shown at the least state of self-acceptance (Figure 25). This sculpture was the first of a series of nine female images in clay, including torsos, heads and full figures, with visible changes in head positions, facial expressions, and body gestures. They ranged from heads bent low with a pained facial grimace and curled-up body to upright figures in lively gestures expressive of recognition of self.

Somewhat akin to gesture is movement. Even in the art of untrained clients in art therapy, we often see 'as if' motions of line and form. Not really there, movement in a picture becomes credible when it animates parts of it, giving the picture kinetic or dynamic qualities. The use of kinetic modes of expression attests to degrees of intensity in the artmaker's mental life, also evoking similar reactions in the observer.

Expression Through Contrast

When a 16-year-old learning-disabled boy of borderline intelligence began emotionally to grasp his painful situation, but was unable to put it into words, he succeeded in giving effable expression of his emotional bind in a picture, without intending to do so.

A good swimmer and diver, he was quite familiar with the underwater flora and fauna and often drew and colour-modelled fishlike forms in characteristic gestures of fish, despite rather low abilities in art. But when he painted the 'Fish Caught in a Net', discussed earlier, it was a fish with a different stance, for it was motionless and still. Handsome and replete with colour and detail, but stiffly suspended in the net and surrounded by a deep blue ocean shimmering with wet paint, the fish was clearly a symbolic expression of the tall and handsome boy's existential plight. What made the picture so moving was expression through contrast. This was a two-fold contrast, a potent device well known to artists, but perhaps only sensed by this boy. One aspect of the contrast was the no-gesture stillness in a fish expected to appear in characteristic fishlike gesture. The other aspect was a colourful elegance of the fish indicating vibrant life – frozen in stillness. Thus, expression attained its fullness by means of contrast. Contrasts also express tension in the artmaker and evoke tension in the observer.

Content, Form, and Expression

A common distinction in art therapy between content and form aroused my interest in an articulation of this distinction. My study of 350 pictures randomly selected from my old collection (one out of five), and an examination of every picture since 1982, grew ever more confusing and difficult. Eventually, I realized that content and form flow into each other and, therefore, they cannot be clearly distinguished. When I wondered what makes them flow into each other, gesture seemed to indicate the answer. Gesture, expressive as it always is, alters form by lending expressive quality to content. Thus, we come back again to expression, the one aesthetic element essential to art therapy.

Pre-Conscious Expression

Expression has its pre-conscious levels in clients' art work. Such levels are sometimes recognized retrospectively by the artmakers themselves in the sequences of phenomenological analysis of the production. That is the time of 'strange' discoveries that are, however, readily recognized by the artmaker and fitted into the description. Occasionally, such discoveries assume a leading expressive role in the artmaker's own analysis of her or his work. This was the case of R, a young woman confronting problems in her recent marriage, when she was trying to remember whether she consciously placed the barge in her picture in its present position: 'I…thought that I could say in this drawing that now I sail in quiet waters. I remember that, at the time, (of the drawing) something inside didn't feel quite right about the picture, but I just left it there. Maybe, this is what I really wanted to see because, somehow, I am not shocked to see how wobbly the barge is.' This preconscious expression supplied my client with an important personal meaning.

Multiple Meanings in Therapeutic Art Expressions

Phenomenologically, it is possible to find more than one meaning in an art expression. In fact, clients often arrive on their own at a few levels of personal meaning in one picture. A young woman's picture made over a scribble is an example of multiple levels of meaning. The capital letters in the following paragraph mark the levels of meanings she found in her picture (not reproduced here).

She gazed at her picture, pointed at an oblong shape in the centre and said, 'I see this male symbol[A]…but… I am used to seeing shapes as male–female genital symbols, so, of course, this represents my husband…'

Th: Yes, it is one way to see it. We will come back to this when you describe the whole of your picture.

Cl: Down here, on the left, this shape might be the female,[B] kind of (*pause*) crouching? I (*pause*) don't like it. Look, they are both blue…

Th: Both blue? Oh, yes, compare the blues on both. What do you see?

Cl: Well, oh, I see…on the male the blue is evenly painted. On the female there are these heavy, sudden lines, lots of shading, nothing even here, see?

Th: We may come back to that, too. Now you are still describing just what you see on the picture.

Cl: Oh, there is this big shape I outlined with this bright pink. Oh, I don't know anything about it…

Th: I wonder how it relates to the central figure, the male symbol…

Cl: I thought that this shape was behind the symbol, but then, the front line, here, should be interrupted and it isn't, so now it looks like something wide put over him, and one can see through it … like glass…how interesting!

Th: Yes, it seems transparent, like a cylinder…put over, as you say…

Both gaze in silence.

Cl: Oh, I think that some things are coming together… (*talks excitedly with rising voice*). I keep him under this cylinder[C]…that's right, so I can see his every move. All these questions I always ask him that he resents: what did you do today? where did you go? with whom? with her? what did she say? He did tell me that he won't answer my questions any more.

Th: You seem to have put together a thing or two. Now, let's look at the picture some more. Look at the lines that shaped these and other figures. Can you describe them?

Cl: Well, the central one is oval and this here circular shape (*bottom right*), the many round and oval lines? Is that what you mean?

(*Continuously circling her finger around the round shapes.*)

Th: Yes, they are rounded and continuous. How do they make you feel as your finger is circling around them and as you look at them?

Cl: Oh, I never…it never occurred to me that they make one feel…anything. Well, these shapes are kind of peaceful?[D] Actually, they are rather simple; they are closed, maybe whole? Yes, they are whole. Does that make sense?

Th: Simple and whole, yes, it makes sense. We do know from studies that different lines or shapes give us different feelings, so the rounded shapes gave you pleasant feelings and a sense of continuity… Do you see on your picture a shape that is not simple and whole?

(*Immediately*) This one, the 'crouchie'!

Th: Try to describe it.

Cl: It's crawling, not simple, not peaceful. All these scratchy lines in it, there is no order in it. I still don't like it. Look at these odd ends and corners.

Th: Yes, the 'crouchie' is rather tangled and complex, but it also has this pleasant looking upper line, see? You noticed earlier that both figures are blue, only one is sort of simple and whole, but the other is tangled and complex and has no order, as you observed.

Cl: (*Suddenly*) Are you talking about me?[E]

Th: What made you think so?

Cl: Well, when I was outlining those shapes on the scribble and when I coloured them, it occurred to me that those are parts of me, my good, uncomplicated ones and my crazy ones. So now, as we talked about these many things on the picture, it occurred to me again.

Th: Yes, today we found that one can see in a picture more than one thing and also more than one personal meaning.

The next session with the same client extended the levels of meaning to the technique used in gestalt therapy, here applied to art therapy, of feeling oneself into the role and mood of one or more of the images in a picture. Thus, my client felt scrutinized and resentful under the transparent cylinder and subservient and undermined inside the crouching figure, but peaceful, steady and protected inside the circles. The personal meanings of the therapeutic art expression emerged on different levels.

Symbols in Visual Expression

In art, symbols are known as special modes of expression. Their characteristic features are that they do not quite fit into the art work and that they carry very private meanings, often known to the artist alone. Occasionally, symbols appear in art therapy also, playing a role similar to that of symbols in art.

Nine-year-old George drew and painted generally popular scenes of sportlife, circus, playground and street. Characteristically, his last touch on each completed picture was a ceremoniously-painted trapezoid shape in scarlet red, spreading horizontally over the upper part of the sky and 'hugging' the picture with two downwardly painted wings. Encouraged by my silent acceptance of the everpresent addition, he eventually volunteered the explanation, 'It is my sunset, it's like a signature'.

In his clay work, George modelled also things from everyday life such as cars, baseball bats, and sport heroes, all the while noisily chatting about his productions. Occasionally, however, he would get silently involved at work on a clay project without as much as indicating what it was. 'Stairs' was such a project. Just as 'Sunset Signature' was not integrated with the rest of his pictures, so 'Stairs' was not integrated with the rest of his clay works.

As the finished project slowly displayed its sides on the turning base, he described in detail the three colourful staircases winding their way to the white plateau that held them together. He talked affably about his struggle with the clay to shape it into the design he 'had in mind', but withheld any mention about what it meant to him except 'these are my own stairs, just for me'. Nor was it necessary to discuss meaning with him. He needed the symbol and created it to satisfy some needs of his own.

What were those needs? In a most general way, the young boy's needs called for some relief from the many overwhelming tensions in his life. The symbols were to unite or, at least, to bring closer together some of the contrasts in his emotional life and in the life around him; or to draw the real and the wishful closer together; perhaps, also, to unite George the little boy with George the precocious pre-adolescent and help him make sense of the reality of his own person, marked by either depressive or euphoric moods of 'I will never grow up' and the fantastic dreams of 'When I grow up'.

For an example of a yet different function of symbols, we turn to an abstract picture reminiscent of a stormy sea. In this picture, a small detail in the shape of a vaguely oblong pink patch is placed in the centre and seemingly sliding down toward a dark mass on the left, away from the dominating strong, tall shape that is itself leaning away. It was hard to know what the patch was doing there even though it was centrally located. At first, it even went unnoticed by the client herself during her rather articulate

description of what she saw on the picture. Once the patch was noticed, however, she had no difficulty recognizing it immediately as the symbolic locus for her feelings about not having had a child. These were not repressed unconscious feelings. Hers was a rather conscious distancing from feelings which she knew but needed to 'deposit' in the pink patch as a symbol of a 'moratorium' she had taken on coming to grips with a conscious problem. There is tension in this picture. Its structure indicates a good painting if elaborated.

Symbols contain most personal, condensed meanings. That artmakers seem unconcerned about integrating the symbol with the rest of their art expression attests to their pressing need for relief of secret tensions in secret ways, to be comforted by creating a private locus to deposit them. For the observer, symbols are the intriguing puzzles in art and in art therapy.

Tension in Therapeutic Art Expression[1]

Tension is a quality that marks many, if not most visual expressions in art therapy. Tension is probably characteristic of all the modes of expression discussed in this chapter. To be sure, every client who reaches out for the chosen art material unknowingly injects some of his pre-existing tensions into the process of art work. But while the art process occasionally seems to offer relief to those tensions, it also creates new ones.

Tension becomes an artistic device when skilfully balanced with relief, observable in components located in specific places in the art work. In art-therapeutic expressions, we can detect tensions in specific components and locations, but rarely do we see relief from such tensions in the same picture.

Tensions arise in contrasts between shapes, sizes, direction, or textures. Incomplete gestalts arouse tension. Heavy hues of colour are tension-laden, as is clash of colours.[2] Distortions of form and unusual locations of form are apt to arouse tension. Exaggerated proximity or distance of related figures may increase tension. Also ground-and-figure relationships can be tension-laden. Briefly, tensions will arise within relationships among components and their qualities or their expressive values. However, tensions alone will only call for relief, but remain unanswered unless they are uncovered and

1 For a discussion of tension and relief in art, see Kreitler, H. and S. Kreitler, *Psychology of the Arts*, Part I, 1:6–20. Also, U. Halbreich and D. Friendly, 'The Characteristics of Tension-provoking Composition and Lines as Presented in Munch's Paintings,' *Confinia Psychiatrica*, 1980, Vol. 23, 3, pp. 187–192.

2 Tension-arousing qualities of colour have been discussed in the previous chapter.

resolved. Our problem is, how can we work systematically with the principle of tension-and-relief in art therapy so as to help our clients to balance their tensions with relief right in their art expressions? That might be a truly therapeutic find.

Expression Perceived

This, the last part of the chapter, is devoted to outside observers' perception of therapeutic art.

A woman came in for her appointment and immediately noticed a painting and a drawing on the wall made by two different clients earlier that day. She looked briefly at each and volunteered her impressions. One was made with poster paints by an 11-year-old girl. Another was drawn in outline with black crayon by a 26-year-old man (the woman observer did not have this information).

Figure 26

She said about one: 'Strong colour. Strong feelings. Maybe anger, or despair? Everything is pushed that way. That hole in the sun, like a pain, an interesting way to paint, but kind of tears you up a little bit, doesn't it. Somebody must be awfully sad.'

The same spectator on Figure 26: 'How upsetting! The emptiness. Like paper figures; pressed together, but they don't touch. Oh, but they do step on each other's feet. Look at the arms, either in the back or on the hips, but not doing anything, not touching. And that baby. Kind of thrown in. Makes me shiver.'

As these reactions aroused in me a curiosity about the impact of the two clients' art expressions on spectators, I asked six additional persons to view the two pictures and relate their impressions. Two of the six were in psychotherapy with me, not in art therapy. The remaining four were not trained in art and were not in psychological treatment. The reactions of the six spectators were very similar to the reactions of the first woman viewer, though less profuse. Asked if they could indicate on the surface of the pictures what led them to 'see' their impressions, all readily designated areas of colour, lines, positions, motions and gestures.

Some of the shared impressions were: the dark blue 'sweeping' across the flowers, the dark blue 'pushing' the flowers 'downwards', the dark red 'smears' strong like some 'mad wind', the 'strong but dark colours' indicating 'love and anger', also 'confusion and depression' because they were 'smeared across', and the 'flowers are strong and pretty, but they are breaking down'. Among the collective reactions traced to the surface were: the absence of facial features or signs of gender were indications of the family being 'a bunch of hollow ghosts', 'inhuman', and 'paper figures'; being crowded but not touching each other represented separateness and inability 'to get away'; the aborted effort at using colour struck some as 'hostile'; and the position of the figures' feet as 'confusion' and 'fighting'. The position of the baby puzzled all the spectators. They wanted to know whose child it was. Was it the artmaker as a baby? Or was he the father?

These spectators were not versed in the language of art and therefore could not have learned to think in terms of organization, components and their properties, or expressive qualities. Yet they seemed to possess a matter-of-fact knowledge that made much sense about the pictures and even about the correspondence of the pictures to the states of mind of the two clients who produced them. How can this be understood? Of the Theories

of Expression,[3] all dealing with the 'reading' of a work of art, it was the Ionic theory that was most helpful in my search for an answer. As is well known, that theory, developed by R. Arnheim, is an elaboration of psychological gestalt principles, mainly the Principle of Simplicity applied to art, specifically to the visual perception of expression in paintings and other works of art.[4]

The Simplicity Principle functions in this way: when a spectator's retina receives patterns of light perceived by his or her senses, these light patterns form simply organized patterns in the spectator's brain called 'brain fields'. The formation of the 'brain fields' in the spectator's brain is actually a transformation of the information that he or she received through their senses. The Simplicity Principle also offers a physiological context for the Gestalt Principle of Isomorphism, which states that moods bear a similarity to their perceivable visual structures or patterns.

Both principles complement the phenomenological concept of intuiting, or direct-experiencing phenomena perceived with our senses and minds. Together, the two approaches, the gestalt–psychological and the philosophical one, provide a better understanding about invisible experience transmitted through visible expression. They also offer an unbiased theory of directly experienced expression in therapeutic art with no need to resort to interpretations based on inferred theories. Also, and most important for art therapy, this objective theory makes pre-conscious visual self-expression accessible to the artmakers themselves with some methodological help from the phenomenologically informed art therapist.

This chapter concludes the four chapters on symbolic expression in art therapy contained in Part Two. We have seen that persons untrained in art used the basic art components – line, shape, and colour – for the expression of their feelings, moods, and feeling-toned thoughts and attitudes. We observed how untrained clients employed in their productions a number of additional aspects and modes of expression well known and refined in art. And we 'heard' some equally untrained observers of those productions express feelings similar to those of the artmakers, and we even 'saw' them

3 For a lucid presentation of Expression Theories in art, read Ellen Winner, *Invented Worlds*, Harvard Univ. Press, 1982, Chap. 2. For a wider background on Expression Theories, read Wordsworth's *Preface to Lyrical Ballads*, Leo Tolstoy's *A Modern Book of Esthetics*, Hans Kreitler and Shulamith Kreitler, *Psychology of the Arts*. For a discussion on expression theory in aesthetics: Haig Khatchadourian, 'The Expression Theory of Art: A Critical Evaluation,' *Journal of Esthetics*, 1965, 3:355–52.

4 Rudolph Arnheim, *Toward a Psychology of Art*, 1972; and R. Arnheim, *Art and Visual Perception*, 1974.

locate those feelings in line–shape–colour and in other modes of expression in the observed pictures.

If it is true that art components and other modes of expression carry and convey personal as well as culturally-shared meanings, then knowledge of such expressive values and qualities is of vital importance to art therapists, for such knowledge could help them read their clients' visual productions in ways similar to the reading of art works. Moreover, familiarity with expressive qualities of components could assist art therapists, and psycho-therapists who use art in their work, in helping clients read their own pictures phenomenologically and thus become aware of their own feelings and emotional attitudes perhaps less painfully and perhaps a little sooner than in verbal therapies.

Part III
Expressive Qualities of the Scribble

CHAPTER 7

The Scribble, Annotated

'The scribble is a kind of play with a freely flowing continuous line. It is a mode without plan or design, and occurs as a result of the easy movement of the arm while letting the chalk trail along in any direction. The line may intertwine or it may be clear and simple.'[1]

The gifted art teacher Florence Cane so described the ubiquitous scribble and thus formalized it as a visual means of transition from free line movement to creative drawing. With chalk in hand, her students stood in a balanced position, making rhythmic arm movements from the shoulder, to draw imaginary lines in the air and then record them on paper. The exercise was to free creative faculties and to 'release images from the unconscious'.

Art therapists readily adopted this conceptualized Cane Scribble with its rationale, and incorporated the technique into art therapy practice. They appreciated its trustworthiness because it drew clients' immediate response to the exercise, to the basic scribble-making, to the search for a shape or image in the twists and loops of the line, and to the final step of making a painting on top of it all. Florence Cane's main purpose was to ignite a creative spark in her art students and guide them towards a genuine experience of an art process. There were, no doubt, some therapeutic gains from this technique for the art students, but the art experience centred on the process and on the product and its artistic elaboration. Not so in art therapy.

In art therapy, evocation of some art experience as such is important, and some clients do gain a satisfaction characteristic of an art process; but it is not the primary purpose, even though the 'spark' does occur at times in the

1 Florence Cane, *The Artist in Each of Us*, Pantheon Books, New York, 1951, p.56. Revised Edition, Art Therapy Publications, Craftsbury Common, Vermont, 1983.

art work process of a client and is of therapeutic value. The art therapist wishes to learn from a client's picture something about the person who made the art work. And so it was with the scribble. Art therapists sensed the expressive values of individual scribbles and derived intuitive knowledge about their maker's inner dynamics. This was a way of knowing from actual doing and from acquaintance with the performer. It could not be called diagnostics, however, for it was not based on a sound generalization of single moments of observed behaviour interpreted as typical of an individual's response to similar situations. Thus, before the publication of the Elinor Ulman scribble series for diagnostics, the scribble had become rather ubiquitous in art therapy as a thing to suggest to patients to do with art materials.

Then, in 1965, Ulman published her diagnostic drawings series[2] based on the Scribble formalized by Cane. It is a procedure which involves a few steps: preceded by a free drawing assumed to represent patients' habitual mode of response, the scribble section is followed by a second free drawing, presumably made in reaction to the flow of unconscious material freed by the unstructured scribble experience. That picture might represent a flight back to the habitual mode of response, or an act of turning to something new. Patients' free associations to their drawings, therapists' comparison of the drawings, and the psychoanalytical model of interpretation lead to diagnostic personality assessment.

The Scribble, Phenomenologically

My own collection consists of over 400 Scribbles administered to people in art therapy and psychotherapy, members of group therapy, participants in workshops,[3] students and art therapists in the USA, England and Israel. I found three intriguing elements of the scribble in need of better understanding. They were (1) the structure of the scribble, (2) the shapes and images found in it, and (3) the relationship of the shapes and images to the scribble structure.

In a random selection of 100 scribbles (out of 400), 78 corresponded, in a general way, to the Cane–Ulman model of a scribble. The remaining 22 were conspicuously different. That group was separated from the rest for a special study reported later in this chapter.

2 Elinor Ulman, 'A New Use of Art in Psychiatric Diagnosis,' *Bulletin of Art Therapy*, 4:3, 1965. Also published in *Art Therapy in Theory and Practice*, Schocken Books, New York, 1975, pp. 361–386.

3 Workshops in spontaneous art expression and art therapy groups were features in my practice over a span of ten years.

The group of 78 scribbles was not entirely homogeneous, even though, at first glance, they looked alike before the markings of shapes and images. There were many individual differences between them: some were sparse, others dense; some slow and 'lazy', others energetic; some condensed more than others; and some, generally, richer than others. Yet, on the whole, all met the general requirement of the model Scribble.

In order to examine both groups productively, the following concepts were applied to the study: Ground-and-Figure; Everyday-Life-World; Self; and Perceptual Articulation.

The Larger Group

The characteristic attitude of this group was marked by spontaneous response to the instruction and by energetic and enjoyable work. The shared features of this group's scribbles were:

1. Execution of scribble according to instruction.

2. Spread of scribble over whole or most of the surface.

3. The structure of scribble – moderately strong line (pressure), flow of line exuding a sense of rhythm and some order, not tangled or too crowded.

4. Strong perimeter lines marking shapes and images.

5. Shapes or images relate to Scribble the way Figure relates to Ground, and ease about the integrating picture.

Everyday Life World and Self

Just as the surface for painting or drawing is considered in art therapy the painter's life space, so a scribble may be treated as its creator's Everyday Life World.[4] The clinical possibilities of a scribble pertain, therefore, to its nature or structure, for the scribble is expressive in some ways of the way each creator perceives, with the senses and with the mind, the surrounding Everyday Life World such as family and himself or herself in it and in relation to it. When the creators of scribbles seek and find a shape or image among the lines and spaces of their scribbles, they symbolically reach out to the Everyday Life World that was there before the rise of self, yet also try to differentiate self from others.

4 The Everyday Life World, the Husserlian *Lebenswelt* is understood here as the immediately encountered reality of our felt, lived experience in the original social environment, the family, and the wider circles of the socio-cultural system.

Figure 27. Spring

Figure 28.

The structure of the scribble stimulates the sight and mind of its author to 'eye' a prospective shape or image. And only the act of marking the 'eyed' area with a perimeter bestows shape upon it. This act is not unlike a beginning of the formation of self, and its effort to contact the Everyday Life world and to establish itself in it, to grow. We do not really know whether or not this material has been freed to flow from the unconscious, but our state of knowledge about that unknown does not alter the visibility of the shape that came into being right there. The finder of the shape has been stimulated by the structure of the scribble, and the outlined perimeter he marked transformed a small unarticulated space into an articulate shape that now stands in relation to the Everyday Life World.

Figure and Ground

The shape or image is Figure; the scribble is Ground. The perimeter outlined around the shape is a boundary between Figure and Ground, or between self and the reality of its surroundings. In order to develop into a mature self, a boundary is needed for self-discernment within the surroundings in the Everyday Life World. As the author of the scribble finds more shapes and marks more boundaries, varied and complex relationships ensue among figure and ground, or self and his or her World. Thus, the Everyday Life World of a child gains a broad psycho-social dimension and responsibility for promoting or impeding the progress of self.

Perceptual Articulation

To understand even more clearly the on-going psycho-social process in the growth of self within its Everyday Life World, we need to consider the importance of perceptual articulation of self. The concept has been formulated by a team of social scientists researching the difficulties of young immigrants, placed in Israeli Kibbutzim, who had serious difficulties in handling social and work tasks.[5]

Some of this research, carried out in several subcultures in Israel with children and adults, informs us that levels of perceptual articulation correlate with degrees of autonomy cultivated in childhood and, specifically, that absence of guided autonomy in childhood correlates with a lag in perceptual

5 J. Preale, Y. Amir, Sh. Sharan, 'Perceptual Articulation and Task Effectiveness in Several Israeli Subcultures'. *Journal of Personality and Social Psychology*, 1970, 15(3), p. 190. Also, Y. Amir, 'Adjustment and Promotion of Soldiers from Kibbutzim' (In Hebrew), *Megamot*, 1967, 15(2–3), p. 250. And, T. Marens, A. Thomas, S. Chess, 'Behavioral Individuality in Kibbutz Children', *Israel Annals of Psychiatry and Related Disciplines*, 1969, 7(1), p. 43.

articulation of self; also, that this childhood lag reappears at adolescence more intensely in the form of serious difficulties in social functioning.

In the context of self-discernment or self-distinction, within the life world, David Wechsler's broad definition of intelligence comes to mind. Among the many facets of an adult's intelligence, he includes an ability 'to deal effectively with (his) social environment'.[6] This might, of course, be extended back to childhood and the social environment as cultivator and promoter of a child's autonomy as an essential ingredient for the development of perceptual articulation of self. It is of special interest to psycho-social diagnostics that early signs of difficulties in self-distinction and in perceptual articulation of self can be discerned through art therapy technique. And it is of particular interest to art therapy that such signs can be visually perceived on the ubiquitous scribble when studied phenomenologically.

On the whole, the larger group of 78 scribbles was composed of good responses, in the sense of the 'gute Gestalt'. In a variety of degrees of energy, intelligence, perceptual articulation, and integration, these scribbles met the original instruction. Among the authors of this group of scribbles were some clients in art therapy or in psychotherapy. Their scribbles attested to some of the difficulties, but also to their abilities to cope individually and socially. Some of these clients put the scribble technique to therapeutic use, as will be exemplified in the course of the chapter. We turn now to the study of the small group of scribbles.

Twenty-Two 'Different' Scribbles

It will be remembered that these scribbles were separated as a group because of conspicuous differences that generally marked them in relation to the larger group of scribbles. To visibly share this observation with the readers, a sample of eight (out of the 22) is shown, with brief notes taken when the scribbles were made.

Although each of the sample scribbles is highly individualistic in style, they share shortcomings caused by inadequate structures of their scribbles and inadequate conceptual articulation of selves. To begin with, most of the scribble creators – six out of eight in the sample and a total of 15 out of the 22 – encountered difficulties in drawing the scribble despite successful participation in the guided exercise that preceded the making of a scribble. The structures of scribbles they made represent Everyday Life Worlds; that is, socio-cultural environments with too little room for autonomically grow-

6 Wechsler, David, *The Measurement and Appraisal of Adult Intelligence*, 5th Ed., Williams & Williams, Baltimore, MD, 1972, p. 79.

ing selves. Thus, their scribbles came out distorted, aborted, fragmented, too confused to deal with, in violence against self, serving some specific disturbed aspects of self, denying realities, fighting rules and conformity, or projecting an experientially overwhelming moment.

Shared Features

The shared features of the group of 22 were:

1. Extreme deviation from the model scribble.
2. Structures of scribbles too tangled for finding shapes.
3. Limited use of the given space.
4. Crowding scribbles in small preferred spaces.
5. Scribble lines not flowing, often scattered.
6. Obsessional images.
7. Most of the scribble makers could not arrive at integrated pictures.

All the scribble authors, represented by the eight examples, were in therapy for treatment of their difficulties at home, at school or at work, and in the few social contacts they had. The What-Do-You-See? procedure helped them recognize the conspicuous features of their scribbles that, in turn, became subjects for therapeutic treatment.

Figure 29. Scribble B. Done by an intelligent female alcoholic obsessively drawing her 'scribble' with no concept of shapes other than turned down loops. Her own question, 'Do I have to go to the end?' stopped the process. Original on 18" x 24" sheet.

Figure 30. Scribble C. A jumbled line drawing by a depressed and aggressive young woman is concentrated in the lower half of the surface and on its left side. The only shape is, repeatedly, the letter L. No painting or colour. Original on 18″ x 24″ sheet.

Figure 31. Scribble D. By a scared eight-year-old girl, this is a hastily drawn pattern of unrelated marks in a number of directions. No continuity, no shapes, or painting. Original on 18″ x 24″ sheet.

Figure 32. Scribble E. This was drawn by an obsessive young man as a continuous line with multiple loops. The only shapes are of the number 8. No painting or colour. Original on 18" x 24" sheet.

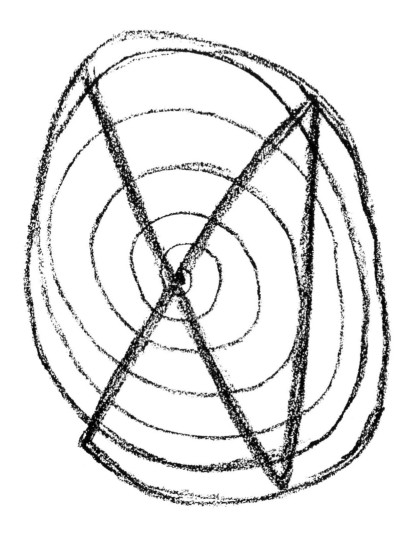

Figure 33. Scribble F. Drawn by an angry young man who started from the inside. The line grew heavier as it approached the outside and became quite heavy when it took a sudden turn into and across the scribble. No shape was found, no painting was made. Original on 18" x 24" sheet.

*Figure 34. Scribble H. This was made with red crayon by a very bright and very upset
10-year-old boy. Underneath this 'scribble' is a fine, continuous scribble flowing in a wavy
and rounded line. He omitted looking for shapes and proceeded to overlay the scribble with
a systematic sequence of dark colours upon light ones, with coloured chalks. Then he topped
the surface with black poster paint. When it dried, he added the strokes with white chalk
saying, 'These are my marks of anger'. Original on 18" x 24" sheet.*

Diagnostic Uses of the Scribble

By their very structure these scribbles did not offer prospective shapes or
images and, thus, did not stimulate initiatives or attempts to relate to whatever
scribble there was on the surface. It seemed that most of these clients recorded
their anguish and pressing need for help in their depression, helpless anger,
obsessive patterns of behaviour, low self-esteem and inadequate conceptual
articulation. These states of mind were confirmed in the clients' individual
projective tests. Clinical observation and investigation of the rearing systems
and parenting patterns in their families confirmed what the study of these
clients' scribbles indicated: extreme authoritarian systems, extreme protective

systems, parental preoccupations to the exclusion of interest in a child's feelings, divisive or hostile home atmosphere, chaotic relationships, divisive strategies – any of these, alone or in combination, deprived the child of assured and guided autonomic development. This resulted in inadequate sense of selfhood, discomfort about relating to others, problems in carrying out social tasks, and a general state of personal unhappiness that the individuals themselves do not quite understand, knowing only that they feel socially discriminated against.

The application of the scribble to rearing and parenting systems in relation to patterns of autonomy for child and adolescent within families yielded helpful diagnostic information. Such information, in turn, was useful in therapeutic work with the parents.

Therapeutic Uses of the Scribble

We will now move from diagnostic to therapeutic considerations of the scribble.

I observed two kinds of therapeutic uses of clients' scribbles in my own work. One kind is the immediate use; the other kind points in the direction of deeper work with personality patterns and traits. The immediate or current use occurs when I briefly apply the What-Do-You-See? procedure after shapes have been defined on the scribble at hand. The client then briefly describes what she or he sees on the mounted scribble. This is in itself therapeutic, offering the client some perspective even as the process is on its way. The client is occasionally prompted to notice additional prospective shapes, thereby taking an additional step toward self-differentiation. I only listen and nod, casually helping the client resume the scribbling and then start the integrative painting. During the painting, I am the observer. I treat all clients and their scribbles in a similar way, even the type of scribble from the smaller group of twenty-two.

When the painting over the scribble is declared complete, my client and I treat it as we treat any art expression: again, we apply the What-Do-You-See? procedure, we look at the painting with concentration, the client describes what he or she sees, tells about the ways arrived at the present picture and recalls changes of ideas or plans and relates feelings. Very often clients talk about the scribble itself, how its turns and loops helped or hindered plans for the integrative painting and how they coped with difficulties. All of this is therapeutic because it confronts the client with small self-discoveries.

The long-range therapeutic use of the scribble is based on the diagnostic findings with regard to the structure of the scribble, self-distinction, auton-

omy patterns, figure and ground differentiations, change and choice, and integration. With clients who have difficulties in any of these areas, I use the scribble as a frequent therapeutic technique, each time also applying the What-Do-You-See? procedure, helping them compare the latest scribble with previous ones and discussing specific qualities and changes. I have seen improvements in self-articulation and change in many cases. For example, the client on the enclosed sample who obsessively saw the number 8 as a shape learned to vary the structure of his scribble and became a little more versatile about prospective shapes. He got away from seeing numbers and even humourized about it. And clients who readily integrated their scribble into a painting but left out certain shapes became sensitive to the unused shapes and questioned their meanings. By the time they arrive at the quest for meanings, clients are ready to volunteer their personal 'hunches', often related to their own feelings and functioning.

Such was the case of the woman who drew large identical shapes over her scribble instead of seeking prospective images inside it. Having made a few such scribbles and looking at all of them as a group, she used the expression 'impose upon' in the description of her scribbles, and went on to describe the background of the imposed shapes; that is, the scribble, as 'the people' and 'situations' in her life upon which she 'always imposed' her 'will'. Thus, it is important to watch for visual patterns in the scribbles; that is, features that reappear again and again.

Several adolescent clients established a new therapeutic use of the scribble when they adopted the technique as the sole vehicle of expression in art therapy. The combination of freedom and structure characteristic of the scribble parallels the adolescents' conflicting forces of autonomy and control. The scribble seems to offer to adolescents a symbolic arena for their struggle between order, chaos, or moderate autonomy, along with an effort to achieve some integration. An example of such use of the scribble is featured in the next chapter, a case study of a pre-anorexic girl and a report about a girl with Anorexia Nervosa.

Summary

The popular art therapy scribble technique has been examined for diagnostic and therapeutic purposes. In addition to Elinor Ulman's diagnostic use of the Scribble in her diagnostic drawings series, the scribble comes into its own in this chapter, as it is phenomenologically researched and as it offers a new perspective on the maturation of self within promoting or impeding psycho-social systems.

A sample of 100 scribbles, randomly selected from a collection of over 400, was separated into two groups in general adherence to the original Cane description and according to the therapist's instruction. The groups were then studied with regard to structure, role of shapes found, and integrative character of the painting. The concepts of figure-and-ground and perceptual articulation were applied to the discussion of the diagnostic potential of the scribble as an indicator of self-discernment, guided autonomy, and social maturation within a promoting or impeding social environment represented by scribble structure. In this sense, the scribble supplies new information for diagnostics and new possibilities for art therapy.

The Scribble as Art Therapy Treatment of Anorexia

Some clients adopt the scribble as a main vehicle of symbolic and therapeutic art expression. Such was the case of a 13-year-old whispering, pre-anorexic girl. She came willingly following her parents' conference with me. When I asked what brought her to me, she lowered her head and anxiously uttered, 'I am a reject'.

This pretty, slim-normal, precocious adolescent did not look anorexic. She appeared lost and sad. And she showed serious signs of potential anorexia in daily behaviour as well as on clinical personality tests, particularly in projective drawing tests, among them the scribble.

Early indications of nearly all known psychopathological anorexia features[1] of physical, conceptual and perceptual disturbance surfaced in her responses: concern about weight, feeding others, fear of psycho-sexual maturation, narrowing of interests, feeling uncomfortable with friends, worries about autonomy and dependency, and a heavy 'overlay' of anger over warmer feelings.

Growing difficulties at home and at school were also reported: slowness in getting ready for school, decrease in school performance and grades, neglect of household chores, not eating lunch, meticulously cutting up meat portions at dinner only to feed them to the dog, and a general sense of not

1 P E Garfinkel, M.D. and D.M. Garner, Ph.D., *Anorexia Nervosa, a Multidimensional Perspective*, Brunner-Mazel, NY, 1985.

being there, except for outbursts of anger when reminded of food and home or school duties. Some loss of weight was also noticed.

Despite a rather high IQ and very good vocabulary, words failed her in the initial interview as she repeated her self-dejecting 'reject' descriptions. However, when reminded of the special interest she showed in the scribble, one of the projective drawing assignments, she said in a lively voice, 'Yes. Can I do some more of those?'

Thus, the scribble became her most absorbing and most eloquent means of symbolic expression in curious structural combinations of line, shape and colour held together by grotesque figures populating the network of a scribble world she created. This structure became the basic format through-out most of her therapy of one year.

Each scribble painting presented a moment frozen in time, of an emo-tionally charged, dramatic situation among a group of grossly distorted human figures in preposterous postures and glaring colours. The collection of the client's scribble paintings takes the spectator into a universe of an inner, first-hand ongoing experience, at once emotional and highly symbolic, of a young imaginative adolescent caught in an emotional impasse within her family and school environment, and within herself.

The Scribble Paintings

The original scribble that initiated the year-long series was actually one of the projective drawing tests. The heavy outlines indicate shapes she was asked to find in it. She described them as 'just shapes'. However, the energetic swing of her arm during the making of the scribble and the serious search for shapes, along with the decisive motions when outlining them, were all in sharp contrast to the girl's general passivity, her stooped walk, stiff facial muscles, colourless tone of voice, and even the way she initially related to the 'just shapes'.

Also, the scribble itself, that is, its structure, was a visual surprise. It was not at all the flowing line, meandering in and out of occasional loops, described to her in the original instruction. Rather, it was a stormy, most irregular confusion of sharp-angled turns and unexpected twists, a most labile scribble. It exuded an angry energy which I have considered positive, albeit bordering on rage contained within itself. Also positive was the spread of the scribble over the whole sheet of the 24" x 18" white drawing paper. In the testing situation the girl had not been asked to make a painting over the scribble. That first scribble has become the prototype format for the rest of her most expressive art work.

She came once a week for about 90 minutes, immediately turned to the easel, produced her basic scribble, and silently proceeded to create the bizarre images with strange gestures and expressive facial features. She completed a picture within her therapy time, gazed at the production, responded to my motion guiding her to distance herself with me, from the picture. Her brief descriptions, quoted verbatim, are extended titles expressive of her own moods and feelings and those of other figures in relation to her.

Below is a selection of ten out of thirty-seven scribble paintings, and three post-scribble pictures of dreams. The scribble pictures are art expressions of stages in the girl's disturbance and therapy, created in her original, unique style, related to her inner experience.

In this group, the client's double identity symbolizes her inner division of physically tall but emotionally small and miserable. In most pictures in this group, the client is on the ground. These scribble pictures (see colour section) are presented in three small groups.

Group I, Figure 35 titled, '*No heat in the house. Cold. Everybody cold, mad, and miserable*'. The background for the scribble is light blue, the scribble line violet. Colours of images from left are violet, green, red, magenta, orange, blue. The artmaker herself is on the far left.

Figure 36, titled '*Earthquake. Walls cave in. A lot of panic*'. Colours: grey background, black scribble. Image colours from the left: green-blue, magenta, orange, dark red, dark blue. The artmaker is in the upper centre, upside-down.

This group of pictures conveys the girl's overwhelming fear of imminent, bodily-suffered disaster and her own abandonment.

Group II, Figure 37, titled '*Sternness and affection for pet*'. Grey background, black scribble. Image colours from the left: red-green with black overlay; image on the right: magenta-green; central image (artmaker as pet): blue-black.

Figure 38, titled '*Music, good time. But they don't see her*'. Yellow and pink background, scribble and music notes black. Image colours from the left: orange, blue, yellow, purple, red. The artmaker is red, on the far right.

Figure 39, titled '*Spaghetti spilled in cafeteria. Sternness. Principal mad. Fear*'. The artmaker is in the centre.

In this group of pictures, the early sense of home misery that assumed the dimensions of imminent global disaster narrows down to specified situations at home, in relation to siblings, and at school. The girl's division between Mother's unhelpful love for a 'pet' and Father's scary sternness; not being noticed by her happy siblings; and collapsing in fear at school – all this culminates in a scribble picture of a fantasized bank robbery (not shown

here) which also ends in disaster, the artmaker in a double role of a tall leader and a small one being apprehended by police (physically tall, but emotionally small and miserable), and crowds streaming behind them. In this group the double identity in images symbolizes the girl's inner divisions and conflicts.

Group III, Figure 40, titled '*Misery, mockery, and help*'. Grey background, black scribble. Image colours from left: on the far left, a violet 'creature is all fingers pointing at me', two orange figures, a brown one and many others. There is a central large blue-pink helping figure, and central small, the girl, coloured blue-black.

Group III, Figure 41, titled '*Complaints, madness, anger, my guilt*'. The white drawing sheet is the background, the black scribble is incomplete. The central image is in magenta, other images are not entirely coloured. The girl, the only human – this time not humanoid – in the picture, is facing her responsibility to the family pets that she has long neglected. In her dream, they gather around her bed demanding her attention.

There are some differences about this picture: the girl is alone; her face is realistic and open-eyed; the animals are not quite distorted; there is no colour background; and the scribble is not quite complete and is made in haste as though it were no longer important. After this picture, the artmaker quietly abandoned the scribble with no formal announcement about it. The few pictures that followed were painted directly on the same size 24" x 18" white sheets of drawing paper, with no return to the scribble.

The girl drew three dreams she had dreamed. The first picture is not titled but described.

Figure 42. She had fallen off a floating board in a stormy sea. Trying to swim to safety, she fears being overrun by the big boat. The captain of the boat does not see her and the waves are pushing her under. Suddenly, waiting on the shore are her brother and sister. The girl woke up, fell asleep again and dreamed a second dream.

Figure 43, this time titled '*My brother rescued me*'. In this picture, in contrast to the previous one, the sea is blue and more peaceful, as her brother makes his way among abandoned boards, his sister on his back.

Figure 44, a third dream, titled, '*Fear and Hope*', is a picture of green and brown hilly grounds. A wildly overgrown tree (a "prop" from the family backyard) spreads over the width of the picture and the blue sky. The dreamer is lost in the tree tangles. Overwhelmed with fear, she tries to scream, but no sound comes out of her throat. She only hopes that her brother will rescue her again. She hears a rustling of leaves and the cracking of dried branches that someone was breaking off as her brother appears, the full figure on the left. Interestingly, when the picture was completed, the artmaker playfully

added a blue scribble over it. 'That's to remember the scribble,' she commented, smiling.

Awakening

The group of post-scribble dream pictures brought forth a new curiosity in the girl, and an equally new speech facility that grew into rich self-disclosure. She wanted 'to know', needed 'to understand', and wondered what had happened to her and where she was 'now'. Why had she 'given up' the scribble? Why did she stop painting the 'strange people?' she asked.

We turned back to the collection of scribble pictures. The girl sorted out and put together pictures that shared themes and variations on the themes in order to arrange them in the groups described above.

As each group of pictures was mounted on the wall or spread on the floor, she looked, reminisced, and discovered. We discussed the structure of the paintings, the functions of the scribble and her need to use it, as well as the time of its abandonment. We talked about the 'strange people' and the role of distortion. The main part of these discussions was devoted to anorexia and pre-anorexia, and to normal features of adolescence and the special difficulties 'teenage' posed for her.

These discussions were informal and unstructured, yet they centred on the unannounced focus of 'how it felt'. The client took the lead and was quite eloquent. Below are some of her feelings and thoughts, here abbreviated.

She liked to draw silently and liked the way I let her go about it by allowing her 'to be', by being there when she 'needed a colour or another sheet of paper', and by not asking her questions. When she 'talked so little', she appreciated the suggestion to do art, and was glad that I 'didn't mind' and '…maybe, I wanted to see if you thought that I was really an imbecile'. But my serious attitude about her pictures and about the way we handled them together put her worry about that aside.

She 'talked a lot to (her) pictures', though. And, at times, 'almost heard these people say things' to her. 'They sort of argued with me…about how I live.' In answer to my question as to how she answered their arguments, she said, 'Well, sometimes I shouted back, kind of, that they are like me; but then I knew they couldn't help it because I put them there, anyway.'

More about the 'strange people': at first she 'made them strange' in anger, but then, in the course of her work, she 'got to like them' and derived much pleasure from the art style that she developed on her own. Also, some of these people made her feel 'sometimes angry, sometimes creepy, sometimes nasty'. But other times she felt 'a lot of power' over all of them, 'like that

Figure 35. No heat in the house. Cold. Everybody cold, mad, and miserable

Figure 36. Earthquake. Walls cave in. A lot of panic

Figure 37. Sternness and affection for pet

Figure 38. Music, good time. But they don't see her

Figure 39. Spaghetti spilled in cafeteria. Sternness. Principal mad. Fear

Figure 40. Misery, mockery, and help

Figure 41. Complaints, madness, anger, my guilt

Figure 42

Figure 43. My brother rescued me

Figure 44. Fear and Hope

principal in the spaghetti picture' who was a part of her, even though she was also the figure that collapsed. Most of the time, however, she appeared in the pictures as the weakest, often upside-down or prostrate person. When she made that person stand up in another picture, she was glad and felt that something good happened 'for a change'.

A few themes issued by the scribble paintings and by the painter herself are of special salience to art psychotherapeutic work and will now be considered.

The Scribble, Role and Symbolic Meaning

Diagnostically, the client's early scribbles and those underlying the scribble pictures starting with Figure 35 are diagrams of the family environment where her panic started, and of the world where her panic grew. The crowded lines, twists, and sharp turns convey the young girl's anguish under the impact of the many contrasts and pressures at home, and inside herself.

There was the distance, 'kind of cold', between the parents, yet both were devoted to the children's health and every physical and educational need; and Father's sternness, but Mother's 'wrong' kind of constant attention that might be professionally described as ineffective; and the client herself, having friends but feeling uncomfortable among them and embarrassed at their talk about boys. She was growing tall and menstruated, but felt that she shouldn't be. She wanted to behave like her older sisters, but was unable to do so and truly regretted that she was not the youngest in the family who had no such problems.

Clearly, the family structure was unable, at the time, to promote the atmosphere for the girl's growing sense of self-articulation, or help her gain a conceptual image of a teenager on the way to adulthood, and to provide for her encouragement and guidance in progressive autonomic growth. In her emotional turmoil, and despite good physical care, the girl stood alone and lost.

Therapeutically, the scribble served her well. The full freedom to shape it allowed her even to ignore the instruction about the scribble as a flowing line. She put into it all the energy of her controlled emotions, all her unused imagination and talent, her fantasies and dreams, all of herself.

As the number of scribble pictures grew, the structure of the underlying scribble changed from complex and rather ferocious to mild and simple. This development coincided with some positive changes in the family environment and the girl's response to those changes due to therapeutic work with the parents.

Humanoid Imagery

The client populated her pictures with many 'strange people', as she described them. These were bizarre human images materializing in the nooks and crannies of the complex scribbles and announcing their presence with loud, shrieking colours.

The chromatic quality of these humanoid images speaks of the artmaker's emotions, 'the hurts', as she named them, and 'the mockeries'. There are very few of the soft or muted colours. Thus, a first visual perception of a number of the scribble pictures displayed together is one of a striking variety of harsh colours, holding one's eye with an impact of a disturbing colour liveliness. Bizarreness of posture and movement contribute to these impressions, accentuated by the prominent scribble lines that seem to hold it all together.

The overall symbolism of the unique structure of the young girl's art work suggests an intensive inner experience of a budding personality caught in an aggravated process of maturation and struggling with tenuous psychological forces beyond a child's ability to cope with them. And the specific structure of the scribbles indicates the difficult psycho-social home environment.

On one level of symbolism, the images in their peculiar postures might represent the girl's struggling forces within. On another level, they also represent her sense and need of being a member of the family at all times; hence, the constant groups of 'people', somehow connected, in the pictures. On both levels of symbolism, the scribble functions as a compressing keeper of it all and also as a boundary to shield the artmaker from loss of control, something she was very afraid of.

The scribble also functioned as a mirror for the artmaker. In that mirror, she saw herself in fear and guilt, in fantasy succumbing to an aberration that carried an illusory promise of power, and she also saw herself gaining authentic strength to rise. The ability to observe herself in her pictures became a source of gradual self-articulation and of a beginning of autonomous functioning in what used to be for her a labyrinth of the family and school environments.

This growth, at first not noticeable in life, showed its early signs in the art work and its components: the scribbles began to be somewhat rounder, the turns less sharp, the twists more wavelike. Some scribbles emerged bi-coloured, a synthesis, or compromise, as it were. The scribble picture of the animal dream was not bizarre. In it, the dreamer had wide-open eyes. She listened to the animals' unhappiness, not to her own perpetual misery. These early signs of growth and of reaching out into the world developed into discernible changes: the abandonment of the scribble, and the new series of pictures with no need for the scribble or for the 'strange people'. In the

compressed scribble, the girl found herself. The scribble accomplished its mission.

Art Expression in Anorexia Nervosa

In another case, one of fully developed anorexia nervosa,[2] the adolescent girl was rapidly losing weight and her lifestyle changed radically. She wore strange adult women's costumes and high heels as though that would magically help her to skip adolescence and reach adulthood. A good student in the past, she attended school, but no longer cared for learning or grades or friends. She was emaciated and complained about being cold in warm weather, and was very sad. Referred by her physicians, she came for psychological treatment. Not willing to talk, she was quite affable with art materials and responded well to the phenomenological method of guided looking at her paintings and sculptures, and reflecting upon them.

Clusters of pictures and clay productions marked distinct stages in her inner experience of anorexia. In the beginning of her visits, she drew and painted pictures of herself or her house in storms or tornadoes. Then came a group of sculptures of queens in power, symbolizing the child who takes over when adults don't. That, however, was followed by pictures of isolation and loneliness.

As she was losing more weight and felt weaker, she began to draw a series of stop sign pictures[3] to let the therapist know that 'the queen' was losing control and power and was no longer able to stop her relentless race to thinness. At that time, she painted her most expressive picture of 'the dog', an image of herself in her art work, 'crossing the hills and he doesn't know if he can make it'. The time on the picture is sundown.

As her weight was nearing the critical limit, the girl was hospitalized for a medically supervised return to a normal diet and eating habits and was released after two weeks only, to return to psychotherapy. She came back well fed and with a keen sense of self 'before and after' as she titled some of her pictures.

One of the many post-hospitalization pictures, 'The Two Girls',[4] is a stage of reflective art expression about the change. Each time she came in for her weekly therapy hour, she drew a dividing line decisively down the drawing

2 See 'Diane' in Mala Betensky, *Self-Discovery Through Self-Expression*, Charles C. Thomas, 1973, pp. 207–243.

3 *Ibid.*, Color Plate XXI.

4 *Ibid.*, Color Plate XXII.

paper, and painted her tense anorexic self on the left and the new, normal teenager grinning on the right.

By facilitating free art expression of the experience of anorexia in all its stages and the methodical application of the art of looking at them, the anorexic adolescent was emotionally and cognitively guided to her inner readiness for change. That readiness helped her cooperate with the medical treatment, shorten her stay in the hospital, and return to normalcy.

A Schizoid Episode in Scribbles

Early in her senior year E, a seventeen-year-old high school pupil, came in for her first session in art psychotherapy, just as her Father was telephoning to inquire whether his daughter had arrived. E smiled ironically about his caring call and said, 'He doesn't really know what goes on with me. He is just trying to impress you.' She then wondered whether 'it is true' that she wouldn't 'have to talk right away', but that she could draw. Obese, pretty, and clean, she wore much-patched jeans and shirt tired from laundering as she looked directly at the therapist, challenging criticism of her appearance.

E was shown the art materials and she smiled to the colours but chose a black crayon, a charcoal grey pastel, a few 18" x 12" sheets of white drawing paper, and settled down to draw quickly and decisively, like one familiar with the images that appeared on the papers.

E came twice that week for two 90-minute sessions, all devoted to silent drawing. Even before the Scribble was introduced to her, she began each drawing with a scribble that resembled the Cane model of a Scribble, though hers had weak and often vague scribble lines on most of her drawings. Her scribbles were also vague and suggestive of a weak supportive family system. She drew her images over the scribbles and skipped finding things in the scribbles.

Clearly, she was working on a series. After the first completed picture, which I mounted on the wall, she immediately turned to the next one and mounted that and all the others, until the series grew to six. Thus, we started with a serial treatment even before she let the therapist in on any of her difficulties.

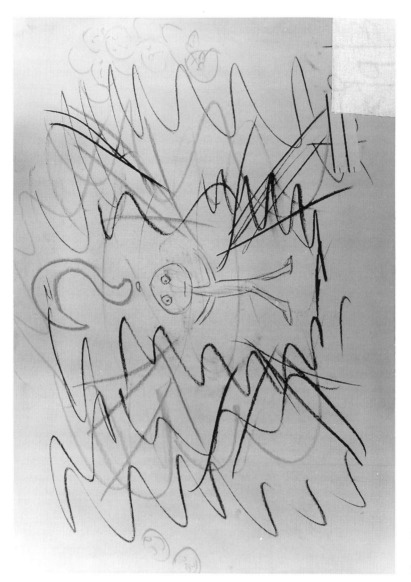

Figure 45

When the What-Do-You-See? procedure was described and explained to her, she uttered a pleasant 'oh' and, after a long, silent gaze at the series, she indicated her readiness to describe her pictures.

Th: What do you see, E?

E: I see six pictures of what happened to me over a week ago, every night just as I was getting ready to go to bed, at about midnight. These 'things' scared me terribly. I think that they really happened or I wouldn't remember them so well. That's why I finally agreed to come here, to find out. My Dad does not know anything about what happened to me and what I drew here.

Th: Now, let's begin with your first picture. Concentrate on it a while. What do you see? (see Figure 45)

E: I started with these scribbles for a background. I know scribbles from the art teacher at school. But this first one is not a scribble. On top of it and from inside it, it's just lines, not connected. The first happening started with these lines, heavy and sharp, kind of shooting at me. I am in the middle (*pause*). I don't have hands, and there is fear in my eyes, and I couldn't run because the line crowded at my feet (*pause*) so I just stood, terrified.

Th: How do you see it now?

E: As I see it now, I look like a little naked kid, an underdeveloped kid with a big head. while I drew it, I asked inside me, 'Is that me?' And so I put this huge question mark above my head and, as I see it now, the question mark might be the beak of some bird of prey.

Th: what about the round little things on the right side? I don't see them well, do you?

E: Oh, yes, I don't know when I put them in. I just noticed them now. They are the little heads that I saw at night. They are scary. Now I see two more on the left…they are no good, kind of mocking. (Turns to Figure 46) I like this scribble. It's different. It's quiet with these round lines, like playful (*pause*) but then there is this straight line across, a cut-off, just below the middle of my legs.

Th: If this line spoke up, what might it say to you?

E: I can hear it say, 'What are you doing here in this nice pleasant scribble. Get off. Go to your ghosts! Don't you see that you are different?'

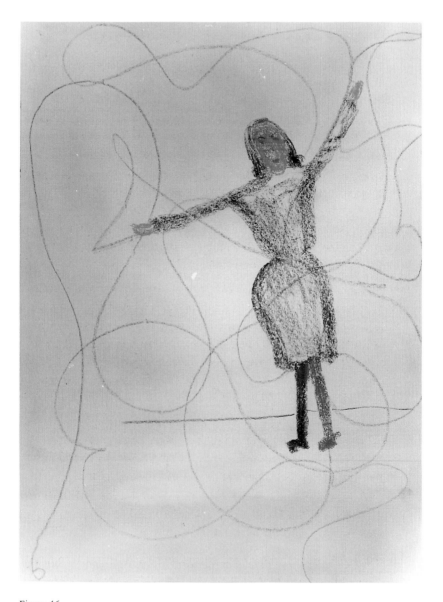

Figure 46

Th: And the girl in the scribble, what about her?

E: Well, she tried to be her age, not that crazy kid in the first picture. She wears a dress, and she started to hop or dance, but she was suddenly pulled up and she can't control it…and I can't…my face is dark and frightened…

Th: You said something about being different – can you take a good look at the picture again to see just what suggests differences?

E: Well, I see one difference between the round lines and this straight one: the rounded ones go somewhere, but the straight one doesn't, because it suddenly stops. Oh, and I see that the girl began to be happy, but she lost control. Oh, and there is this light background of the scribble, so different from the dark figure of the girl; and maybe, if you can see, some light mood in the centre of the girl clashing with fear that kind of frames her. Are contrasts in a person bad? And do the bad parts always win? That's another thing I must find out.

Th: All humans have contrasts. We try to examine them to see if the bad ones are really bad and the good ones really good…and we learn to live with them so that there is no constant struggle. For kids your age, it is upsetting to live with contrasts. We will try to work through that gradually. Your pictures are a helpful beginning. Let us both look with concentration at the next one. What do you see? (Figure 47)

E: I don't remember where I started this scribble. It is all closed. And I don't think that I saw it at night. I just started to make the scribble and it suggested this face, the single scared eye and the empty space for the other eye (*pause*) it looks like a Picasso. And, oh, his distorted faces always scared me. I think that this is my self-portrait. But why did I suddenly draw myself?

Th: Yes, why? What comes to mind?

E: (*Looking back at the earlier pictures*) I guess, maybe I needed to draw myself more grown-up, after those two – the naked baby, then this flying girl…This is a portrait of a woman, and it is scary…

Th: What about it is scary?

E: Well, if I saw it in an art book, I would say that this is an interesting way to draw a portrait with one movement of the crayon, but if it is myself, then I dread to think that I look at the

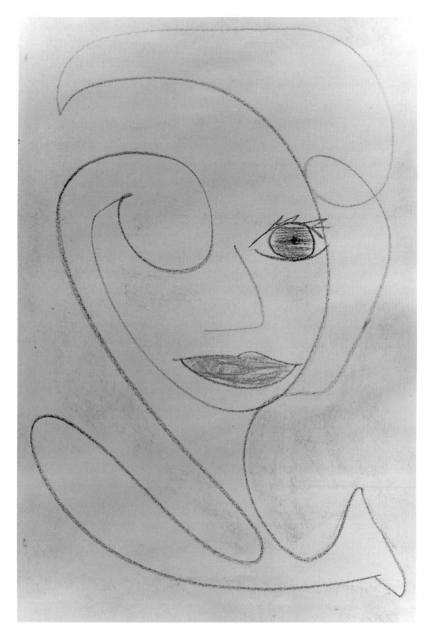

Figure 47

world with one eye only (*pause*) and it is such a scared eye (*suddenly turning to the next picture* (Figure 48) E *looking at it a long time, finally nodding.*)

Th: What do you see?

E: This one happened the night before last. I think it was real. And it happened two and three nights before, too. I am seated on the bed leaning on a pillow, knees up, enclosed in some narrow, closed-in-place like a cell or a cave, or maybe in my room in my Dad's and Stepmother's new house where I live. I am scared to look at my left-hand wall. On the picture it is this heavy wavy line. It was shaking. Behind it, or on the side of it, on top of a funny window or balcony of this tall tower or maybe a ghost's vehicle, were these two ghost creatures, teasing. Perhaps these were some of those little mocking faces from the other picture (*see* Figure 51). They were going to come at me right then. That's why the wall was shaking, to warn me. I wanted to pull my pillow and throw it at them, but I couldn't. So I sit there like nailed down.

Th: What else to you see on the picture?

E: Well, there are all sorts of lines, thin, thick, and wavy ones in the scribble, but I don't see anything in them and I don't remember whether they were there at night (*turns to next picture, see* Figure 49).

In this one my head is separated from my body, which remained in the cave. The arms and legs are free now, but they can't do anything because the head is not there to make decisions and to think thoughts about what to do. I see now that the body is turning toward the head, perhaps to be joined again? The head looks pretty good. It has all the features and clear eyes, and hair, and a neck to fit into the body.

Th: In what kind of place is the head? Can you see?

E: (*Searching*) Now I see some kind of an angel with arms on this part of the scribble, and with a large rounded wing turning to the separated body. This here is the angel's head, and my head is right underneath it. (*Turns back to* Figure 47) As I look at this again, I see very clearly the scribble lines that you noticed before. Now I see two large profiles turned toward each other, not

Figure 48

Figure 49

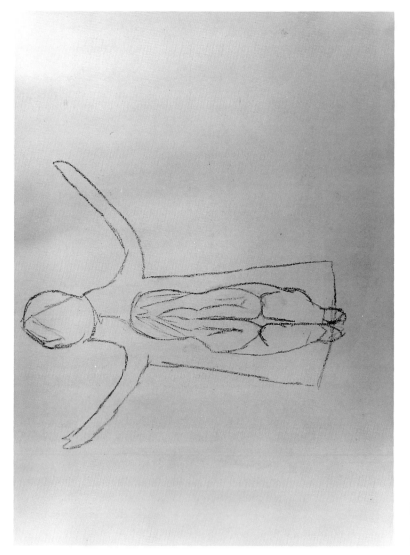

Figure 50

actually looking at each other, but turning toward the kid in the cave.

Th: Can you describe these profiles, each by itself?

E: The one on the kid's left is thick, soft and wavy. Now I see it as a woman's profile, perhaps trying to speak to the kid. If you look from this line to the end of the paper, the whole area becomes the woman's head and in it, high up, is a little ghost creature. And even the two scary mocking ghosts and even the tower, are all in the woman's head.

Th: How about the other profile?

E: That is a different kind of line. Actually, that area is also a shape now, but it is less human. Its mouth is shut, his nose almost meek – near the woman's nose; his is stronger, but she is more alive. (*Long silence, then suddenly*) Do you think that they are my Mother and Father? They have been divorced a long time now, you know. (*Abruptly turns to the next picture*, Figure 50) Here I am out of the cave, but what? Am I mad? Was she mad? You see, my Mother, she throws her arms up again. She can't do anything! She was always that way, could never do a thing! (*Crying*) How do these pictures help?

Th: Take a quick look at the series you have drawn – and don't be embarrassed about crying, it's OK – now *see* then *say* if the pictures already helped you in any way.

E: Well, about the crying – see, I never cry. I can say that all these fears are now like bad memories. I think that all these pictures were like hallucinations that I felt I must draw at once, remember? I found out in these pictures that what I was never told but felt must be true, that my mother was sick or very, very disturbed. So how could she take care of two little children, my sister and me, all by herself? And I always thought that everything was my fault...

Th: You found out many things in your pictures. These things are so important that you may call them discoveries, self-discoveries.

E: (*Whispering*) self-discoveries...self-discoveries... Do you ever tell what *you* see in somebody's pictures?

Th: No, see, I don't really know what personal things are in their pictures. But I believe that a person's experience inside prompts

her or him to draw their pictures. So I try to help you see and notice all that can be seen and noticed in your pictures. I help people see lines, shapes, colours or shadings, and also see what goes on among them. These may well be their feelings, memories and thoughts. The pictures help you put it all together. And then, if you are ready, we talk about it.

E: That's a neat way. I remember that before I came to you I made up my mind that if you make me talk, I will never come back (*laughing*).

E continued to come twice a week for a while. She reported that the hallucinations had not come back and that she slept well. She felt a need to go way back to early childhood at home in another state. Thus, her paintings were now colourful and spreading on large sheets of drawing paper. There were hilly landscapes, flowers, brooks, and playful children.

During that span of therapy, she discovered among the art materials a box full of small shiny blocks in a variety of colours. These blocks became her building material for quite original castle structures with towers and turrets. And noticeable was her pattern of placing one block precariously perched on the top of a turret when the castle was almost completed. She then watched with morbid excitement the little block struggling to survive, its ominous fall and with it, the destruction of the castle.

'Let's look at your castles the way we look at your pictures,' I suggested one day. Evasively, or perhaps trying to play the role of therapist, E asked what interested me most about her castles. I liked the imaginative style of her castles, I told her, but I was most interested in that one little block whose fate was to bring down every castle with its own fall. There was no direct answer. As her time was almost up, she uttered, 'Oh, my trouble is to talk about my troubles,' and left. There were no more castles built.

Perhaps the castle period and the brief verbal exchange about it ushered in a new series of drawings radically different from the first series, simpler and less artistic. This was a series in shapes that were somewhat scribbled and heavily shaded. Simple as the shapes themselves were, they carried messages they actually announced, for all of them were titled, some in print, others in cursive writing. All this was suggestive of E's felt need to deal with specific problems that she, personally, had to come to grips with, instead of the global suffering and detachment that she had used as a refuge for too long. I suggested that she draw shapes to express what she felt and thought.

Figure 51 simply states a fenced-in relationship between Father and his wife leaving E 'out'. Figures and 'fence' are heavily shaded, indicating a high

Figure 51

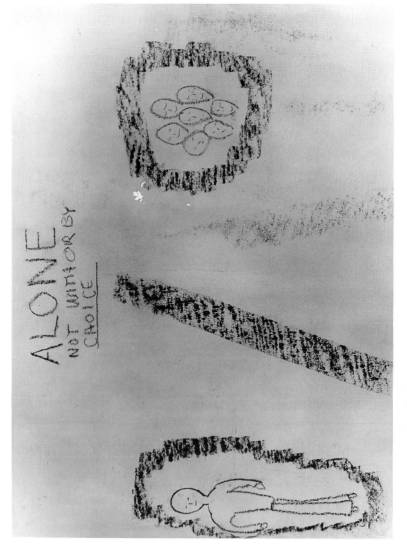

Figure 52. Alone, not with or by choice

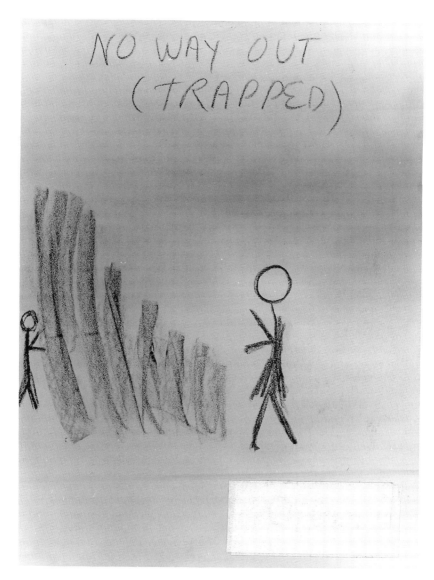

Figure 53. No Way Out (Trapped)

degree of E's anxiety. In her loneliness, E stated that she feels awkward around 'people who have each other'.

Figure 52 'Alone, not with or by choice', underscores E's feeling of being excluded and lonely. Father, the leaning column, turns away from E towards his wife, the pale grey column, her 'greyness' meaning 'the impatience and anger with me for my sloppiness and my lack of participation in the household chores'. On the right is a cohesive group of friends she 'used to have long ago', now closed to her and leaving her out, framed in the lonely fear. The person on the left resembles E's first picture of the 'naked kid'.

Figure 53 is titled 'No Way Out (Trapped)'. Looking at it from left to right, E sees herself in the small figure on the left, 'behind some huge barriers or blocks set up for me to be trapped'.

Th: Now, let's try to look at your picture from right to left, can you do that?

E: You mean to start from this big person and go to the little one?

Th: Yes, what do you see now? Take your time, then describe what you see.

E: (*Gazing a long while in amazement*) The barriers start small and they grow bigger and heavier as they come closer to the little person, and the big person doesn't push them, doesn't touch them! And the largest block is nearly falling on the little person and I don't see whether she tries to push it away. What do *you* see, and what do *you* think it means?

Th: Well, the meanings are in your eyes and mind because you experience that which makes you draw your pictures. I am only helping you to arrive at your own meanings. And now, to help you do that, try to look at the two persons in your picture, just those two. Who might they be? Take a long look at them – and what do you see?

E: (*Gazing at the figures*) Perhaps, on the left, I am the little girl who lets the barriers grow until she is unable to bear it? And on the right, I as a grown-up girl, look at how the barriers grew, what they did to me, and (*tears*) what happened to me, how I am now?

Th: How you are now?

E: (*Shouting, in tears*) You see me, don't you? My sloppy clothes, my weight, skipping school all the time, lying to my Father about notes from school and hating him all the time. I even put him in a

Figure 54. Sunday in the garden

cage in a picture I drew at home and decided not to show it to
you…and I will flunk out of school for sure and never even
graduate…

A new chapter in E's therapy had just started. It seemed that the secretive
part of self that she had angrily and proudly cultivated and jealously kept
away from the therapist could no longer remain hidden. The adolescent girl
began to face herself, despite the emotional difficulty of taking the risk of
giving up the destructive power that she had developed in order to survive
the permanent emotional injuries suffered in childhood and adolescence.

Figure 54, one of her busy new-style scribble drawings of the post-schiz-
oid therapy, titled 'Sunday in the Garden', represents E's struggle with her
inner destructive forces. On an early spring Sunday, gardening proceeds
energetically while she, with her back to all the liveliness, weighs in her
mind whether there is still time for her 'to come back' – to family, to
normalcy, to her real self, her talents and intelligence, and to her dreams of
college and a profession, all symbolically represented in the digging of the
garden at the new house in the spring. She wondered whether 'the bad little
ghosts' were still intriguing her, perhaps even still 'working at' her, no longer
in hallucinations, but 'inside', against her better self, this time in reality.

E improved her school attendance and turned in all the homework that
was due. She took the summer school semester and graduated with good
grades. Her Very Superior IQ report with a letter from the therapist helped
her acceptance to the college of her choice. She went to visit with Mother
and sister to develop a more open relationship with them and returned from
the visit with a feeling of belonging, but not wishing to live with them. She
went to register at college and, overwhelmed with a fear of the crowds of
students, ran out before the procedure was over. This, then, became the theme
for her next chapter in therapy.

Part IV

Art Expression for
Art Therapy Diagnostics

Diagnostic Aims

The aim of art therapy diagnostics is to tap personal resources not verbally accessible and to reach personality aspects that are particularly responsive to expressive arts: spontaneity, the ability to experience joy verbally and visually in colour and form, optimism, and self-assertion evoked by an art experience. The process of diagnostic assessment starts with accurately observing a client's behaviour. Such observation includes noticing and reporting the client's sensory reactions to art materials, choice of materials, particularly colours, reactions to suggested tasks, patterns of tension and relaxation at work in the variety of tasks, reactions to error and failure, reactions to the finished product, use of acquired learning in furthering the art work process, and self-discoveries during that process and during the client's viewing of the finished art work.

A few art therapists have provided the field of art therapy with some diagnostic programs for the assessment of children,[1] adults,[2] and families.[3] No diagnostic program in art therapy has been designed for adolescents as a special developmental group.

In this chapter, an attempt is made to further diagnostic work in art therapy by broadening its scope. Building on the work of other art therapists and my own diagnostic experience, I have added structured assignments to free diagnostic art work, designed a special program for art therapy assessment of pre-adolescents and adolescents, and included two standardized projective tests to enrich art therapy diagnostics with information contributed by psychologists and relevant to art therapy.

On Diagnostic Method

On the whole, the suggested program is, as is art therapy itself, based on the idea that to be scientific, diagnostics as well as research in art therapy do not

1 E. Kramer and J. Schehr. 'An Art Therapy Evaluation Session for Children,' *Am. Journal of Art Therapy*, 23:1, Oct. 1983. Also, J. A. Rubin, 'A Diagnostic Interview,' in *Child Art Therapy*, Van Nostrand Reinhold Co., 1978.

2 E. Ulman, 'A New Use of Art in Psychiatric Diagnosis,' *Bulletin of Art Therapy*, 4:3, 1965. Also published in *Art Therapy in Theory and Practice*, Schocken Books, NY, 1975, pp. 361–386.

3 H.Y. Kwiatkowska, *Family Therapy and Evaluation Through Art*. Charles C. Thomas, Springfield, IL, 1978.

have to be quantitative alone so long as we learn as much as possible about the subject of our study by a rigorous method of observation, description, and clear definition of what we learned. That said, we must also consider other diagnostic and research needs. For even though the descriptive qualitative method uniquely suits the nature of art therapy, art therapists in special settings such as psychiatric hospital wards need to contribute art therapy diagnostics in terms compatible with established psychiatric labels and codes. Recent developments attest to such needs.[4]

The Structured and the Unstructured

Rich as is the telling quality of a child's free, unstructured art work,[5] this is not all that can be learned about the child in art therapy evaluation. When bright and creative seven-year-old John disrupts group, class and family, yet is quite responsive to free diagnostic art work, during which he has the full attention of the diagnostician, observation will indeed tell us much about him; but it will also conceal his special difficulty. John cannot afford to grow up on his terms only, for his insistence on getting what he wants when he wants it will reappear at adolescence in more serious ways. To learn about this side of some children and in order to be able to help them, we must provide some structured art therapy tasks in the diagnostic program, as will be suggested below.

The program is built in the form of batteries for different age groups. Each battery has a number of both unstructured and structured diagnostic items, allowing the diagnostician to design smaller battery formats as needed. Some of the items on the batteries for adolescents and adults are time-consuming and, therefore, evaluation for these age groups may call for two or three hour-and-a-half sessions. It is important that the diagnostic sessions be task-oriented, continuous, and not interspersed with unrelated conversations or problems brought up by the client. Administration of diagnostics as well as observation are part of art therapy training, along with preparation of diagnostic reports.

4 Barry M. Cohen and Associates, 'The Diagnostic Drawing Series; a Systematic Approach to Art Therapy Evaluation and Research', The Mount Vernon Hospital, Alexandria, Va.

5 J. A. Rubin, *op.cit.*

Diagnostic Batteries for Children

Children, 3–6, 7

Materials: 12" x 9" white drawing paper, crayons, primary colours of poster paint in small jars, brushes, finger paint and suitable paper, small portions of clay; doll's house, flexible dolls of family, doctor, nurse; flexible animals, a few coloured blocks.

Time: about one hour

Items:

1. Let's see what these materials are.
2. Free drawings and paintings in colour.
3. Handling clay to make something.
4. Play with toys in doll's house and a story about it.
5. Draw your family (crayons).
6. What did you like to do best?

Administration and discussion:

1. Diagnostician says, 'See, we have here a few things for art and for play. Look at each and say what it is and what you can do with it. What is this?' If child answers correctly, diagnostician encourages continuation independently. If child does not know, diagnostician offers an answer and continues, checking back later to see if there was learning.

2. Picture making starts with white paper and crayons, followed
 by a picture with finger paints,[1] then a picture with brush
 and paint for the older children.[2] Note components used and
 developmental nature of pictures.

3. Clay work is important for the observation of regressive
 behaviour, sensory reactions, signs of creativity, and two- or
 three-dimensional work.[3]

4. Report all observations of play, silent and verbal. Is there a
 story and does it relate to play? Is there a central idea for the
 story?

5. Draw *your* family or *a* family with crayons is followed by
 diagnostician's, 'Tell me about your picture'. Child's
 description is recorded verbatim.

6. All the productions are displayed on the table or on the floor.
 Diagnostician says, 'We are finished now. You have made
 many things. Which do you like best? And what would you
 like to work with another time?'

Scoring is on a scale of 1–5 for each item. The chief criteria for
scoring, in addition to those discussed above, are liveliness (generally
and on specific items), a measure of energy or enthusiasm, ability to
follow instructions, expressivity with specific art materials, and flow
or coherence in stories and descriptions.

Children, 7–10[4]

Materials: crayons, Alphacolor pastels, poster paints and brushes,
white drawing paper 12" x 9" and 18" x 12", six 7" x 8" sheets of
white paper for H-T-P test, 24" x 18" newsprint, pipe cleaners, clay

1 A. Kadis, 'Finger-painting as a projective technique.' In Abt, L.E. and L. Bellak (Eds.),
 Projective Psychology, Knopf, NY, 1952, 403–431. Also, P. Napoli, 'Finger Painting.' In
 Anderson, H.H. and G. Anderson (Eds.), *An Introduction to Projective Techniques*,
 Prentice-Hall, NY, 1951, 386–415.

2 R. Alschuler and I.W. Hattwick. *Painting and Personality*, Vols. 1 and 2, Univ. of Chicago
 Press, 1947. Also, V. Lowenfeld and W.I. Brittain. *Creative and Mental Growth*, MacMillan,
 NY, 1957.

3 C. Golomb, *Young Children's Sculpture and Drawing*, Harvard Univ. Press, Cambridge, Mass.,
 1974.

4 Some 10-year-old children may be considered pre-adolescents. See Battery for
 Pre-Adolescents and Adolescents.

Time: One-and-a-half to two hours

Items:

1. Informally guided play-experimentation with painting art materials.

2. Free picture in colour, free choice of materials and paper.

3. Make a scribble on 24" x 18" newsprint paper, then find a shape or shapes (painting over scribble *not required*).

4. On 18" x 12" paper make a picture of *your* family or of *a* family.

5a. Work a little bit with these pipe cleaners.

5b. Now work with clay – free modelling.

6. The House-Tree-Person (H-T-P) with pencil and with crayons.

7. The 'Grouping Game'.

Administration and Discussion

1. For rationale and suggestions see Part I, Chapter Two, *The Phenomenological Method of Art Therapy*. The chapter offers a detailed sequence of steps and their therapeutic value.

2. The time to offer an 18" x 12" drawing paper for a free picture in colour is when diagnostician observes a transition from play–experimentation to art work. Drawing materials and colours are freely chosen. The picture is taped on the wall or easel for the What-Do-You-See? procedure, limited to client's description only, to be reported verbatim.

3. The explanation of the scribble and demonstration of an imaginary scribble with client's participation is the structured part of this assignment. The free part consists of making a scribble, finding a shape or shapes in it, then outlining and describing the shapes. That is when the scribble assignment terminates for children. The evaluative meaning of this reduced scribble task is the level of the child's readiness to discern small entities within a larger complex and thus bestow upon them a measure of autonomic existence within that complex.

Diagnostically, the child's ease or difficulty with this part of the task parallels his ease or difficulty with autonomic growth in the Everyday Life World. On the other hand, the nature of the child's scribble as compared with the original instructive explanation and description of a scribble might tell something about that child's life-world with regard to promotion or hindrance of his autonomic growth. In addition, performance of the scribble may indicate the child's ability to perform according to specific instruction. (For more on this, see Part II, *The Scribble Annotated*.)

4. The alternative of making a picture of *a family* to making one of *your family* was inspired by Kramer's[5] omission of family picture assignments because of that author's sensitive concern for children who have no families. 'Family' is, however, an ever-present concept and image in all children's most private existence, concretely and in imaginary ways. Rather than leave the pain of not having a family to a child's or adolescent's lonely suppression or avoidance, I have tried to offer opportunities to deal with the concept of family by visual art expression in whatever form that suits the child.

One child extended his family feeling to a stepbrother, an uncle, the dog and a teacher, saying, 'She is my school teacher, but I just wanted to put her in my picture'. Another child made a picture of a pet family, the cat and her new litter of kittens, in response to 'a family picture'. And a number of children and adolescents from concentration camps drew their families 'as they used to be, at home', a home that no longer existed, but remained very much alive in memory. These and some other bereaved children accepted the *your* or *a* family picture assignment with a matter-of-fact attitude and often with relief.

When family pictures feature parents, siblings, and even family pets, I often ask the child or adolescent to draw lines of special closeness among any two figures in the picture

5 E. Kramer and J. Schehr. *Op. cit.*

('Who has to do with whom?').[6] Even fairly young children understood the request and immediately drew lines connecting a parent with one of the children, two of the siblings, or even a sibling with a pet. Upon close examination of two connected figures one may notice some shared identical component, such as colour.

5. Free play with pipe cleaners, flat but of material that can be formed into three-dimensional shapes, promotes a transition to the true three-dimensionality of clay. The malleable clay evokes sensory feelings new to a child. Some of those feelings give rise to creative work, others evoke regression. Many learning situations occur in clay work as well. It is important, therefore, to observe the child's ability to assimilate new information in the process of art work with clay. Being a responsive material, clay also offers opportunities for creative inventions and artistic devices, challenging the child client's curiosity and daring to take risks and to cope with this 'live' material. Observing such responses and initiatives as clients work with clay offers much information about them.

6. The House-Tree-Person Test,[7] Achromatic and Chromatic: This projective test, extended into a chromatic version, is here formally included in art therapy diagnostics. Children's responses are most surprising and gratifying as they react to the expressive power of colour.

The diagnostic format I developed for the administration of the test is as follows: when both series, the achromatic and the chromatic, are accomplished, the diagnostician mounts

6 For an example, see Mala Betensky, *Self-Discovery Through Self-Expression*, Charles C. Thomas Co., Springfield, IL, pp. 214–215, 1973.

7 John N. Buck, 'The H-T-P Technique, a Qualitative and Quantitative Scoring Manual', *Journal of Clinical Psychology*, Monograph Supplement No. 5, 1948. And John N. Buck, 'The H-T-P Test,' *J. Clinical Psychol.*, 4:151–159, 1948. And, J.N. Buck, 'Directions for administration of the achromatic-chromatic H-T-P,' *J. Clinical Psychol.*, 7:274–276, 1950. And, J.N. Buck, 'The quality of the quantity of the H-T-P,' *J. Clinical Psychol.*, 7:352–356, 1951. Also, E.F. Hammer, 'The House-Tree-Person Projective Drawing Technique: Content Interpretation' and 'The Chromatic H-T-P, a Deeper Personality-Tapping Technique', in E.F. Hammer, *The Clinical Application of Projective Drawings*, Charles C. Thomas, Springfield, IL, 1958, 5th Printing 1978, pp. 163–234.

Naive Descriptions of House (H) of H-T-P

H achromatic

Therapist's observation: hesitation, facial grimace; time before drawing: 80 sec.

This house? Just made it up. I never lived in this house. It's just a house. Who lives in it? Oh, just people... maybe...Mr. Smith and Mrs. Smith and their three sons, George, Kenny, and, oh...Terry. It's just any house.

(*Shoves it to me, then takes it back and adds hastily the two rows of windows.*)

After an 80-second-long hesitation and dissatisfied facial expression, the boy settled down to the drawing of a controlled, stereotypic, rather elongated building he 'just made up', and populated by 'just people'. The formal lines of the almost formal building devoid of intimacy, the long wall with no windows, the strange location of the entrance door, the much later hastily added windows, and the stereotypical chimney smoke – all suggest the boy's avoidance of an authentic experience of this house, or that he is obligingly responding to an unwanted assignment.

H chromatic

Therapist's observation: serious, decisive; time before drawing: 10 sec.

This little house is on fire. Inside, they were cooking, and something caught on and started the fire and it spread. Here, it's coming out from the windows and the door. The people, mother, father, and the kids, got out. The house is gone. It had a white door and the house was blue.

(*Keeps on looking at it, then hands the picture to me.*)

This decisively and quickly made picture presents an intimate home being consumed by fire from within. While the members of the family escaped bodily, the family structure has been destroyed. The size and colours of the house and the singled out 'white door' indicate a sense of loss of what had been. The pointed roof and shape of the house, resembling a small countryside church, also suggest feelings of mourning and loss.

both vertically on the wall in parallel columns. Thus, each of the picture sequences – House, Tree, Person – forms a horizontally situated pair of the same image, one in pencil, the other in colour. The What-Do-You-See? procedure is then applied to obtain the client's precise description of all that can be seen in each pair of images, in each series, and in both. The diagnostician may remind clients to notice omitted components by saying, 'I wonder about...or 'What about...'

H-T-P Further Discussion

Naive description and diagnostic description[8]

Clients' descriptions of their art productions and of their viewing experiences of the productions are of basic importance in art therapy diagnostics because the artmaker is the bearer of the experience. Thus, his or her experience is a phenomenon and so is the authentic description. Phenomenologically, we want to be as close to the phenomenon of each picture as possible as we try to learn about the person who is the artmaker. However, the artmaker's description, precise as it may be, is not a professional record in its wording. Being a description of a first-hand experience, it is a valuable raw material, subject to refinement in professional language. To become such a material for a diagnostic report, the client's naive description must be rephrased into a diagnostic description in concepts and terms shared by professionals in the relevant field. Nor should the rephrasing become an interpretation of the naive description according to any pre-conceived theory. Above is a partial sample of an eleven-year-old boy's naive descriptions of his achromatic and chromatic pictures of House in the H-T-P series, followed by rephrased diagnostic descriptions. As noted, this is a sample to be followed in the evaluation of the H-T-P test.

H-T-P: diagnostic comment

The opportunity of colour effected a dramatic change in the boy's visual expression. The new freedom to express himself visually and verbally gave him a sense of relief from the strain of the long avoidance

8 The concept of 'naive' descriptions as phenomena to be translated into professional terms for phenomenological research is adopted here from psychologist Amedeo Giorgi (Ed.) *Phenomenology and Psychological Research*, Duquesne Univ. Press, Pittsburgh, PA, 1985.

of facts. Perhaps it even afforded him an acceptance of the breakdown of his family. In colour, he was able to shape his overly controlled emotions into the dramatic form–colour image of the burning home, and he grew calmer. The ability to achieve that indicated a source of strength in the young boy.

7. The 'Grouping Game': The drawing and painting materials, modelling mediums, textured fabrics, scraps of wood, and tools and implements tend to fall into disarray by the end of a diagnostic series. I found this condition helpful in designing a concluding activity to be used at diagnostician's choice, since some children may need it more than others. Scraps of fabrics and wood are part of the 'disarray'.

 The diagnostician says, 'See, with all we have been doing here, the art materials and things got so badly mixed up. Try to put these and other materials together in bunches that belong, or go together, and tell me when you are through'.

 This sorting or grouping exercise originated during a diag-nostic evaluation of a disoriented nine-year-old girl who couldn't read and presented a problem at school. She was in need of some sense of order in her disorganized, overwhelming world. We started by looking at one small object in the art-play room, such as a small jar of paint. Lifting the object, turning and touching it helped her describe what she saw and to name the colour of the paint. Other objects taught her about odours (leather, wool – wet and dry) and still others helped her describe differences in sounds (metals, glass, a bell, pounding).

 The 'Grouping Game' can be used as a final activity with the aim of tapping the child's sense of things belonging together by some shared quality, or purpose, not just for order; or it can be used in therapy for the disoriented, overwhelmed, or fear-stricken child clients.

Qualitative scoring

The scoring on this battery is most useful when, at the end of each item, diagnostician sums up briefly and specifically *What do we learn about (name) from this test?*

Additional Modality for Child Diagnostics: In Groups

A group of five children was formed for a few diagnostic art therapy meetings with an open-ended possibility of continuing as an art therapy group or to define modes of therapy for each. The members of the group, three girls and two boys, aged eight to ten, had low average to superior intelligence, a few individual abilities in mathematics, art and language, and indications on each of their IQ tests of some emotional difficulties. The children's complaints during individual interviews were: being disliked by other children, being laughed at, being overlooked. The parents related difficulties in controlling their child, upsetting school reports, and the child's conflicts with children on the block. One complaint mentioned eating problems and acting 'dream-like'. With the help of two art therapy students, a diagnostic program was designed and carried out. Based on a combination of group art projects and free individual art work with a variety of art materials, the program combined a few arts: painting, clay modelling, music in combination with movement, and games with qualities of sociograms. Most successful was drawing and cutting out each other's figures, then mounting them near 'someone you would like to be friends with'.

By the end of six weekly sessions, it was possible to pinpoint the difficulty that each individual had had that contributed to their conflicts in groups. The eldest girl was pre-anorexic; the middle girl held on to an unrealistic notion that she was 'great' and was out to impose that notion on others; the youngest girl was afraid to grow up and to become 'a woman'; the older boy, clown of the group, was afraid of 'going crazy'; and the younger boy lived with the understanding that 'the littlest one gets everything first', fighting for this right everywhere.

The group continued as an art therapy group through to the end of that school year, a total of seven months. Three of the children were actually helped by the group. The boy who was afraid of insanity and the pre-anorexic girl remained for a while in individual psychotherapy focused on art therapy.

Summary

This chapter presented a program of art therapy diagnostics for young children and for older children. A discussion about aims and methods of the program preceded the batteries. Specific features of the program were: a combination of free unstructured art work with structured assignments,

inclusion of two standardized projective tests pertaining to therapeutic art expression and to evaluation, new diagnostic assignments designed by the author, and a new method for the evaluation of the H-T-P projective test. Qualitative scoring was suggested with the aim of what could be learned about the child from each test.

Diagnostic Battery for Pre-Adolescents and Adolescents

Applicable also for testing adults

Art Materials:

> 24" x 18", 18" x 12" and 12" x 9" white drawing paper
>
> Poster paints in primary colours, a brush for each
>
> Alphacolor pastels, box of 12
>
> For House–Tree–Person (H–T–P):
>
> 6 sheets of 8.5" x 7" white drawing paper, box of 8 crayons and #2 pencil
>
> Small handful of clay ready for handling
>
> Scraps of fabrics and wood

Time: as needed or 2–3 1 hour sessions

The Battery:

I. Colour Form Blocks, Weigl-Goldestein-Scheerer

II. Experimentation with Poster Paints, I and II

III. Free Picture with Free Choice of Art Materials

IV. Free Clay Sculpture

V. House–Tree–Person (H–T–P), achromatic (pencil) and chromatic (crayons)

VI. 'Self-in-the-World' Scribble

Diagnostician may select fewer tests to assemble a smaller Battery, as needed. When testing pre-adolescents, *omit* the abstract Family picture. When testing adults, *omit* the Adolescent Window Triptych. Throughout the testing, S will represent Subject, D will represent Diagnostician.

I. Colour Form Blocks[1]

About the test

I like to begin a diagnostic art therapy or psychological evaluation of adolescents and adults with the brief and playful Colour Form Blocks. The task consists of a two-part sorting assignment of twelve colourful geometric shapes (forms). Tested is clients' ability to shift from one criterion of sorting to the other: from colour to form or from form to colour. Which of the criteria is employed first is worth noticing, as the sequence may be compared with clients' colour-form responses on the Rorschach Examination and also checked with their use of colour and form in free art work. This test also points to a wider perspective on personality traits. It indicates clients' flexibility regarding alternatives or seeing 'other possibilities' in situations, problems, solutions, and self, especially in individuals whose firmly established understandings and meanings do not admit alternatives. Such phenomena of a person's most inner life often go unacknowledged and at times even escape recognition in psychological assessment. This brief psychological test, however, recognizes the hidden phenomenon of self through a simple visual device of the manipulation of colour and form.

Administration of the Colour Form Test

D empties the box of Colour-Form Blocks onto a 12" x 9" sheet of white drawing paper in front of S and, brushing up the blocks, says, 'Turn these blocks right side up. Now arrange them in a way that will make them belong

1 Weigl-Goldstein-Scheerer Colour Form Blocks can be obtained by clinical psychologists or by mental health agencies from The Psychological Corporation, New York, Los Angeles, and other cities.

together. Go ahead.' S's questions, 'How do you want me to…' or 'You mean …' are all answered with, 'That is up to you.' When the client finishes the task, D asks, 'How did you go about it?' or 'What makes them belong together?' D records the answer, and outlines the block arrangement with pencil placing the first letter of each colour in the centre of each outlined block (b for blue, etc.) when the colour criterion is used. She/he then gathers the blocks and places them again in disarray on a fresh sheet of drawing paper saying, 'Now arrange them again, this time in another way that will make them belong together. Go ahead.' The procedure of marking outlines is repeated with no indication of colours if shape criterion is used. For recording, D may use the record sheet that comes with the test, or the two 12" x 9" drawing papers.

A variety of responses

1. S may immediately name the two criteria – colour and shape (or form) – and ask which to use first. D's answer is 'That is up to you'. D writes down the client's response and action.

2. S may ask to repeat the instruction. D repeats it and makes sure that instruction is understood.

3. S may carry out the instruction on the first part of the test sorting by colour or by shape, but is unable to proceed with the second sorting. D asks client to say verbally how the first correct arrangement was made, then to imagine another possibility. This failing, D silently displays the second correct arrangement and says, 'Look at this. Is this another way to arrange them?' She then brushes up the blocks, asking S to perform the sample arrangement and to tell what made the blocks belong together. The whole procedure must be recorded in detail.

4. Having received the initial instruction, S may begin to build with the blocks or make playful patterns, without apparent grasp of the task and the criteria for sorting. D then repeats the instruction in simpler words saying, 'Not building, just putting them together in bunches the way they go together'. If S proceeds to build again, D displays one of the correct sortings, asks S to look at it, brushes up the blocks saying, 'Make one the way I showed you'. If S fails, D patiently accepts the response and says, 'Now we have finished this test', and records all in detail.

Scoring for the Colour Form Blocks

C = Colour F = Form (or shape)

1. A quick grasp of both criteria, colour and shape or shape and colour, followed by correct sorting in both parts of the test without questions or doubts, scores FC+ and CF+ depending on the sequence of the criteria. Both FC and CF are good combinations of inner attitudes to life, although one is dominated by emotionality (C), the other by rational control (F). Both are Rorschach concepts and symbols relevant to art therapy.

2. Correct sorting by C or by F in the first part of the test, but failure to come up with the other possibility in the second part calls for D's sample arrangement. If client learns from it, score is -FC or -CF. If the effort to repeat D's sample and name the sorting criterion fails, score is FC- or CF-. Detailed qualitative report with regard to grasp, sequence, difficulty, and learning must follow scoring.

3. Persistent building or making patterns and failure to learn from D's sorting samples scores 0, followed by a qualitative report with regard to grasp of task, sequence of performance, and learning difficulty on that test.

II. Experimentation with Poster Paints

Part A

1. Placing in front of S a sheet of medium size white drawing paper and poster paints in primary colours with a brush for each, D says, 'Now you will do some things with colour. Choose two colours, place a daub of each right next to the other, and mix (or blend) them. You just made a new colour.'

2. 'Now choose two other colours and mix them.'

3. 'This time, choose a colour you like and try to change it into another colour that you would like.'

4. 'And now choose a colour you don't like and try to make it likeable.'

In case of S's difficulty about any of the above tasks, D displays a sample and makes a note about it for the report. D also observes S's ease or difficulty about handling colour: joy, a sense of discovery, hesitation, consideration of the process as something that must be done 'to pass', and so forth.

Part B

1. D says, 'Let's try something different: dip the brush in red and release (drop) a generous drop onto the paper. Now dip a brush in the yellow and release a drop into the red that you have on the paper. Watch what happens and describe accurately what you see.'

2. 'Now let's reverse it: release a drop of yellow onto the paper, then a drop of red into the yellow. Watch it and describe what you see.'

3. 'Now choose your own colours for this experiment, then reverse the colours. Watch, see, and describe what happens.' Again, D notes all S's reactions to colour: facial and verbal expressions, pace of work, invested energy, and interest or excitement.

Scoring for Experimentation with Poster Paints A and B

Scoring categories will be determined on a scale of 1–10. The categories are: 1. Initial response, 2. Interest at work, 3. New initiatives, 4. Choice of warm colours, 5. Choice of cool colours, 6. Sense of discovery, 7. Observation, 8. Description clarity, accuracy.

The following Table presents Categories and Scores.

	Categories	*High*	*Med.*	*Low*	*Part A*	*Part B*
Date	1. Initial response					
Name	2. Interest at work					
Age	3. New initiatives					
Name of D	4. Warm colours					
	5. Cool colours					
	6. Sense of Discovery					
	7. Observation					
	8. Description					

III. A Free Picture with Free Choice of Materials

D says, 'Look at these art materials and choose any of them to make a free picture, and give a title to your picture. Go ahead and let me know when it is ready.'

D displays the picture on an easel or on the wall saying, 'Now quietly look at your picture and notice everything on it. When you are ready say 'OK' and I will ask you to describe it.' At the 'OK', D says, 'Now describe your picture for me. What do you see? Begin with "I see …," please.' D takes verbatim notes.

Qualitative Evaluation

This test calls for verbal qualitative evaluations according to the following categories:

1. Recognizable content: realistic or abstract

2. Fitness of description to content and title

3. General impression of richness or poverty of picture

4. Does the picture present something whole, or something scattered and disconnected

5. Expressive qualities of lines and shapes: straight, wavy, jagged, rounded, etc.

6. Are limbs or parts of limbs missing

7. Are human motions or gestures (head, legs, arms, hands) restricted, free, etc.

8. Materials: pencil, crayons, pastels, paints, a combination of some

9. Quality of colour: warm, cool

10. Shading: dark, light

11. Painterly technique: full colour, colour outlines, scarcity of colour, smearing paint, textures, omission of colour on details

12. Use of experience from Play-Experimentation

13. Description of speech: flowing, hesitating, poor or rich vocabulary

14. Description connecting to personal memories, wishes, dreams

15. D says, 'Often a person's painting has some special meaning to him or to her. What does your picture mean to you?' D takes verbatim notes of S's description and answers.

IV. Free Clay Sculpture

D places the clay on a small revolving base (or a square of wood) in front of S and says, 'Pound the clay, work it with your fingers to get the feel of it and to get an idea of what it can do. Then make something that looks *alive* to you. Go ahead and let me know when your sculpture is finished, and give your sculpture a title.' D turns the base with the completed sculpture for both to see it from all sides as S describes the sculpture. All the while, D observes carefully and notes the following aspects of S's work with clay for qualitative evaluation:

1. S's initial contact with clay: appreciative, repulsive, exciting, etc.

2. Pounding and manipulating: energetic, lethargic, aggressive, creative

3. Transition to form: quick, slow, idea-oriented, perpetuating play, inventive

4. Ease or difficulty with three-dimensionality

5. Comparison of creativity and expressivity in clay and in Free Picture III.

V. House–Tree–Person (H–T–P)[2]

For general information and administration procedures of the H–T–P, D must study Item 6 in Diagnostic Battery for Children, ages 7–10. That information contains a new, qualitative method of translating S's descriptions of their H–T–P pictures into Diagnostic Descriptions in professional terms. Examples of 'naive' and Diagnostic Descriptions are included in the above-mentioned Item (6) for older children.

Administration of Finished H–T–P Picture Series

D mounts both H–T–P series (achromatic and chromatic) in two parallel columns and says, 'First, look intentionally and with concentration at all your pencil and colour pictures of the House, the Tree, and the Person; then, when you are ready, describe in detail all that you see and also what you feel and think of them. Begin with "I see…" Go ahead.'

D takes verbatim notes of S's 'naive' description and later translates it into a professional diagnostic description for the report. Also for the report, D

2 For background on the H–T–P and reports on H–T–P, see Footnote 7 in Chapter 10, p.147.

studies the two columns vertically and horizontally for comparison of vertical commonalities of style and locations of the pencil drawings, and horizontal differences due to colour. D then studies the whole-qualities of the parallel pictures.

D checks appropriate evaluations, adding her/his own observations, in the table over the page for each of the pictures.

	Pencil	Colour
1. Content: realistic, unrealistic, surrealistic		
2. Proportion, disproportion of the H, the T, and the P		
3. Location of H,T,P: centre, upper, lower, right, left corner		
4. Details: abundance, scarcity, missing, none		
5. Coverage: expanded, constricted, empty		
6. Line quality: fluent, rigid, discontinued, staccato, straight, rounded, jagged		
7. Pressure: strong, weak, disrupted		
8. Colour: warm, cool, abundant, scarce, rich		
9. Coloured outlines only: all, some, none		
10. Shading: light, heavy, dark		
11. Movement and gesture: still, rigid (hands, arms, legs), floating, relaxed		
12. Facial expressions: eyes, mouth		
13. Whole-quality of structure: coherent, incoherent, spatial, tight		
14. Reappearing features		
15. S connects pictures to self, examples		

VI. Self-in-the-World Scribble[3]

The Ulman procedure[4] is followed half-way: D introduces the Cane description of a Scribble, has S practise according to the Ulman format, and asks S to find shapes, images of 'things' in the scribble. Now D studies the

3 For background on the Self-in-the-World test, see 'The Scribble, Annotated,' Part III, pp.97ff.
4 For reference to the Ulman Scribble, see Footnote 2 in Chapter 7, p.98.

phenomenology of S's Scribble: the structure, the shapes found in it, and the marked perimeters. D also notes the ease or difficulty for S to carry out the task.

In the phenomenological use of the Scribble, the ground, that is, the scribble itself, represents the socio-cultural everyday world in which S was reared and raised. Shapes found and marked with perimeters are aspects of self. The perimeters around the shapes are boundaries between self and the world, necessary for self-articulation within that very world. Thus, it is important for D to note the perimeter lines with regard to pressure of the crayon, its strength or weakness, for it indicates self-assertiveness and self-articulation.

Every scribble is to be accepted and studied regardless of its adherence to or deviation from the initial model. Scribbles resembling any of the eight 'different' examples are of diagnostic and therapeutic importance as they cast light upon environments that impede self-articulation in contrast to those that promote it. Thus, the concepts of Everyday Life World (ground), Self-in-the-World, and Conceptual Articulation are not only interesting, but also functional for diagnostics and for therapy.

When a scribble is made, shapes found and perimeters marked, D checks appropriate qualities on the list below for qualitative evaluation:

1. Scribble as a whole: fitting the model, partly fitting, not fitting at all

2. Scribble line: flowing, rounded, wavy, jumbled, jagged, interrupted, staccato

3. Pressure of scribble line: faint, weak, moderate, heavy

4. Density of scribble: crowded, tangled, large spaces left, hardly any spaces left

5. Spread of scribble: over the whole surface, over most of, concentrated in parts (which)

6. Shapes (images, things): many, few, very few, none, one or two repeated over and over

7. Stated content of shapes

8. Perimeter lines: clear, strong, weak

D writes in report about the above findings with an evaluative comment about the psycho-social environment and its promoting or impeding influence on self-articulation and growth of self-in-the-world. Condensed and tangled scribble lines, crowded ones in one part of the surface, and scribble lines that leave no spaces, represent psycho-social environments that do not

encourage comfortably-formed shapes or images. Images found in such scribbles tend to be obsessive; that is, bound by one form and repeatedly appearing. Shapes or images in flowing-line scribbles have varied contents and clear parameters. The former indicates difficulty in self-articulation; the latter, normalcy in growth and self-articulation.

The above directions for qualitative evaluation are not a complete personality assessment. The Self-in-the-World scribble is only one of the tests, and it offers only psycho-social indications in a visual modality. The results of this test must be confirmed by other tests, psychologically and art-therapeutically.

VII. Adolescent Window Triptych, A Projective Test[5]

The Adolescent Window Triptych is an original, qualitative diagnostic procedure designed by the author for use with pre-adolescents and adolescents.[6] Based on the psychological premise that, normally, adolescents include the future in their present, the procedure has been tested in my work with most clients of that age group over a span of ten years. Four examples of the triptych are accompanied by subjects' naive descriptions and followed by diagnostic descriptions.

Procedure

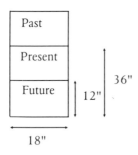

Figure 55

Diagnostician places in front of S a box of 12 alphacolor pastels and three 18" x 12" sheets of white drawing paper to be arranged in a vertical column measuring 36" x 18" as the papers touch along the 18-inch edge (see diagram) and says, 'These are three window-panes in a large window called a triptych, as in art, when a painting is composed of three parts that go together. Imagine that you are looking through each windowpane and see yourself in each at a different time of your life. You can quickly frame each windowpane by breaking an inch off any pastel you like and marking one

5 Practised over a span of ten years, the Adolescent Window Triptych (AWT) is published for the first time in this book.

6 In Battery administered to adults, *omit* the AWT.

inch around the edges of each. Start with Past. Use memory and imagination and make with these colours a picture of yourself in a childhood situation, event, or moment that remained with you. Use the whole space and fill it with colour. Go ahead.'

When Past is completed, D mounts it on easel or wall high enough to leave space below it for the next two pictures, yet comfortably visible for S's eye level. D says, 'Take a good intentional look at your picture. Concentrate your eyes on it so that you see all that can be seen. When you take some distance from your picture you may notice things that seem new and surprising.' Both D and S silently look at the picture for two to three minutes. Then D says, 'Now that you have taken a long look at your picture, describe it in detail. What do you see? Start with "I see..." D takes verbatim notes S's description.

This procedure is repeated with Present and Future. Generally, the procedure is limited to S's description, but D may point at and ask 'What about...' details that S omitted. D then places the next sheet of paper in front of S with a reminder to print PRESENT at the top centre, and to frame the windowpane. Again, silent study of the picture and S's description follow.

When S is ready for the last picture, D places the third sheet of paper and says, 'This time your task is a little different for you are asked to put your mind and imagination to what you want to be in the future as a grownup. So, print FUTURE at the top centre and frame this windowpane, too. Use the whole space, fill it with colour, and let me know when your picture is finished. Go ahead.' D again takes verbatim notes of the description. Discussion with S of the triptych as a whole leading to meanings is postponed to therapeutic hours.

Method of qualitative scoring of Triptych

Subjects' verbatim descriptions are called Naive Descriptions. Each Naive Description is followed by a professional Diagnostic Description based on the Naive one, but conceptually written in professional terms.

Four examples of Triptychs, Naive and Diagnostic Descriptions[7]

1. TRIPTYCH BY A 14-YEAR-OLD BOY – NAIVE DESCRIPTION

Past: I see what I remember when I was a little kid. My mom and dad were fighting, I think, over me. I didn't know what to do. I hold

7 For more on Naive and Diagnostic Descriptions, see Chapter 10, the House–Tree–Person.

my arms this way (*imitating his passive arms in the picture*). What could I do? The colours mean for me anger, there was a lot of anger, so I coloured the anger, I think (red and orange).

Present: I like this picture so much better. I see the three of us – my younger brother, Dad, and me – on a biking trip. I am ahead. Now we are together with my father and we do all these things on weekends. The yellow background shows a nice day, and here are all the shrubs… I am ahead. See, I want to be ahead of my father (*pause*) I want to be smarter than him.

Future: I see a courtroom. That's me. I am the lawyer advising my client and this is the judge. At this other desk is another lawyer with his client. And that's the American flag. I think that I helped my client win. I had some trouble drawing the courtroom, but when you asked how we know where the floor ends, I added these lines and then I saw the walls, and added these windows so the sun could come in, and here is a sunny spot on the rug.

DIAGNOSTIC DESCRIPTION OF TRIPTYCH A

In *Past*, the boy is re-experiencing his childhood trauma of the parental conflict that ended in divorce, and in his separation from his younger brother who remained with mother for a while. The gestures of the persons in the picture and the consciously chosen colours convey feelings of anger, helplessness and sadness.

Present carries a change of mood and the boy's new determination to do well effectively expressed in content, colour, movement, and in the organization of the picture – all indicating the boy's awareness of personal growth, relaxation of childhood tensions, and perhaps a possibility that the boy may overcome the disruption in his past.

Future attests to the fact that this adolescent does bring future into his present as he sees an image of his own mature person in action. This seems to be realistic thinking of his future and a beginning of a normal flow in his development.

2. TRIPTYCH OF A 17-YEAR-OLD GIRL – NAIVE DESCRIPTION

Past: I see my mother sick as always. Doesn't she look like a little kid? Here is my father. I like him best. And this is my sister. She's older than me. She goes to college and has a job. I don't think she is doing well in college; she's on drugs, I *know*. She doesn't live at home, she's on her own. My parents think she's great, but *I* know what she's really doing. Oh, she doesn't care for me at

all. The colours? Oh, you can see mom is sad and makes us sad. Sister hides in this great stuff she tells about herself. Me, I am hoping, maybe, dreaming, and here is my dad. He is good to me, even when I'm bad.

Present: That's a fantasy, and, yeah, the title is 'Fantasy'. I'm walking down a rainbow, to happiness. All the colours are light and happy. And there are lots of round lines and shapes, kind of neat. Oh, I thought that I drew flowers in that jar, now I see these hearts. That's neat.

Future: We, me and my friends, were sitting on this mountain, holding hands…and we got up and we are dancing. That feels good. You can see from the colours that everybody is happy. that's me in the pink, that's my big dress. I just now see that I have a face, nobody else has a face, hmm… (*Sudden change of mood.*) Oh, that's not a good picture. It's crazy, see? It's crazy!! (*Tears. Adds the dog, with crayon, climbing up to her, herself 'crying or praying', on the side of mountain.*)

DIAGNOSTIC DESCRIPTION OF TRIPTYCH B

What the girl sees in *Past* is a rather sharp, realistic way of appraising her family situation where she grew up and which she found impossible to cope with. The ingenious modality she invented to express her childhood situation and impasse is the visual technique of framing each family member in specific cubicles and colours conveying the moods of the family members, captives in their separate mental and situational worlds: the artmaker as a child framed in pink in the upper left-hand corner, viewing the scene; mother in blue-back frame, in her regressive existence of an asexual doll; sister doubly framed in green and brown in her most enclosed world; and father, in warm yellow frame at the centre, remote and helpless, yet his frame touches the frames of his daughters – his way of trying to break out of his isolation and get through to theirs.

In *Present*, the little pink girl of *Past* moved on to adolescence, still in pink, at a growing distance from reality and filling her Present with a dream of happiness, hope and love waiting for her somewhere in an unreal world at the end of a rainbow.

Her image of *Future* is even less realistic as she hopes that her adolescent marijuana-smoking meetings will last forever. However, the visual confrontation with the picture she had just created jolted her painfully back to some harsh realities of her situation.

The triptych opened up some possibilities for art therapy. Progress was, however, constantly thwarted by passive though caring family support, by the strong impact of friends, and by the girl's fluctuations from ecstatic to depressive to desperate moods.

C. TRIPTYCH BY A TEN-YEAR-OLD BOY – NAIVE DESCRIPTION

Past: I see a room in our old house, a long time ago. My father and mother locked themselves in this room and I couldn't get in. Only our dog got in. They had a fight, I could hear the shouting. It was scary. The dog heard it and cried. I put this tear under his eye. I made the walls red for anger and the floor blue for sadness.

Present: This is outside our new house, the one my mom, my brother and I live in now. My mom is calling me – it is sunset – to come in, and I am coming right down the path. I *really* listened to her. This here is my friend. I'm not going with him, I'm going to my house. I like the colours, they look happy. I like them better than the colours in my first windowpane.

Future: I see me grown up here. I am an archaeologist. I want to specialize in fossils and also make a lot of money. Here I dug up a very ancient fossil and I am selling it to a dealer. He gives me $1,000 for it. The yellow colour around us is daytime in the summer and the pink shows that the sun is somewhere near.

DIAGNOSTIC DESCRIPTION OF TRIPTYCH C

This precocious and sensitive pre-adolescent experienced the trauma of conflict – divorce and separation from father. The disruption changed him into a chaotically thinking and acting boy. Resenting his total dependence on mother alone, he tried to become independent in belligerent behaviour, wandering off for long hours and returning home at will, and being aggressive and destructive at home. In *Present*, he draws himself wishfully as a most obedient child, indicating a new awareness and the beginning of a change which, indeed, occurred sometime later.

Future attests to the transient nature of the boy's disturbance which occurred due to the family crisis. The boy includes the future in his present precociously early, but projects his true and real present fascination and preoccupation with fossils, into his future maturity.

D. TRIPTYCH BY A 12-YEAR-OLD PRE-ADOLESCENT GIRL – NAIVE DESCRIPTION

S chose to make her triptych in pencil, not colour.

Past: This is the last trip I took with grandpa before he died. I am on the road with my brother, my uncle, my grandfather and my grandmother. No, this is not a road. It was a road, but now it's a river, with mountains behind it. The people who worked for us lived in that cottage. I remember there was a radio with a red bow on it and a real wood-carved horse. I remember sitting in a rocking chair on my grandfather's lap (*pause*) there was a nanny there.

Present: These two houses are too little. This large one is your house. Here is the pumpkin that was there when I first came to you, and here is your cat. That's me in the door and that is the note you wrote to your daughter. And those are houses on the other side of your street, and the grasses.

Future: Here is this girl and this is her painting on the easel. She will get a college degree in art therapy. She will have to work hard all these years to be an artist. When she is 45 or 50, she will be a success and sell her pictures for a lot of money.

DIAGNOSTIC DESCRIPTION OF TRIPTYCH D

Despite an initial instruction to draw the triptych in colour, the client used pencil as the only means of drawing even though she had used colour in her free art work. The pencil lines are very thin as a result of weak pencil pressure. The preference of pencil is a telling choice. It indicates an effort to keep under control the many fragments of emotion-laden childhood memories crowding her mind when evoked by the idea of *Past* – memories of journeys, losses of loved ones, loss of comforts and security, disruptive changes, and new places to grow in. The final new place is associated with the art therapist's house and person, both exuding peace, attention, and cozy order, the steadiness of lasting relationships, and a reassuring model of what one wants to be in the future. And so, the pre-adolescent girl's future is included in her present; however, probably not as a natural development of her own identity, perhaps out of a need to identify with her art therapist who is a multiple symbol of experience and knowledge: how to help with problems, how to help through art, how to develop a good mother–daughter relationship, how to grow into maturity and become somebody. This identification is temporary but helpful in carrying her through to self identity.

QUALITATIVE EVALUATION OF THE ADOLESCENT WINDOW TRIPTYCH

(i) Naive Description

(ii) Diagnostic Description

(iii) Phenomenological Review of the Triptych with regard to:

 (a) individual structures of Past, Present and Future Windowpanes

 (b) continuities and discontinuities in the flow of past, present, and future

 (c) expression and evidence of S's perception and sense of reality

 (d) the active and the passive in the three windowpanes (high, low, none)

 (e) expressivity in line, shape, and colour

 (f) verbal expressivity compared with art expressivity

 (g) observed degree of involvement in the Triptych process (high, moderate, low).

VIIIa. Draw Your Family (or A Family) Picture, Representationally

D places an 18" x 12" sheet of white drawing paper in front of S and opens a box of pastels saying, 'With these colours, draw a picture of your family (or *a* family).' D mounts the completed picture, applies the What-Do-You-See? procedure for description of content and structure, then says, 'I wonder who has to do with whom, or who is especially close to whom. Draw lines with a colour connecting persons who feel something about each other. Now take another colour and draw lines from you to whom you would like to be close.' This simple sociogram helps D learn something of S's family dynamics and also a little about his/her place in the family. D takes verbatim notes.

VIIIb. Draw Your Family (or A Family) in Shapes, Abstract Version[8]

Placing a fresh 18" x 12" drawing paper in front of S and pointing at the open box of pastels, D says, 'Now try to imagine your family in shapes and colours, not with faces and bodies. See each member in your mind's eye as a coloured shape that somehow fits the person you are trying to visualize. This time they don't have to be in order of birth. Try to draw and colour the shapes in the order of closeness and distance. Go ahead.

8 When testing pre-adolescents, *omit* the Abstract Version of family picture.

D follows the same procedure of mounting the picture (possibly next to the representational family picture), followed by the What-Do-You-See? procedure and description, noted verbatim. D says, 'Look at both pictures now and say what you see.' For the report, D compares both sociograms and also the S's place in each. The abstract format of the family picture releases more expression of S's inner experience of the family and its structure. In that sense, the abstraction functions here as does colour in the H–T–P.

IX. Draw a Sociogram About You and Your Friends

D says, 'On a fresh sheet of paper and with these colours, draw a group of your friends in a circle, mark with colour intimate friendships, moderate ones, and just acquaintances according to the way you see it. You may do it again in shapes and place a first letter of each person's name above the shape. Then draw colour lines for warm, moderate, and so on, types of friendship. If the friendship is mutual, indicate it on the line with vectors directed in both ways. If it is one-sided only, indicate that with a vector in one direction. Go ahead.'

The finished picture is mounted on the wall and the What-Do-You-See? procedure applied.

D notes in the report information gained about S's psycho-social position among friends as compared to that in the family. Qualitative scoring in brief statements is addressed to the following issues:

1. Patterns of closeness and distance in the family according to both formats, representational and abstract

2. Patterns of closeness and distance among friends

3. S's place in the family and among friends

4. Expressive use of colour, line and shape

5. A summary about S's modes of relating to others: closeness, distance, guarded, hostile, angry, isolated, seeking closeness, etc.

X. Free Picture with Freely Chosen Materials

D says, 'Finally, you are now entirely free to make a picture about anything you want with any materials you choose. Well, choose the size of your paper and start. Let me know when your picture is finished.' D mounts the picture and applies the What-Do-You-See? procedure, taking verbatim notes of S's description. No inquiry or comment necessary except what S offers.

Evaluation

D mounts Free Picture of Test III beside the above free picture and compares the two free pictures with regard to the following aspects:

1. Specific differences and commonalities: content, size, structure, components and mutual relationships, coherence, expansion, etc.

2. Does the last free picture benefit from the test experience?

3. If the last picture is in any way a return to the free picture of Test III, specify in what ways.

4. Is the last picture a venture into something new? What is it?

Final Diagnostic Report and Recommendation

1. Subject's name, gender, age, school and grade, or schooling and occupation, source of referral, and reason for referral.

2. If D selected a number of tests for a smaller battery, that battery must be specified.

3. Individual reports of each test results, evaluated and scored.

4. Naive Descriptions should be attached to Diagnostic Descriptions.

5. Art works (drawings, paintings, play experimentation, and photos or slides of clay work) should be placed and marked in appropriate folders easily reached.

6. A final Summary addresses the following issues and questions:

 (i) noticeable changes in S's level of response in the course of testing

 (ii) favouring or avoiding certain art materials

 (iii) the manner of using colour: abundant, scarce, outlines only, kinds of brush strokes, smearing, etc.

 (iv) did free choice of materials promote expressivity

 (v) evidence of benefit from earlier test experience

 (vi) harmonies or discrepancies between S's art work and the verbal description

 (vii) did art work promote increasing self-disclosure

 (viii) responses to structured and unstructured tasks

(ix) were any specific 'traits' observed in the course of testing: artistry, elaboration, obsession, minimal care, richness, poverty, use of space, etc.

Recommendation

D recommends, does not recommend, suggests postponement of art therapy to a later time, and cites specific expectations, reasons, and purposes for each recommendation.

Part V

Art Expression by Children
Under Ultimate Stress

Art Expressions by
Children Under Ultimate Stress
(Terezin Concentration Camp, 1942–44)

Previous chapters addressed art expressions by children and adult clients locked in various forms of mental stress. Their stress emerged from certain discontinuities in the flow of familiar, person-to-person and person-to-world relationships. For some, particularly children and adolescents, the stress was aggravated by the maturational struggle between compliance and control. The affected individuals often suffered a loss of place in their world and had difficulties about renewing contact. Their world, however, had not ceased to exist. It was there to respond. Also, help was available when reached for. Therapeutic art helped revive their basic human needs and abilities to create and to express, to search for self, to reach out again and to communicate.

This chapter, too, addresses art expression by children. The chapter's subjects, however, are not live clients under the stress of emotional difficulties in their normal surroundings. The real subjects of the chapter are pictures by Holocaust children at the Terezin Concentration Camp during the span of 1942–44. Fifteen thousand Terezin children[1] left 4000 pictures.[2] Theirs was the ultimate stress of the threat and awareness of violent death. Under that stress, they drew and painted and cut-and-pasted their inner feelings, memories and thoughts as though they wanted and needed to tell the world. The children remained children as long as it was humanly possible under

1 Fewer than one hundred survived.
2 Collection of the State Jewish Museum, Prague.

the rapidly changing conditions from minimum standard conditions for inmates in early Terezin, the Nazi showcase of a benevolent concentration camp, to Terezin the extermination camp. The pace of that change is reflected in the children's pictures. Thus, we have only their pictures to look at, to feel ourselves into and, perhaps, to gain from them a sense of the inner experience that each child artist visualized.

An Exhibit tour

This chapter assumes the format of a tour to view a small exhibit of fifteen pictures selected out of forty shown in the United States in 1983.[3] Let us perceive each picture as a phenomenon with a structure of its own, that mirrors in some ways the inner experience of the young bearer of the experience. We will try to see all that can be seen in each art production. We will follow the now familiar steps of (1) visual display, (2) distancing, (3) intentional looking, (4) phenomenological description, and study of the structure. For phenomenological unfolding, we will have to have recourse to the expressive qualities hidden in the structural components and in their mutual relationships, and try to grasp the child artists' symbolic expressions mirrored in their pictures.

An Example of Seeing

In order to illustrate how we might look, see, and grasp a visualized experience, I shall preface the tour with an example of a picture by a Terezin child, not included in the selection, but reproduced here from a print of its original in colour pencils titled 'Children in the Park'.[4]

Slim trees, outlined in blue-green, reach as high into the sky as the two birds fly; the upright tree trunks are marked with multiple short lines and are conspicuous with jumbled blue lines inside the perimeters of the round crowns. At some distance, on the right, a couple of school sweethearts, perhaps, are seated on a bench under a tree, special with its golden crown and a bird perched at the peak. Turned toward each other, the two friends

3 'Image and Reality: Jewish Life in Terezin,' B'nai B'rith Klutznick Museum, Washington, D.C., part of 'The Precious Legacy,' Judaic Treasures from The Czechoslovak State Collections. Exhibition organized by the Smithsonian Institution Traveling Exhibit Service, 1983.

4 By permission of the State Jewish Museum, Prague, from ...*I Never Saw Another Butterfly...*, Schocken Books, NY, 1978.

watch other children jump ropes which are protectively suspended in the air. And a hill bursts with yellow spring flowers.

Children will draw such pictures, for it is their natural way to draw and colour pleasant moments of their life. Drawn by a child in a Nazi concentration camp, however, it is a memory of a life that has been.

While the picture is at first glance pleasant and serene, it has many signs of acute anxiety. How do we find these signs in a rather pleasant picture? A look at the structural components will help us, for they hold the expressive qualities invested in them by the artmaker.

The upright and upward stretching tree trunks, symbolizing healthy human bodies, are stabbed with short, violent lines. The handsome round treetops drawn in good proportion to their trunks and corresponding to the round jump ropes, might well represent the tranquillity of happy childhood – in normal life. But look at the tempestuous whirls within the confines of the crown perimeters, and notice the protective jump rope lines, or the transparency of the children-on-the-bench detail. These lines and shapes tell about the emotional upheaval inside the young child inmate, stunned by an incomprehensible reality.

Figure 56. Children in the Park

A last look at the picture as a whole strikes the attentive viewer with its stillness. All, except the whirring lines in the treetops, seems to be frozen at a certain moment in time. Thus, the picture can be seen both impressionistically and expressionistically.

We turn now to the exhibit proper.[5]

A glass case protects two worn pictures, a collage and a watercolour.

PRAHA (Prague)

Figure 57. Praha

A crossroad sign to PRAHA – the destination marked on one of its arms – is the central image of the collage, a cut-and-paste composition made on a Czech office form. The other arm of the sign bears no destination. The pole that holds the sign continues upward as a thick black staccato line which reaches into the sky, thereby dividing the collage vertically through the centre. On the right of the PRAHA sign is a shadow of a person unable to

5 By permission of the State Jewish Museum in Prague, Czechoslovakia.

act, arms tied in the back. On the left, destination unknown, is a robot-like figure with no facial features, duplicating the crossroad sign. Rays of a pale sun touch the blank part of the road sign and the stiff arm of the robot figure. Heavy, dark clouds spread over the left part of the collage and over part of the sun. The colours are: beige for the background form, black and brown for clouds, pale yellow for sunrays, dark grey for the shadow figure, almost white for the robot figure, and black frames for the sign arms and the extension line. That line, perfectly executed, speaks of the child artist's sense of dehumanization, disruption, separation, and the finality of it all.

Terezin Courtyard (not shown here)

The second art expression in the glass case, a watercolour by a 13-year-old boy on the reverse of a blotter paper, portrays what used to be a courtyard typical of the Czech historic fortress town, now famous as the Terezin Concentration Camp.

Two gable windows, strikingly painted as a pair of eyes, watch over the still greyness of the courtyard as an adult and a child walk toward a narrow entrance to the unknown. The courtyard widens, its walls growing larger toward the viewer; that is, toward the world, but narrows down, closing upon the central black arched passage which emanates threat. Colours are black and shades of grey.

Day and Night

This is a pencil and pastel drawing on a wrapping paper by a 12-year-old-girl.

The upper two-thirds of the picture has Night on the left and Day on the right, coexistent. Night, more active than Day, is allotted more space. Stars, a Star of David among them, and two moons assist Night in carrying out its chief action: dispatching the large loop of a multi-wagon train headed by a locomotive which emits a column of smoke. Above the train hangs a canopy-shaped cloud, heavy with drops of rain or tears. The train reaches a centrally located building with two smoking chimneys and black-framed windows.

Day has some small homes with small garden fences and smoking chimneys indicating that people live there, but are not seen to take interest in what is happening across the way.

A large sun is placed above the picture but seems ineffective, for its rays do not reach anywhere, and small black clouds are moving in on it. The restless blackbirds seem to sense something. A wide fence closes up the upper

two-thirds of the picture. The bottom third underneath the fence is a body of water. The lines indicate some storminess, but boats move about, perhaps with people who sail to safety.

Of all the mental forces operating in the emergence of an inner experience and in its visualization, thinking was probably the most prominent in the drawing of this picture. Children are genuine thinkers. They see and wonder and try to figure out in their naive ways things that philosophy and metaphysics deal with. Like many of her inmate peers, this 12-year-old did some hard thinking about the way the world operates. She might have started with an effort to maintain the established order of the world as she used to know it – a time and order for day and a time and order for night, day alive and active and night quiet and restful to get ready for the next day and, thus, grow within the certitude of that cycle.

What we see in the picture defies that order. Day is impoverished and grim even though a full sun is there. Night, assisted by two moons and an entourage of stars, operates the cattle train as it precariously speeds to the lit-up house of smoke. There is no human figure in the picture, but our thoughts go to those packed into the wagons.

The fence underscores the child's sense of doom. Yet the bottom third of the picture – the ocean and the freely moving boats – also express her belief that life is not foredoomed to stop forever, that the ocean offers freedom, that the ineffective sun on the picture will give its warmth, and that, after the nightmare, the world will return to its old order.

Memories of Vacations

This colourful chalk-and-pencil picture by a 13-year-old girl represents a series of memory pictures. These are visualizations of happy times when life was normal. There were many memory pictures in the large collection. In them, memory was the principal mental force that moved the child painters to visualize what they lost. We see a re-invented joyous summer day with friends at play in the park. A blue spinning carousel is the central image. Children play games. Carriages and colourful toys enliven the playground or the peaceful countryside picture of a village where vacations were spent. Colour, line and movement convey warm feelings.

Similar memory pictures not shown here are 'Children in the Orchard' and 'Games in the Park', two busy pencil drawings of children playing in a wooded area or on a wide parkway between rows of large old trees. The use of pencil alone might indicate troubled emotions as the children invoked their memories. 'Children in a Meadow' (not shown here) is a moving memory picture. The large front image of a nicely dressed dreamy girl

observes, or recalls, a distant scene: children at play in a green flower-dotted meadow, herself one of them. Occasionally, it happens in art therapy, too, that children paint themselves twice into a picture of a dream, memory or fantasy as both observers and participants.

Yet another memory picture, not shown here but of special interest, is 'House with a Garden'. The exterior of the house is heavily shaded in black. The garden fence is given very special emphasis on height and solidity, but there is no sign of a garden. Most probably, when the young artist began to draw his house and garden as they used to be, bleak reality moved in on the memory images, and so he reached for black to mourn his house. The garden fence became a tall, impenetrable fence of a concentration camp.

Sun pictures

Two peer inmates drew pictures of the sun. One drew a memory picture titled 'Sunning', a lazy summer day scene with two children stretched on a blanket and sunning themselves among flowers and shrubs.

The other child made an almost abstract picture of 'Two Suns'; one a very pale yellow, the other black, surrounded with a hazy violet, both above a field of grasses in violent disarray.

From the streets of Terezin, the children could occasionally see the sun. But, in their oppression, many experienced a profound change of feelings about the sun. The deep trust in this most benevolent element of nature that gives children so much pleasure and warmth in normal life, changed into a sense of betrayal by the sun, now pale, distant, and ineffective. Art productions expressive of these feelings indicate a growing anxiety about the prospect of survival. We have examples of this in the pale sunrays and the cloud moving in on the sun in Figure 56, in the large formal but ineffective sun in Figure 57, and as described above in 'Two Suns'. We will see more of this struggle between light and dark forces in other pictures.

Some child artists found refuge from the dark forces in fantasy.

Little Village Under the Mountains

This is a fantasy in colour pastels of a charming village, lively and serene in nowhereland, surrounded by mountains and with no roads to reach it. Warm pinks, golden yellows and rosy browns bathe the nowhere village, a child artist's refuge from ultimate terror. That terror is, however, artfully symbolized by a stark black omen at the peak of a distant mountain. This is but one representative of many similar fantasy pictures.

A large group of family pictures, closely related to the memory pictures, is represented in the small selection by two art expressions.

Family

This picture, by an anonymous child artist, is a collage made of cutouts from a yellowed office form on reddish wrapping paper. We see the front images of a couple of parents, one of them holding some precious possession; a baby, perhaps. At some distance behind them, children dance in a circle – a symbol of growth as a memory of the past or a hope for the future. The collage is expressive of loss, separation, deep concern about children's fate, and hope.

Home

The other family picture, also by an anonymous child, is a watercolour on a Czech office form.

Two parents seated at a table with light red table cloth, the man in a red plush reclining chair, turning to his wife as if trying to persuade her. The wife, seated in a brown highback chair, wears a hat and a wrap, perhaps fur. Between them stands a child. The lady's hat and wrap and the man's visible agitation suggest, perhaps, a hurried last-minute exchange of plans before they leave the home to escape arrest and deportation.

The emotional state of high tension finds its expression in the organization of the picture, its background, and in the use of colour. The whole scene is condensed in the upper right quadrant of the proportionately large surface: from the right, a small powerful area of black is moving in on that space, emphasizing the man's white profile, and separating the parents. The rest of the picture consists of a background wall, made of scraps of office forms incorporated in the picture. In sharp contrast to the unsure brush strokes of the scene are the perfectly straight lines of the form paper, symbolizing the concentration camp. A yellow-brown floor, horizontally stretching across the picture, is violently cracking and undermining the man's chair. The child's inarticulate body is gradually merging with the floor. Thus, a child's experience of a last family picture.

Life in Terezin

Terezin Interior

This picture is a watercolour by a 14-year-old boy on the reverse of a blueprint.

The reddish browns accentuated with black, the picture is expressive of the bleakness of life, of the violence of family destruction, and also of the

intimacy of the shared lot in a Terezin children's dorm. We see bunkbeds crowded in the background and on the sides of the picture, children huddled together on a bench, and the back of a tall departing adult – all in a dimly lit small space, well organized into a work of art. With limited art materials, the young boy succeeded in expressing a grim mood of a group in dim light, yet also the magic intensity of a shared moment.

And there were the cleanup pictures of children working at a project of shining up the Terezin camp. They shake blankets, pound a mattress, hang out clothes for airing – a lot of activity. One might expect that the children experienced excitement resembling happy moods of pre-holiday cleaning when life was normal. But signs of Holocaust reality are in the picture: the fence on the upper boundary of the drawings irrevocably reminds the child painters that this is the boundary between concentration camp and life, and that this is a familiar kind of cleaning up. For the children knew only too well that the cleanup project was the 'Befehl des Tages' – Order of the Day – in anticipation of a periodic visit by the International Red Cross Commission to check on a required minimum standard of living conditions for inmates in Terezin, the showcase of Nazi benevolent treatment.

Philosophical Pictures

As the breakdown of the showcase camp brought on hunger and epidemics and disappearance and finally the oven deaths, ultimate anxiety became the dominant mood. But it was often accompanied by a kind of precocious philosophical meditation about life, the good and the evil, and the meaning of it all. Some children wrote poems on these themes. Others drew, painted, and composed ingenious collages in abstract or semi-abstract style despite the acute limitation of art materials.

Mask

In watercolours on cut cardboard we see a threatening face of a not-to-be-trusted evil man. His devilish smile reveals decayed teeth. Red lines mark his yellow-greenish skin. And dark glasses beneath hollow eyes emphasize a chilling stare into the world. An anonymous child's visualization of evil.

Landscape with Blackbirds

This is a young girl's abstract collage on a yellow Czech office form. What do we see?

From left to right a bulky area of black overwhelms the meek sun and invades a yellow-brownish body of trees on the right. Though dimensionally smaller, the black entity seems powerful and threatening with its driving force. In an ominous line formation above, three blackbirds make their way towards the black invader, as though identifying with it. A huge composite of a sharp-angled cloud in greys and yellows spreads above the scene. As it devours the last of the sun's reflection (upper left), the cloud resembles an oversized, voracious prehistoric animal.

It is a wonder how a child, herself in ultimate anguish, can still mobilize all her mental forces to visualize the collective and personal inner experience into a well-organized, evocative and strong statement with line, shape and colour, by means of very poor materials. This is not a depressive picture. It is a silent cry for the world to see.

Butterflies

At the far left on the exhibit wall are a few butterfly pictures. They represent many more in the large collection, often accompanied by butterfly poems. Figure 58 by a 10-year-old girl is a picture in soft warm watercolours on tan wrapping paper, of trees in bloom, a body of water. Above it all, two butterflies larger than the trees, suspended in the air, dominate the picture. Another girl's bright watercolour on the reverse of yellow wrapping paper. The colour of the wrapping paper happens to make a fitting 'sunny' background for the massive green interspersed with small red flowers that brings forth the two dominant images: a red-orange flower and a blue one, both in full bloom, and an elegant butterfly nestled in each. Surrounding elongated grasses receive a touch of the sunrays.

By means of round and oval lines and shapes, and with warm colours, the child painters succeeded in evoking long-gone but well-remembered experiences of a still moment on a hot summer afternoon, as intense as is a butterfly's clinging to the source of life in a flower.

Butterflies, hardly visiting a concentration camp, held a magic for the inmate children. Their legacy of pictures and poems tells of the love affair between them and the lovely flying gems of nature charmingly busy, beautiful, and free. So much akin to children.

A 12-year-old girl made a line drawing with pencil on wrapping paper titled 'Fear'. We see multiple shaded lines rushing toward the centre of the picture. In the centre, a huge black heavily shaded shape is descending upon a child with frozen eye, standing hair, and bare arms in protective gesture. Noticeable are two small circular shapes: the bright light on the descending shape and the dark eye of the child.

Figure 58. Butterflies

Figure 59. Fear

Girl and Lightning

At the exit of the exhibit hall we stop to look at this, the last picture in the
selection. It is an artful collage by a 14-year-old girl. She made it with scraps
of old papers. The lower part of the background is a combination of yellow,
beige and brown – the earth on which the central image, a girl, stands. The
upper part is a composition of grey and black paper scraps to signify a
dramatically changing sky on a stormy night. The slim girl, tense as a wire,
is being struck by a bold of lightning. She and the ground are illuminated

by the sudden light. Astonishment in her face and the position of her arms attest to the shock of the experience. If we gaze intentionally at her, we can almost bodily feel the tension in her body. Symbolically, and most succinctly, this collage is a visualization with simple art materials of the inner experience of Holocaust children.

Summary

In the format of an exhibit tour, 14 art productions by child inmates of the Terezin Concentration Camp were examined. Following the approach and method presented in the book, an effort was made to help readers and viewers grasp the structure of the individual child artists' inner experiences by studying the structure of their visualized art expressions.

The children's pictures are visual evidence that no matter what the scarcity of art materials and the degree of stress, there is a capacity for self-expression and creativity. These children ingeniously expressed their inner experience with scraps of discarded office forms and bits of colour more readily than with words, although many also wrote poems. To see the expression invested in the pictures in the absence of dialogue with the child artists, one had to be helped by phenomenological and Gestalt concepts incorporated in this book – intuiting, the art of seeing and visualizing, the concept of structure and its dynamics, and the expressive values of the components.

List of Criteria for the Judgement of Affect Categories – Adults

ANGER
Colour: Red, red–blue, red–orange, red–black, grey–black, black–red, black–green, purple. Overlay of colour (i.e., one colour on top of another).

Shading: Occasional background shading, heavily pressured crayon lines, heavily shaded lines.

Line & Form: Multiple lines over space, parallel or crossed; spirals in jagged scribbles; zig-zag lines and forms; overlay of lines; condensed centres with outward bursts of lines; sharp angular scribbles; sharp angular forms; pointed and jagged converging lines and forms.

Movement: Dynamic burst; dynamic spread; continuous, ongoing movement in the round; continuous clashing, angularity of lines.

Whole Qualities: Dominant colour: red; intensity of colour; intense pressure of crayon; spacing of production in centre of paper; overall strong dynamization. Aggressive to violent energy patterns.

LOVE
Colour: Dominating pastels; rose, orange, green–blue, light reddish brown, orange–green, orange–blue, orange–yellow, yellow–orange–blue, blue–green–violet, and multicoloured. Three out of 20: strong red and red–violet.

Shading: Lightly shaded halos in pastels.

Line & Form: Predominantly circular and oval lines, forms and images. Rounded centres with bursts of lines, centres with halos, multiple-linked circles, human images embracing, spiral forms intertwined, paisley forms embedded in each other.

Movement: Coming toward, contacting, touching, swirling, reaching; aesthetic encounter of forms, forms containing forms.

Whole Qualities: Combinations of circular forms in pastels and in occasional strong reds within continuous circular motion of lines, well-centred on page or occupying whole space, create a sensation of compelling stress; energy gently enveloping in pleasing patterns.

FEAR
Colour: Grey, black, grey–black, pale blue, blue–grey, blue–black, pale yellow, yellow–grey, orange. Two out of each 10: strong, firelike combinations of black–red–blue.

Shading: Shaded areas, shaded lines, shaded backgrounds.

Line & Form: Zig-zag lines from bottom to top, spirals from centre point outward, condensed spots or forms, fingerlike forms, pointed or rounded.

Movement: Closing in on, spreading, creeping up, floating above, pushing upward.

Whole Qualities: Combinations of line, colour, shading, and movement create in the beholder threatening, ominous, chilling, or dangerous sensations; energy creepingly spreading rather than violently attacking.

Experiment with Children

INSTRUCTIONS FOR DATA GATHERING:

1. Materials: Have three 12" x 9" sheets of drawing paper and boxes of 8 crayons per box on each child's desk.
2. Say 'We will start our art work today with something special. Here is what we will do. Put one of these sheets of paper in front of you and take the crayons out of your box so that you have them handy. I will say a word. It will be about something we all feel. As soon as I say it, you take the colours that seem right to you for that word and make a picture in colours and lines of how that word feels. You get *two minutes* for each picture. The first word is *FEAR*. Go.' *(Instructor begins to mark time.)* 'Stop. Now print an F in the upper, right-hand corner and put your picture on the side, blank side up.'
3. 'Now put the second sheet of paper in front of you. The next word is *LOVE*. Go.' *(Instructor begins to mark time.)* 'Stop. Now print L in the upper, right-hand corner and put your picture on top of the first one, blank side up.'
4. 'Now put the last sheet of paper in front or you. The last word is *ANGER*. Go.' *(Instructor begins to mark time.)* 'Stop. Now print an A in the upper, right-hand corner and put your picture on top of the other pictures, blank side up.' Instructor collects all the pictures and says, 'Thank you, we finished this part of our art work.'

Useful Hints

1. Timing must be strictly observed with a stopwatch, two minutes from Go.
2. All questions about details should be answered, 'That is up to you'.
3. The idea is to obtain abstract pictures in colour and line, not pictographs, stick figures, hearts, or 'smiley'/frown faces.
4. If the children want to talk after the experiment, guide their verbal expressions to what they felt while they were making their pictures, how they chose their colours etc. Do not display the pictures.

Instructions for Judgements

Preparation: every child has a page and pencil on the desk. Before you tape up *Display No. 1*, you say, 'My name is _____ and I am going to do something special with you. Children in the fourth, fifth and sixth grades in another school were asked to make pictures of how it feels to love, to be angry (or mad), or to be afraid (or scared). We all know how these things feel. I will show you six pictures for each of these feelings, *Love*,

Anger, Fear, that those children made with colours, lines and shapes. But I will put them up in a different order. Look at each set of six; put yourself in the mood of Love or Anger or Fear and as soon as you know which feeling each group of six pictures portrays, write it down. Any questions?

'Now, in the upper left of your page, write *No. 1* and next to it you will name the feeling of your choice. I am now taping up the first display and beginning to time you for five minutes. Go.'

'Now, write *No. 2* in the middle of your page and under the No. 1, so you can name the feeling of your choice next to No. 2. Here is the second display. I am beginning to time you. Go.'

'Now, write *No. 3* on the bottom left and next to it name the feeling of your choice. I am beginning to time you. Go. And now we are through.'

APPENDIX IV

Judgements: Tally Sheets

GRADE IV

1. Number of children present: 5 boys 5 girls
 Overall number of judgments in this grade: 10 x 6 = 60

2. *The Judgments*

 (a) When Fear was shown,
how many wrote Fear:	9
how many wrote Love:	0
how many wrote Anger:	1

 (b) When Anger was shown,
how many wrote Anger:	10
how many wrote Love:	0
how many wrote Fear:	0

 (c) When Love was shown,
how many wrote Love:	10
how many wrote Fear:	0
how many wrote Anger:	0

GRADE V

1. Number of children present: 9 boys 9 girls
 Overall number of judgments in this grade: 18 x 6 = 108

2. *The Judgments*

 (a) When Fear was shown,
how many wrote Fear:	17
how many wrote Love:	0
how many wrote Anger:	1

(b) When Anger was shown,

how many wrote Anger:	17
how many wrote Love:	0
how many wrote Fear:	1

(c) When Love was shown,

how many wrote Love:	18
how many wrote Fear:	0
how many wrote Anger:	0

GRADE VI

1. Number of children present: 8 boys 10 girls
 Overall number of judgments in this grade: 18 x 6 = 108

2. *The Judgments*

(a) When Fear was shown,

how many wrote Fear:	17
how many wrote Love:	0
how many wrote Anger:	1

(b) When Anger was shown,

how many wrote Anger:	17
how many wrote Love:	0
how many wrote Fear:	1

(c) When Love was shown,

how many wrote Love:	18
how many wrote Fear:	0
how many wrote Anger:	0

Additional References

BOOKS

Allport, G.W. (1968) *The Person in Psychology*. Boston: Beacon Press.

Burton, A. (1968) *Modern Humanistic Psychotherapy*. San Francisco: Jossey-Bass.

Derlega, V.J. (ed.) (1987) *Self-Disclosure*. New York: Plenum.

Douvan, E. and Adelson, J. (1966) *The Adolescent Experience*. New York: John Wiley & Sons.

Esman, A.H. (ed.) (1966) *The Psychiatric Treatment of Adolescents*. New York: International Universities Press.

Gendlin, E.T. (1978) *Focusing*. New York: Everest House.

Giorgi, A. (ed.) (1985) *Phenomenology and Psychological Research*. Pittsburgh: Duquesne University Press.

Ghougassian, J.P. (1972) *Gordon Allport's Ontopsychology of the Person*. New York: Philosophical Library.

Green, G. (1969) *The Artists of Terezin*. New York: Hawthorn Books.

Hammer, E.F. (1984) *Creativity, Talent and Personality*. Malabar, Florida: Robert E. Krieger.

Johnston, C.M. (1986) *The Creative Imperative*. Berkeley, California: Celestial Arts.

Messer, A.A. (1970) *The Individual in His Family*. Springfield, Illinois: Charles C. Thomas.

Merleau-Ponty, M. (1968) *The Visible and the Invisible*. Evanston, Illinois: Northwestern University Press.

Morris, D. and others. (1980) *Gestures*. New York: Stein and Day.

Rubin, J.A. (1978) *Child Art Therapy*. New York: Van Nostrand Reinhold.

Rubin, J.A. (ed.) (1987) *Approaches to Art Therapy*. New York: Brunner/Mazel.

Shaver, K.G. (1975) *An Introduction to Attribution Processes*. Cambridge, Massachusetts: Winthrop Publishing.

Wils, L. and others. (1977) *Spielenderweise*. Wupenthal, West Germany: Hans Putty Verlag.

Winner, E. (1982) *Invented Worlds*. Cambridge, Massachusetts: Harvard University Press.

ARTICLES

Arnheim, R. (1958) 'Emotion and Feeling in Psychology and Art,' *Confinia Psychiatrica*, 1:69–88.

Betensky, M. (1987) 'Phenomenology of Therapeutic Art Expression and Art Therapy,' In *Approaches to Art Therapy*, Judith Aron Rubin, editor. Brunner/Mazel, pp. 149–166.

Betensky, M. and Nucho, A.O. (1979) 'The Phenomenological Approach to Art Therapy,' *Proceedings*, 10th Annual Conference of the American Art Therapy Association, Washington, D.C.

Betensky, M. and Nucho, A.O. (1981) 'Phenomenological Seeing – Paper and Videotape,' *Proceedings*, 12th Annual Conference, American Art Therapy Association.

Betensky, M. (1982) 'Phenomenology of Art Materials,' *Proceedings*: Media Potential, 13th Annual Conference, American Art Therapy Association.

Betensky, M. (1973) 'Patterns of Visual Expression in Art Psychotherapy,' *Art Psychotherapy*, Vol. 1, pp. 121–129.

Betensky, M. (1978) 'Phenomenology of Self-expression in Theory and Practice,' *Confinia Psychiatrica*: International Colloquium for Psychopathology of Expression, Jerusalem. Basel: S. Karger, 21:31–36.

Betensky, M. (1977) 'The Phenomenological Approach to Art Expression and Art Therapy,' *Art Psychotherapy*, Vol. 4, pp. 173–179.

Bornstein, M., MD, and others (1984) 'Commentaries on Merton Gill's Analysis of Transference,' *Psychoanalytic Inquiry*, Vol. 4, No. 3.

Mook, B., PhD (1982) 'Analysis of Therapist Variables in a Series of Psychotherapy Session with Two Child Clients,' *Journal of Clinical Psychology*, Vol. 38, No. 1, pp. 63–76.

Poffenberger, A.T. and Barrows, B.E. (1924) 'The Feeling Value of Lines,' *Journal of Applied Psychology*, 8:187–205.

Schaie, W.K. (1961) 'Sealing the Association between Colors and Mood Tones,' *American Journal of Psychology*, 74:266–273.

Scheerer, M. and Lyons, J. (1957) 'Line Drawings and Matching Responses to Words,' *Journal of Personality*, 25:251–273.

VIDEOTAPES

Nucho, A.O. and Betensky, M. *Art Therapy: The Phenomenological Approach*. A 7-part videotape series, 3/4" U-Matic format, colour. The Media Center, University of Maryland, Baltimore Campus.

Nucho, A.O. and Betensky, M. *Phenomenological Seeing*. Videotape, 3/4" U-Matic format, colour. The Media Center, University of Maryland, Baltimore Campus.

The Making of a Scribble, Part I. Dr. Mala Betensky conducts an art therapy session with a pre-anorexic adolescent girl.

The Making of a Scribble, Part II. Dr. Aina Nucho and Dr. Mala Betensky discuss videotape Part I as they view the collection of scribbles. Producer: Aina Nucho, PhD., School of Social Work and Community Planning, University of Maryland, Baltimore Campus.

Subject Index

Author
Index